TEXAS

A VISUAL JOURNEY

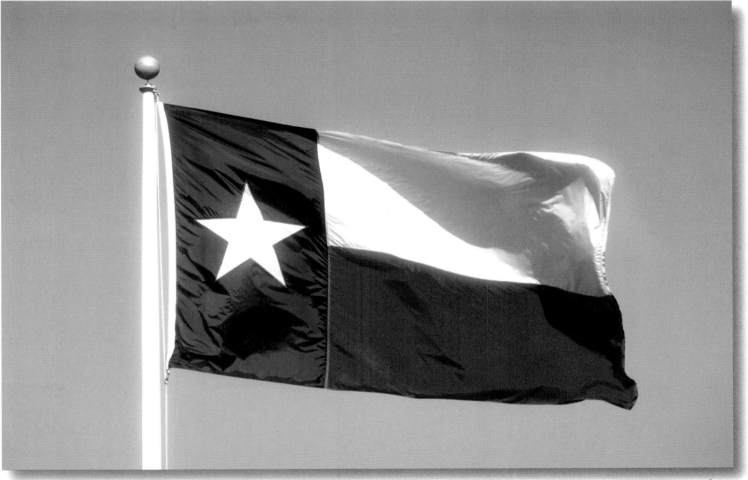

Scott Teven photo

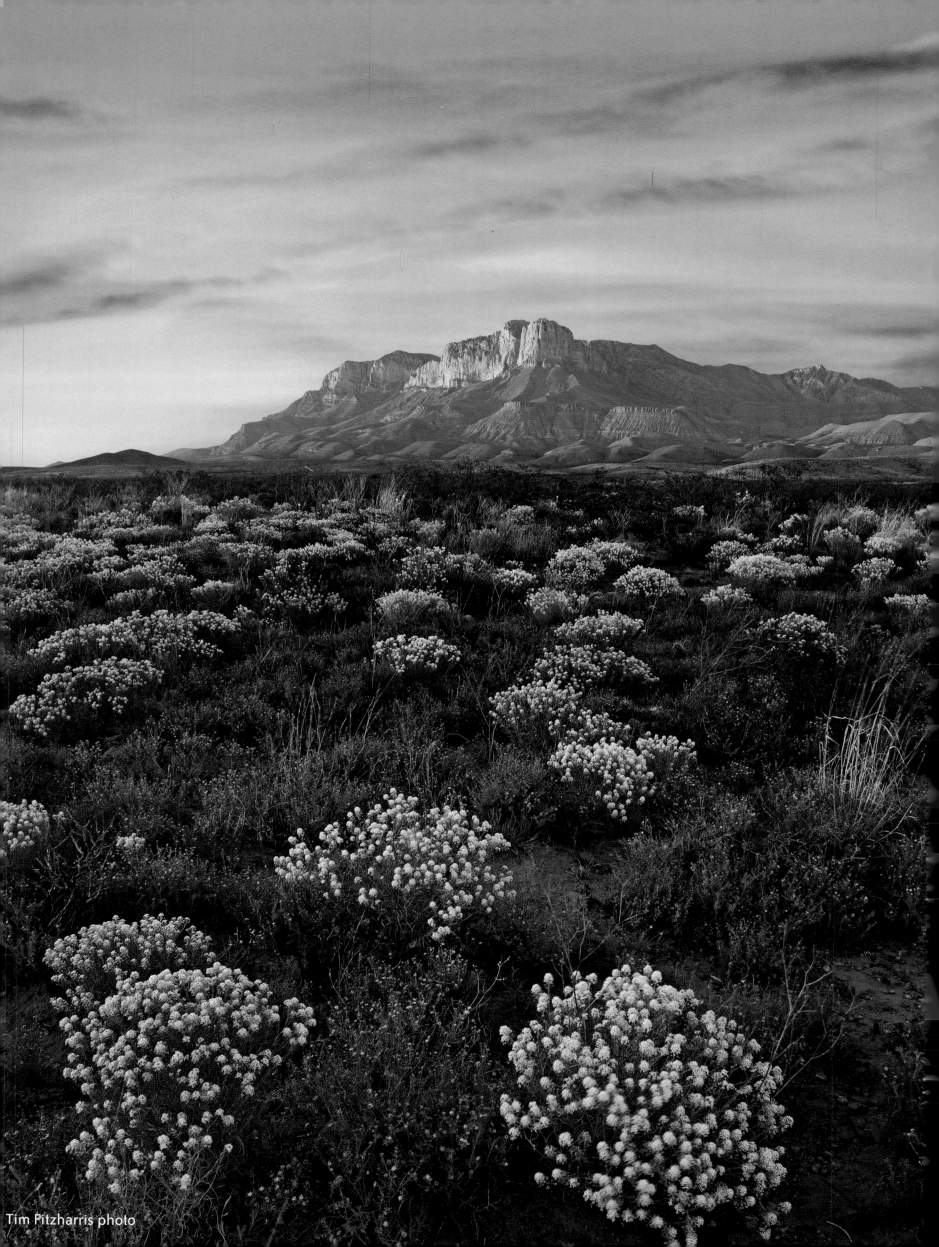

TEXAS
A VISUAL JOURNEY

whitecap

Text by Claire Leila Philipson
Photo selection by Diana Bebek
Edited by Ben D'Andrea
Interior design by Five Seventeen & Jesse Marchand
Cover design by Susan Greenshields and Jesse Marchand

Printed and bound in China by WKT Company Ltd.

Library and Archives Canada Cataloguing in Publication

Philipson, Claire Leila, 1980–
 Texas : a visual journey / Claire Leila Philipson.

ISBN-13: 978-1-55285-857-8
ISBN-10: 1-55285-857-X

 1. Texas—Pictorial works. I. Title.

F387.P44 2007 976.4'0640222 C2006-904982-3

The publisher acknowledges the financial support of the Government of Canada through the Book
Publishing Industry Development Program (BPIDP) and the Province of British Columbia through
the Book Publishing Tax Credit.

 For more information on other Whitecap Books titles,
 please visit our web site at www.whitecap.ca.

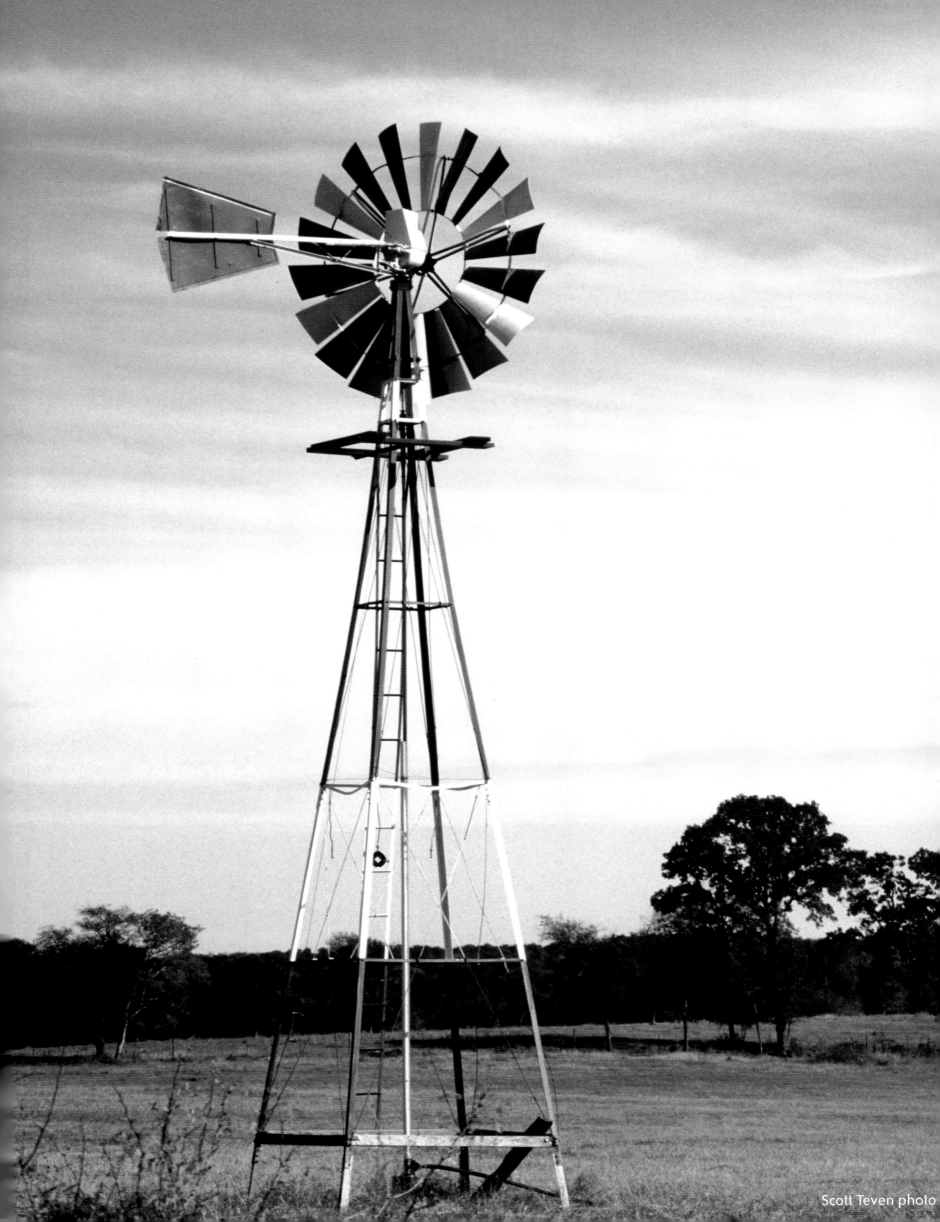

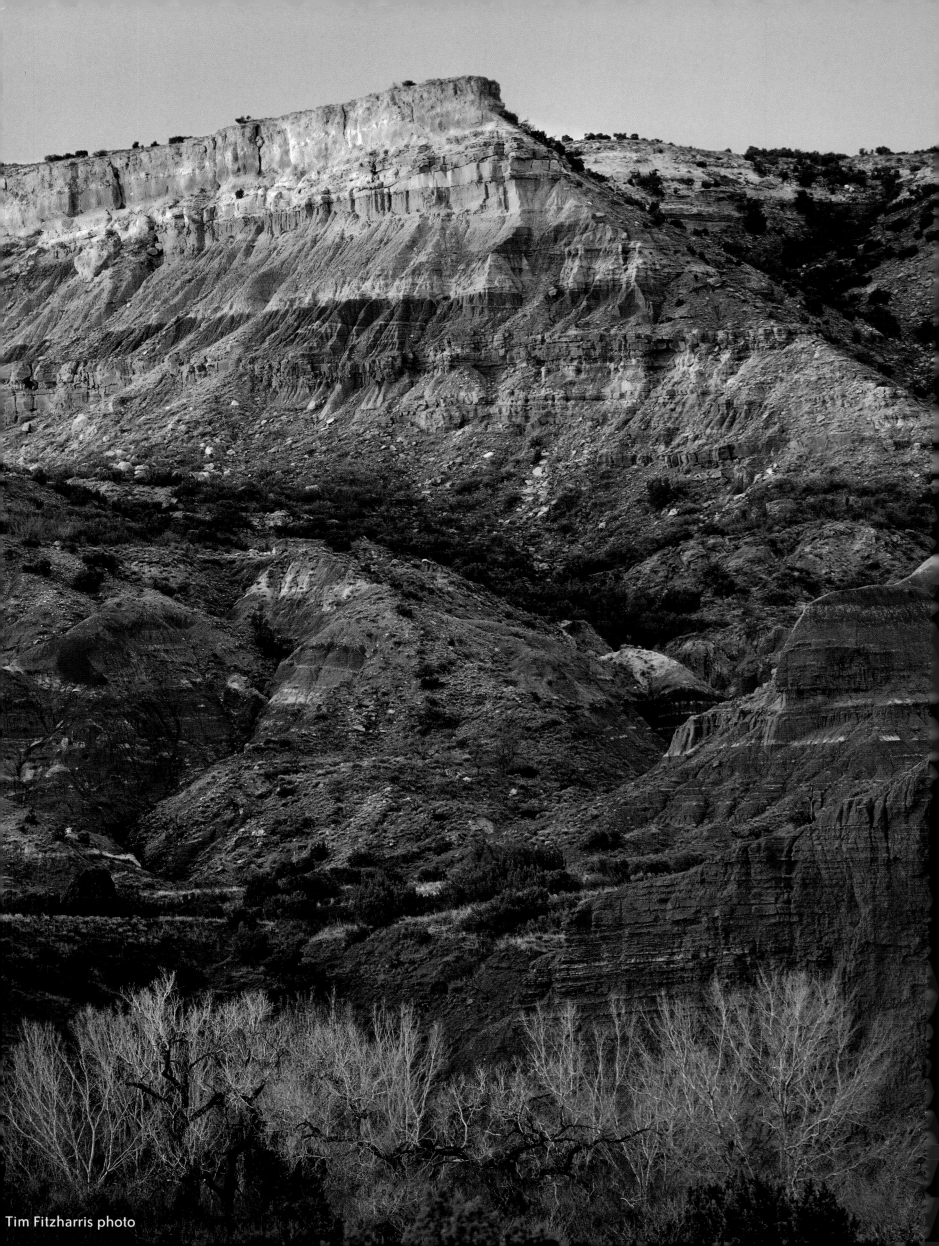

INTRODUCTION

A land of legend and largess, Texas is so distinctive that it is often referred to as a nation unto itself. Author John Steinbeck famously said: "Texas is a state of mind. Texas is an obsession. Above all, Texas is a nation in every sense of the word." The Lone Star state has been shaped by the six different countries whose flags have flown over its immense terrain: France, Spain, Mexico, the Republic of Texas, the Confederate States of America, and finally the United States of America.

The second-largest state in the U.S., Texas is awe-inspiring, as eclectic as it is vast. Its geographical assets range from the arid, mountainous landscapes of Western Texas — where the majestic Chisos and Davis Mountain ranges rise dramatically from the earth — to the picturesque beaches along the Gulf Coast in the south. Amid huge regions of protected wilderness, ranchland, and parks, Texas' cosmopolitan cities are hubs of industry and culture. Space-age Houston is the center of the nation's oil industry and home to NASA's Mission Control Center. Beautiful San Antonio is renowned for both the Alamo mission and the picturesque river winding through its downtown core. Austin has a reputation as one of the most progressive music scenes in the world, and Dallas offers up world-class culture and cuisine.

The rugged adventure of the Wild West resonates throughout the state. The cattle drives that brought pioneers on a dusty and unfamiliar journey to Texas in the 19th century are re-enacted every year, the largest and most famous ride culminating in the Houston Livestock and Rodeo Show. Although the cattle industry has been taken over by oil as the state's economic stronghold, Texas is still dotted with working ranches presided over by cowboys and cowgirls.

From ranchland and oilfields to Galveston's restored Victorian architecture, from deserts and beaches to vibrant cities, Texas has earned its motto: "It's like a whole other country."

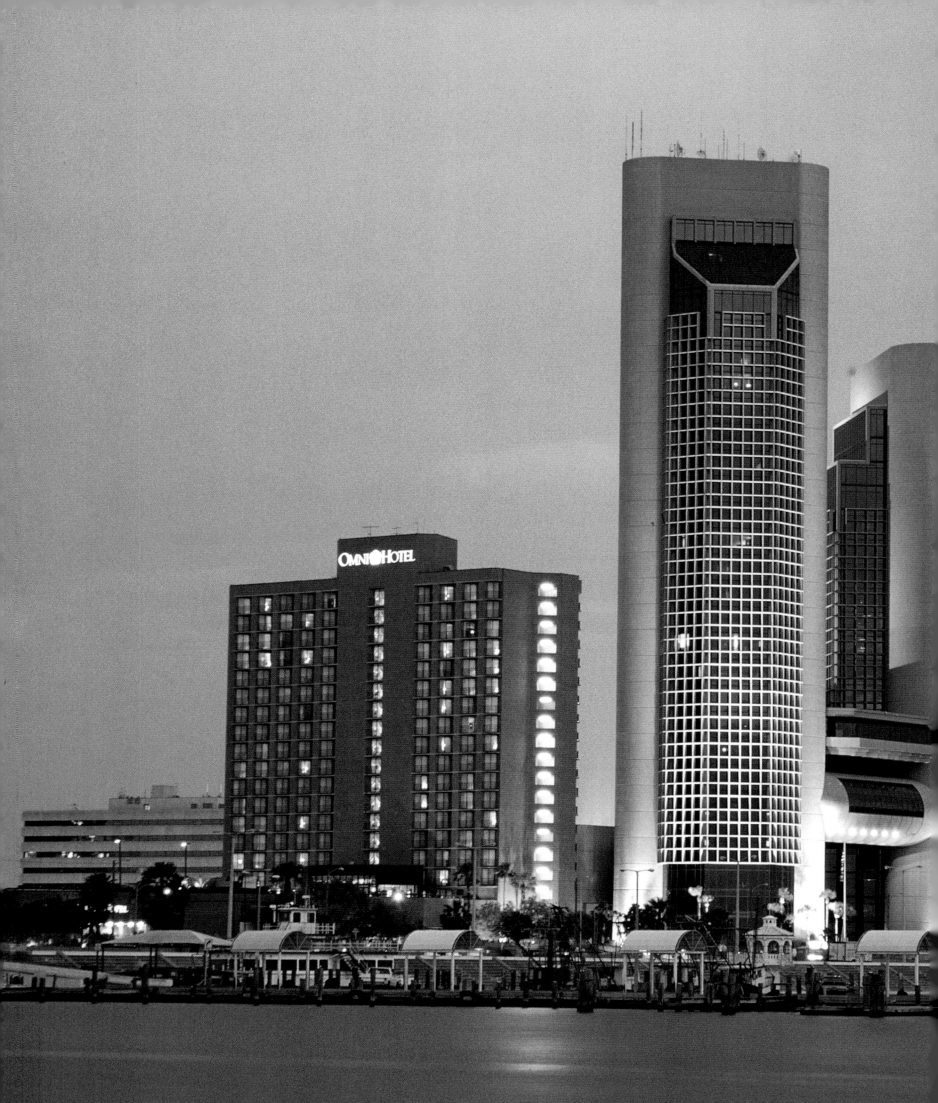

The largest coastal city in
Texas, Corpus Christi offers up
a memorable blend of urban
attractions and picturesque
beaches. This city was named after
the day it was discovered in 1519
— the Roman Catholic feast day
of Corpus Christi. Today, Corpus
Christi's lively marina, awe-inspiring
views, and endless beaches
have earned it the nickname the
Sparkling City by the Sea.

Richard Cummins photo

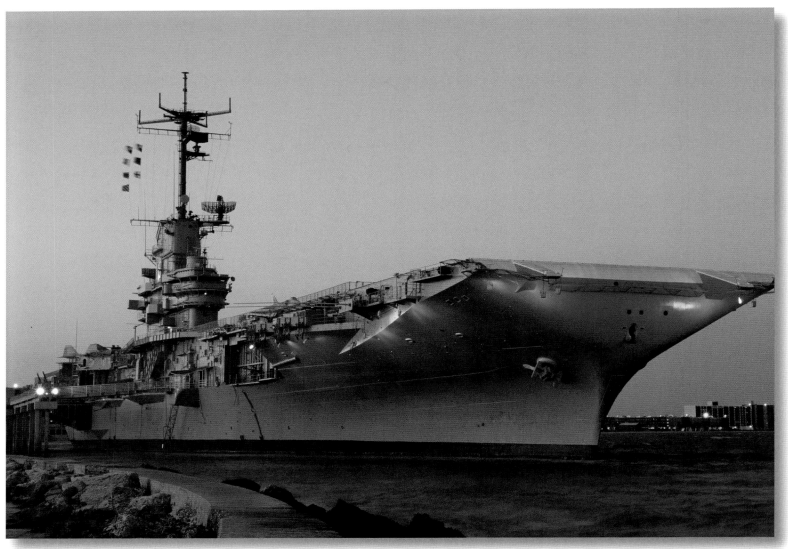

A stately ship that earned herself the nickname the Blue Ghost, the USS *Lexington* served the U.S. longer and set more records than any other carrier. After being commissioned in 1943, the *Lexington* participated in almost every major operation in the Pacific. Before being decommissioned in 1991, this powerful ship earned multiple awards for battle and destroyed hundreds of enemy aircraft and cargo ships.

The Spindletop oil field propelled Texas' economy into oil and petroleum at the beginning of the 20th century. It was here that Louisiana mining engineer and oil prospector Anthony F. Lucas drilled the discovery well and unleashed the future of the Texan industry. When first discovered, the well produced about 75,000 barrels of oil a day, more than all the other wells in the U.S. combined. *(right)*

SANGSTAD
OSLO

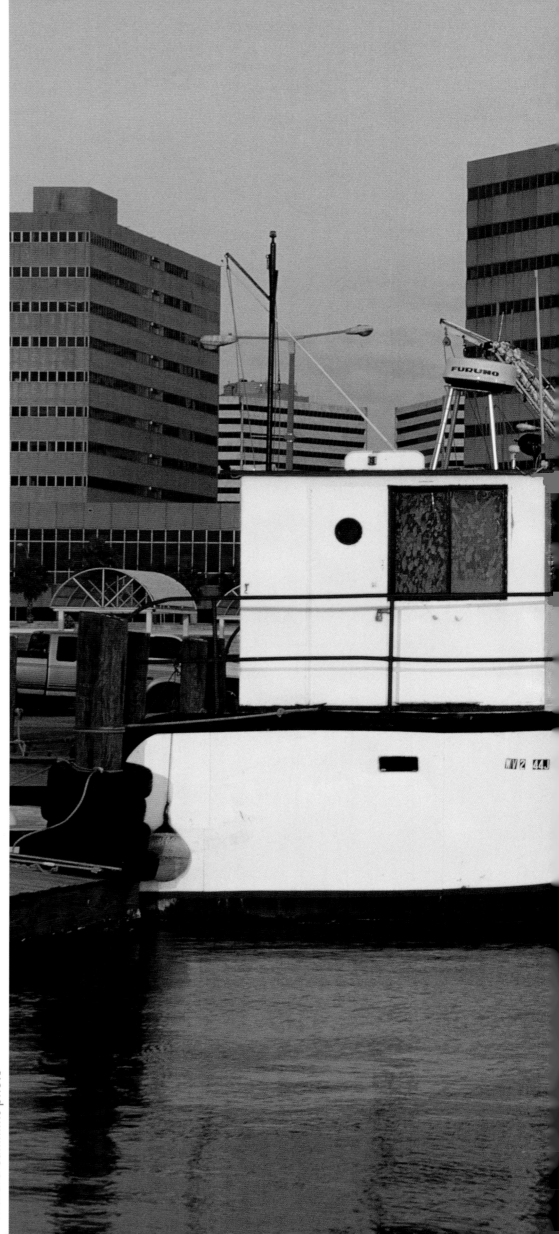

At the heart of the historic coastal port of Corpus Christi is the city's dynamic marina. On regatta days, colorful sails dapple the horizon.

Corpus Christi boasts some of the best fishing in the U.S. The city's proximity to Corpus Christi Bay, the Gulf of Mexico, and Laguna Madre attracts fishing enthusiasts from all over the world. Corpus Christi is also an important marine biology research center.

Many industrial vessels pass through the port of Houston, including this liquid petroleum gas tanker. *(previous pages)*

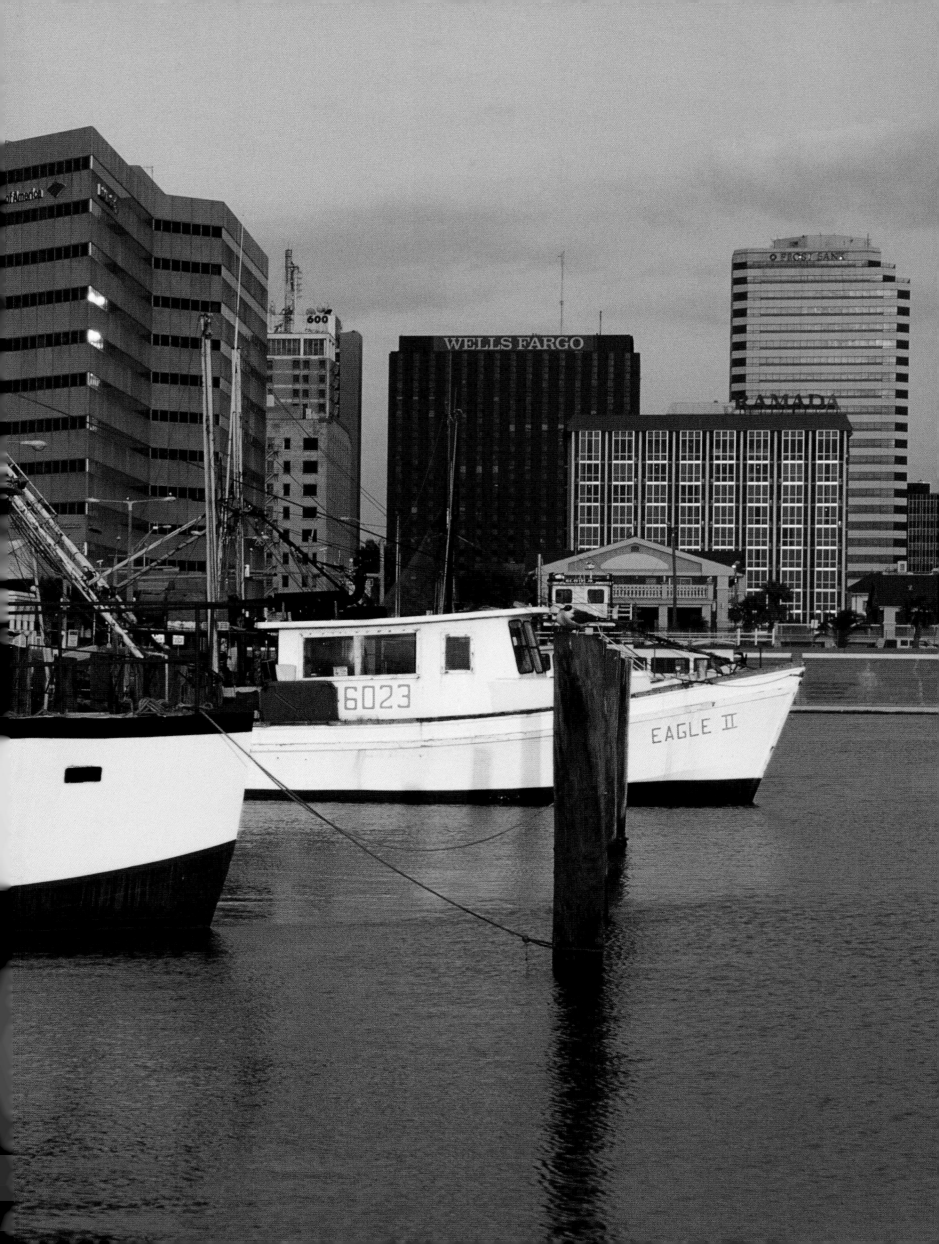

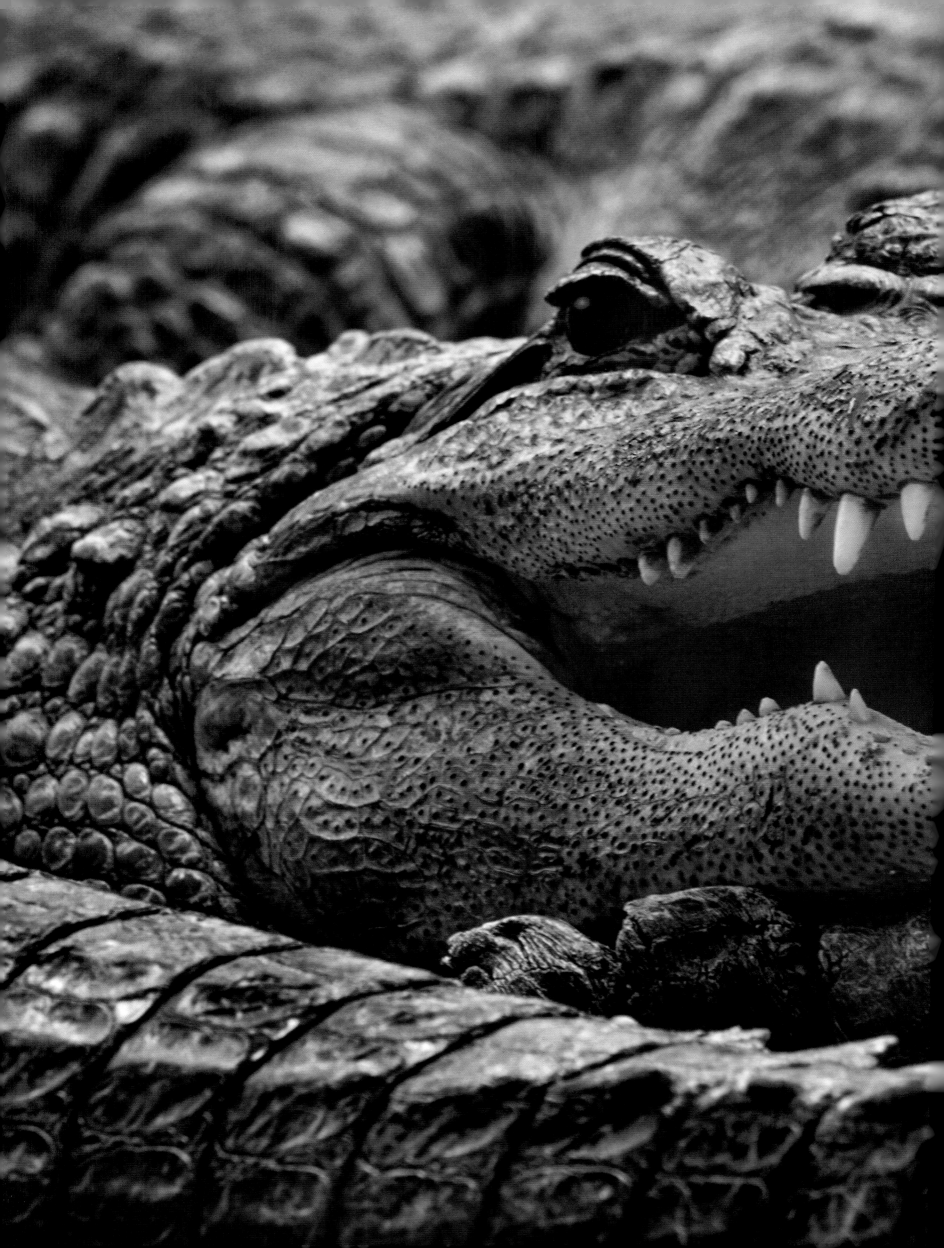

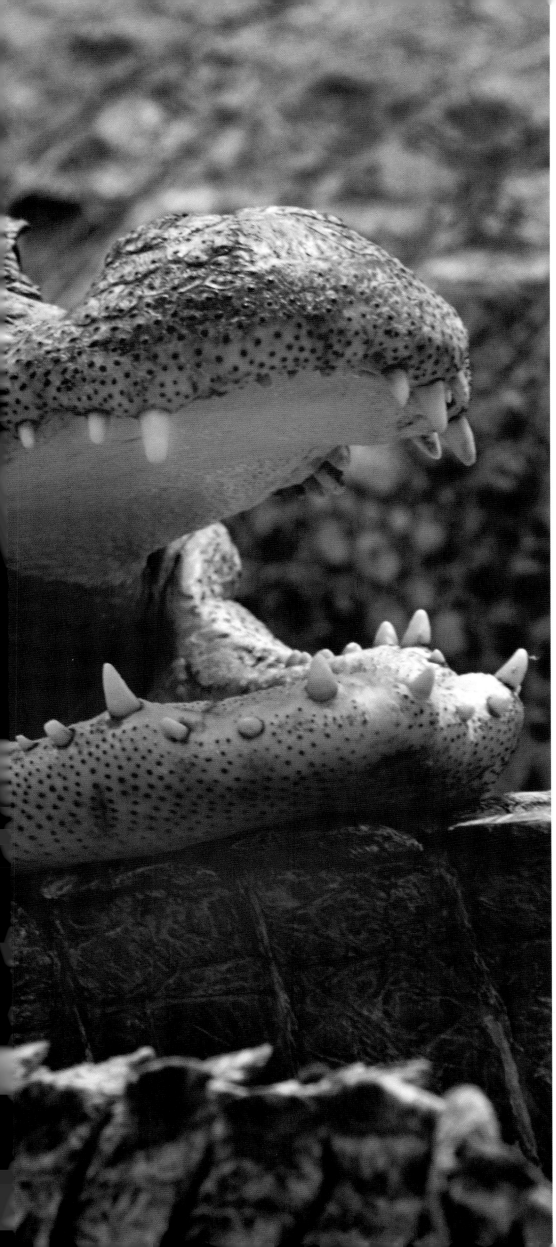

The American alligator is North America's largest flesh-eating reptile. Once considered to be on the verge of extinction, it now flourishes as a protected game animal in Texas.

One of the American alligator's most important homes is here at the Brazos Bend State Park. Spanning about 5,000 acres, its lush landscape provides sanctuary for over 270 species of birds, 23 species of mammals — including the bobcat, white-tailed deer, and raccoon — and 21 species of reptiles and amphibians.

Bolivar Flats includes beaches, salt marshes, and tidal mud flats. Spanning 555 acres, this shorebird sanctuary provides a haven for hundreds of thousands of birds. Gulls and terns, herons and egrets, the American white pelican, the brown pelican, the peregrine falcon, clapper rails, and seaside and sharp-tailed sparrows all use Bolivar Flats as a roosting and feeding site. *(overleaf)*

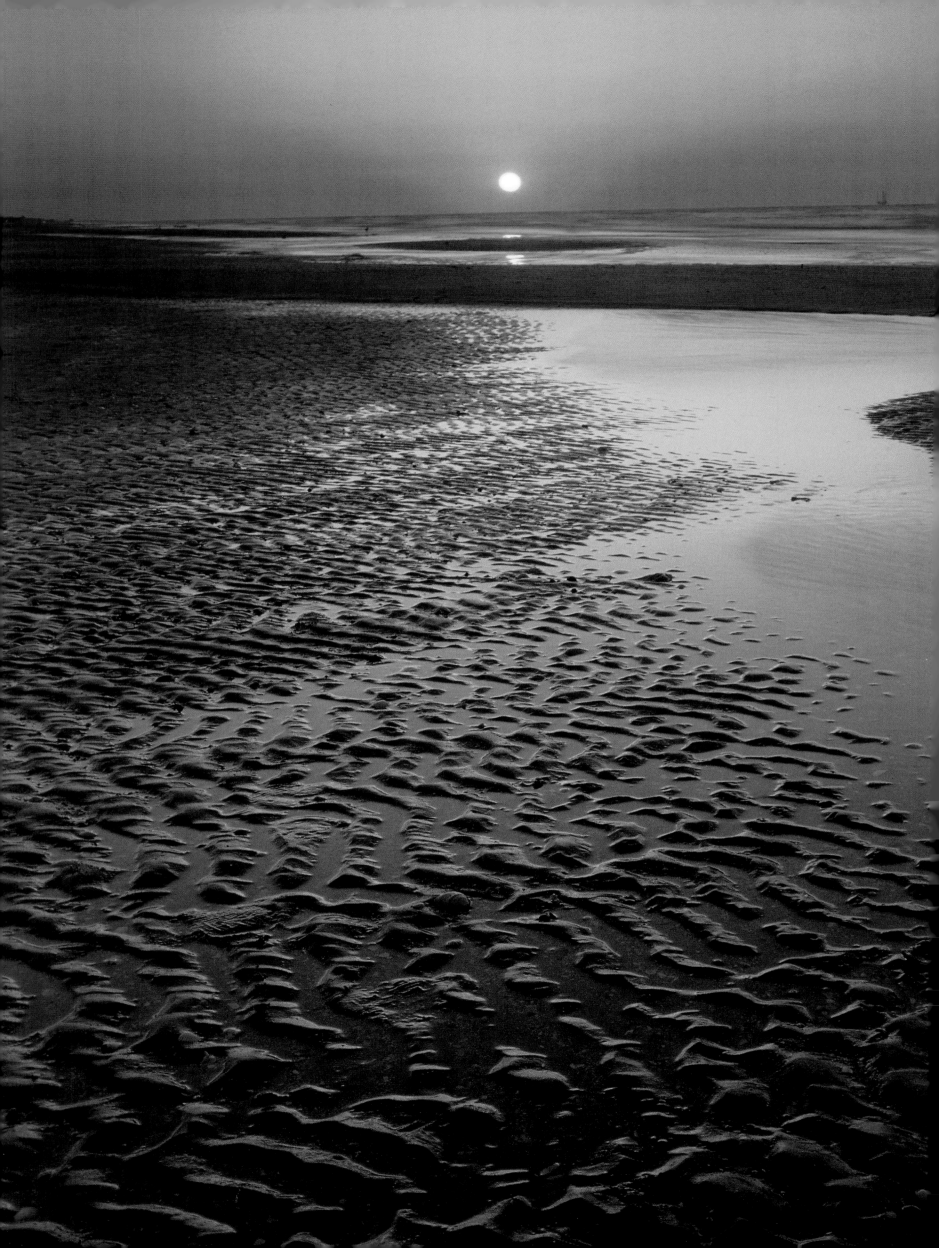

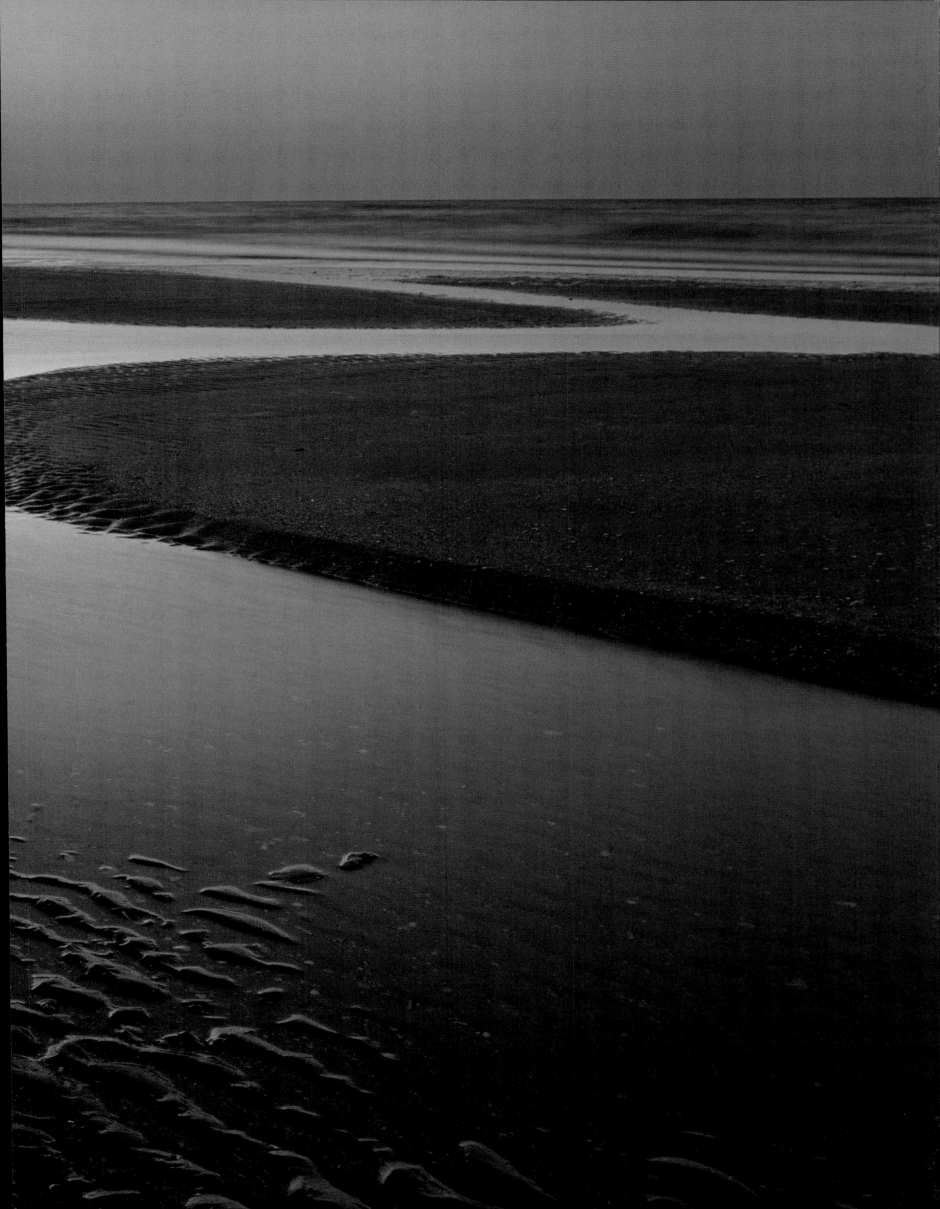

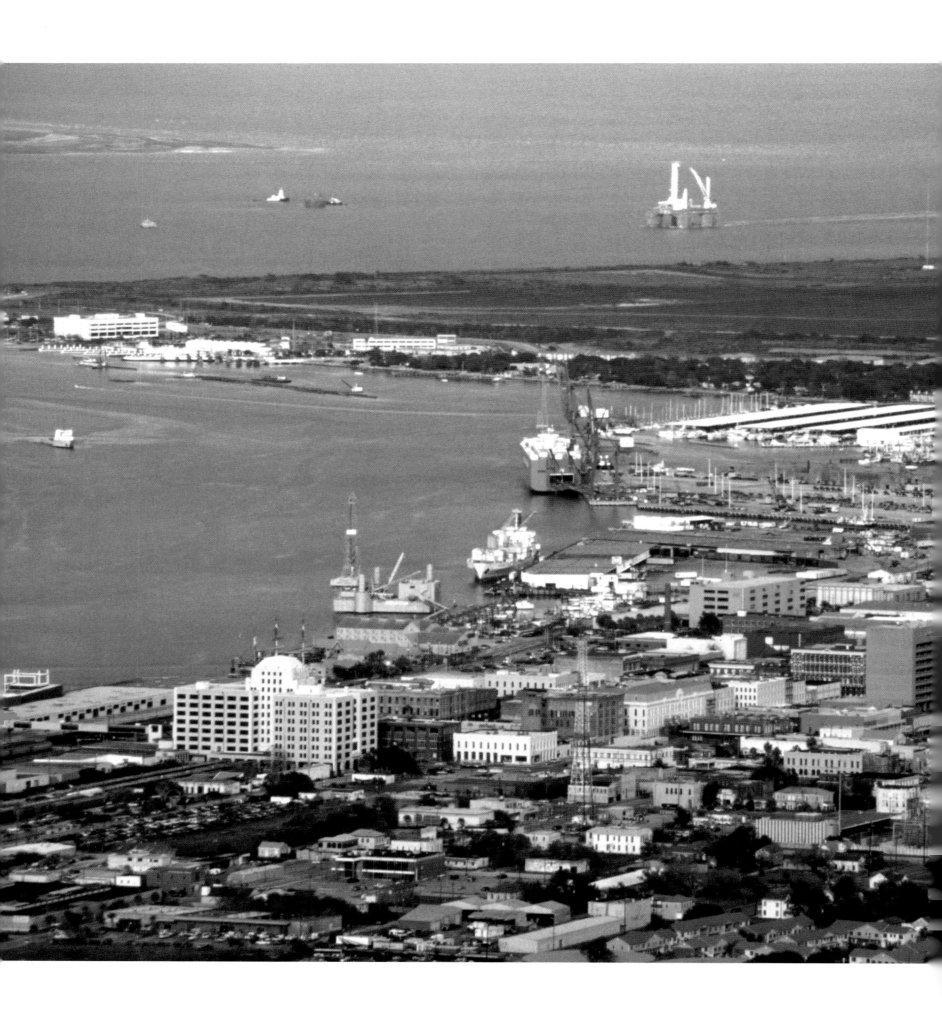

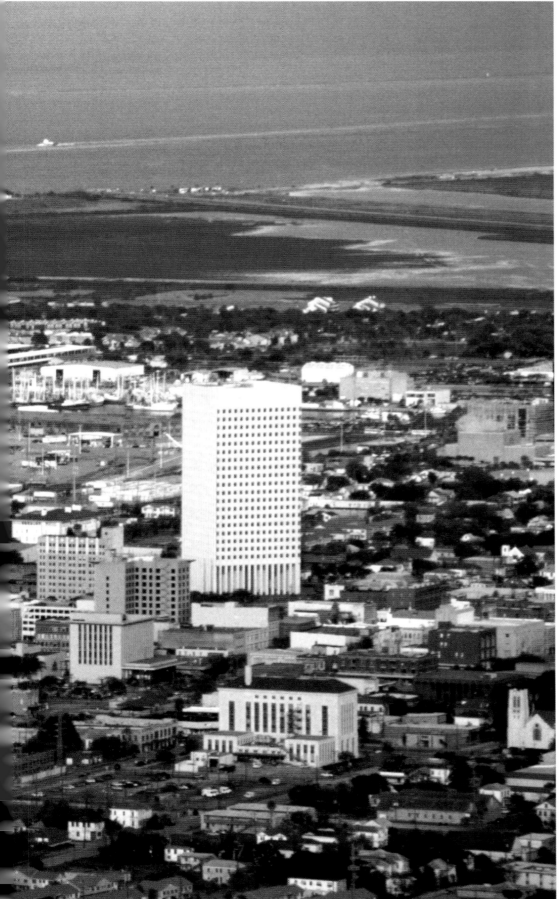

Scott Teven photo

Nestled on Galveston Island two miles offshore in the Gulf of Mexico, Galveston is an enchanting blend of nature and culture. Along with 32 miles of pristine beaches, the city boasts one of the largest, most impeccably preserved collections of Victorian architecture in America. Galveston's historic downtown core and refined mansions reflect this city's dignified history as the first capital of the Republic of Texas. Galveston was Texas' centre of trade and industry at the end of the 19th century.

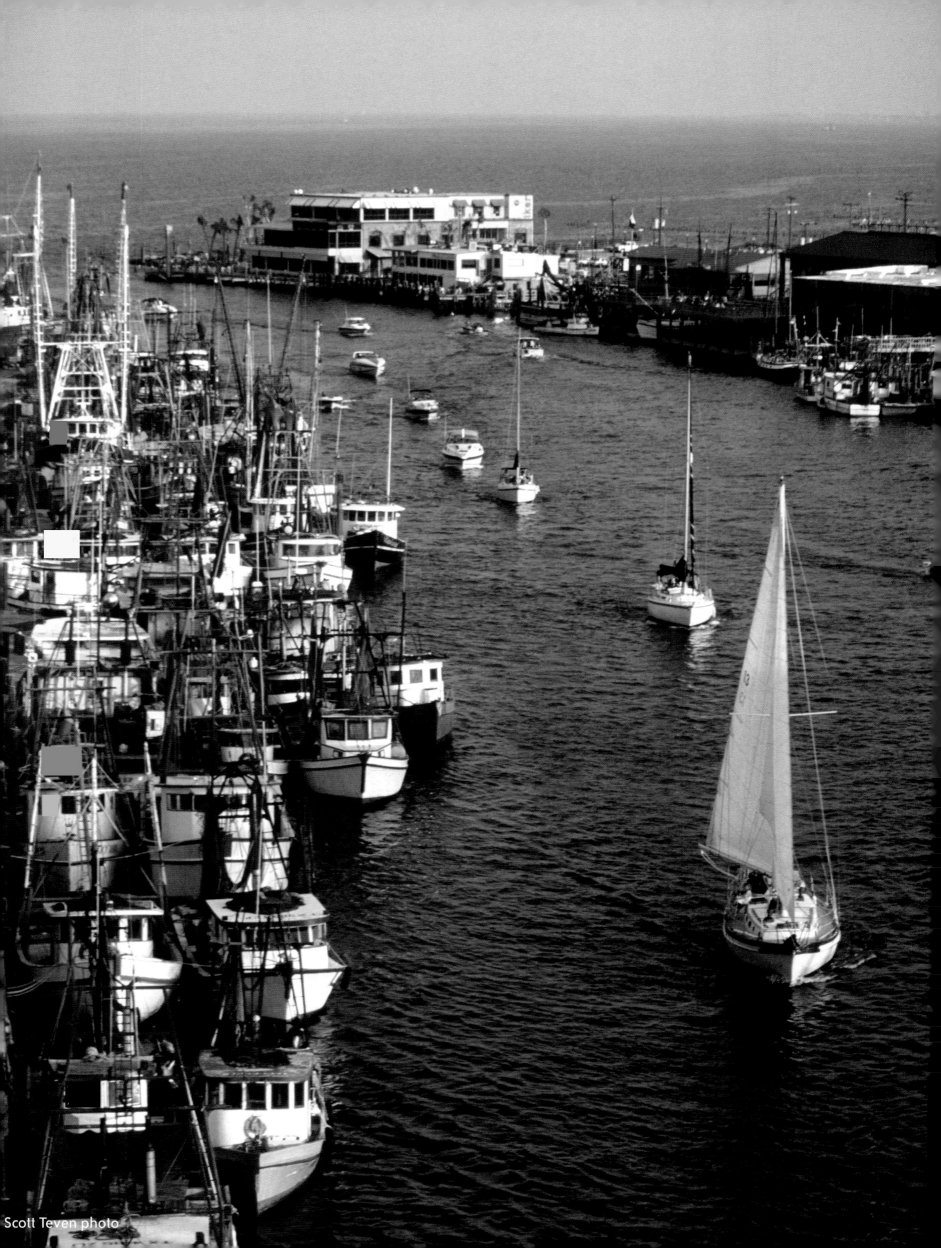

Scott Teven photo

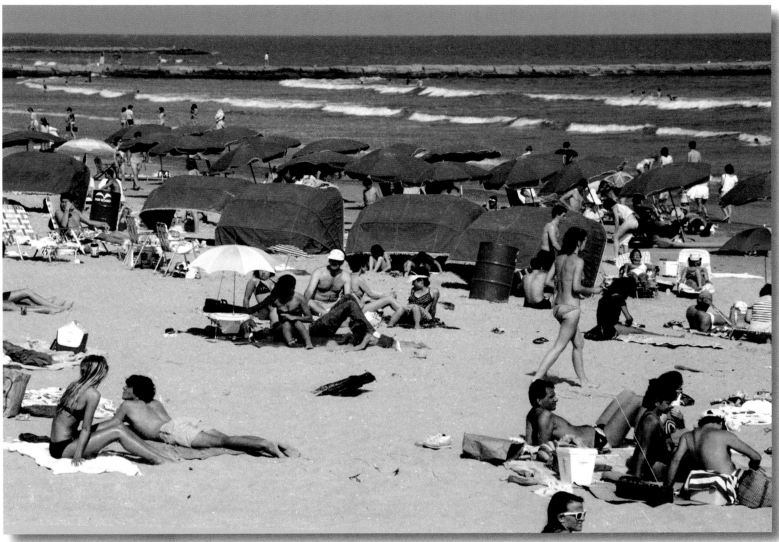

Sunbathers at Galveston Beach enjoy the sun and an ocean breeze off the Gulf of Mexico. No doubt thanks to its beauty Galveston Island is the oldest continuously settled area in Texas.

As another summer day draws to a close, sailboats pass through the Clear Lake Channel connecting Galveston Bay with Clear Lake, Texas. Galveston's Port and Ship Channel hosts cruise ships, freighters, tankers, oilrigs, private pleasure boats, and shrimp boats.

Shrimping is Texas' most important commercial fishing industry, and Galveston Bay produces approximately one third of its catch. Galveston Bay, which produces millions of pounds of shrimp every year, has been exporting shrimp since the 1920s. *(left)*

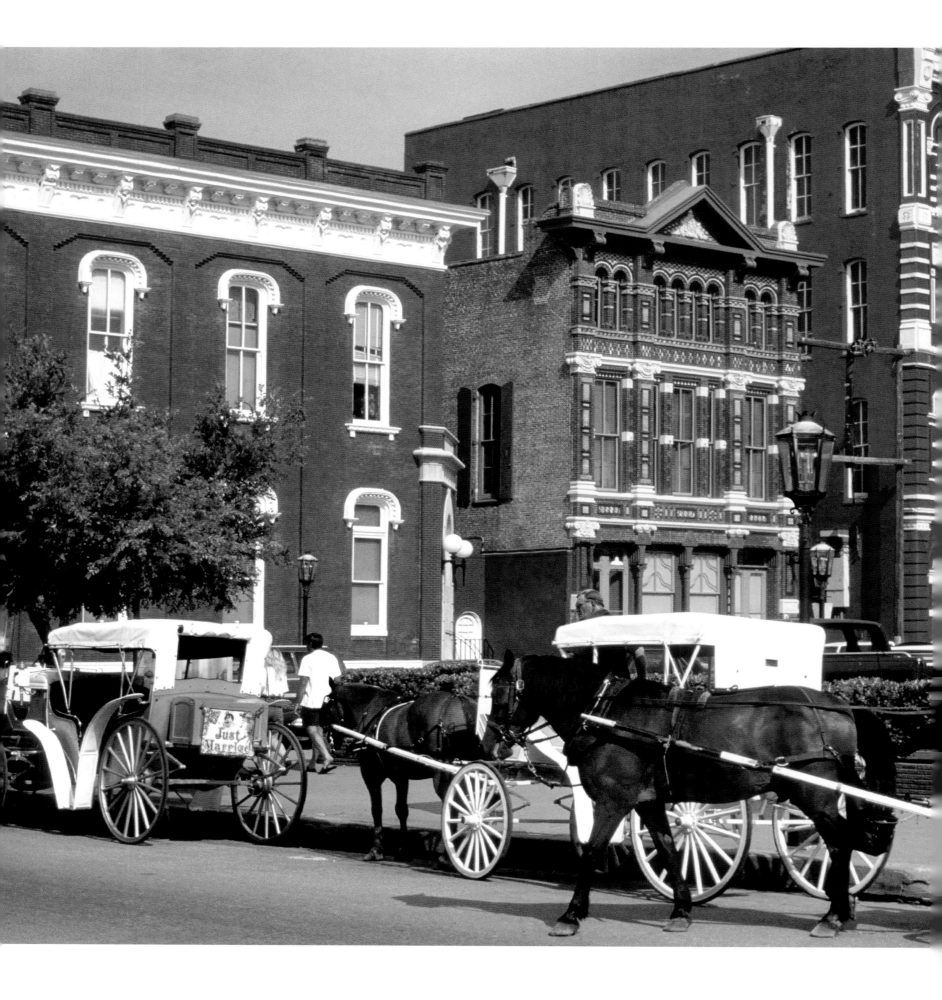

Located in the heart of historic Galveston, the Strand is a charming district that recalls a bygone era. Horse-drawn carriages meander through picturesque streets lined with many fine examples of 19th- and 20th-century Victorian architecture. When Galveston was an influential port city, this strip was known as the Wall Street of the South. After the Galveston Hurricane of 1900 leveled much of the city's infrastructure, however, Houston became Texas' major centre.

Scott Teven photo

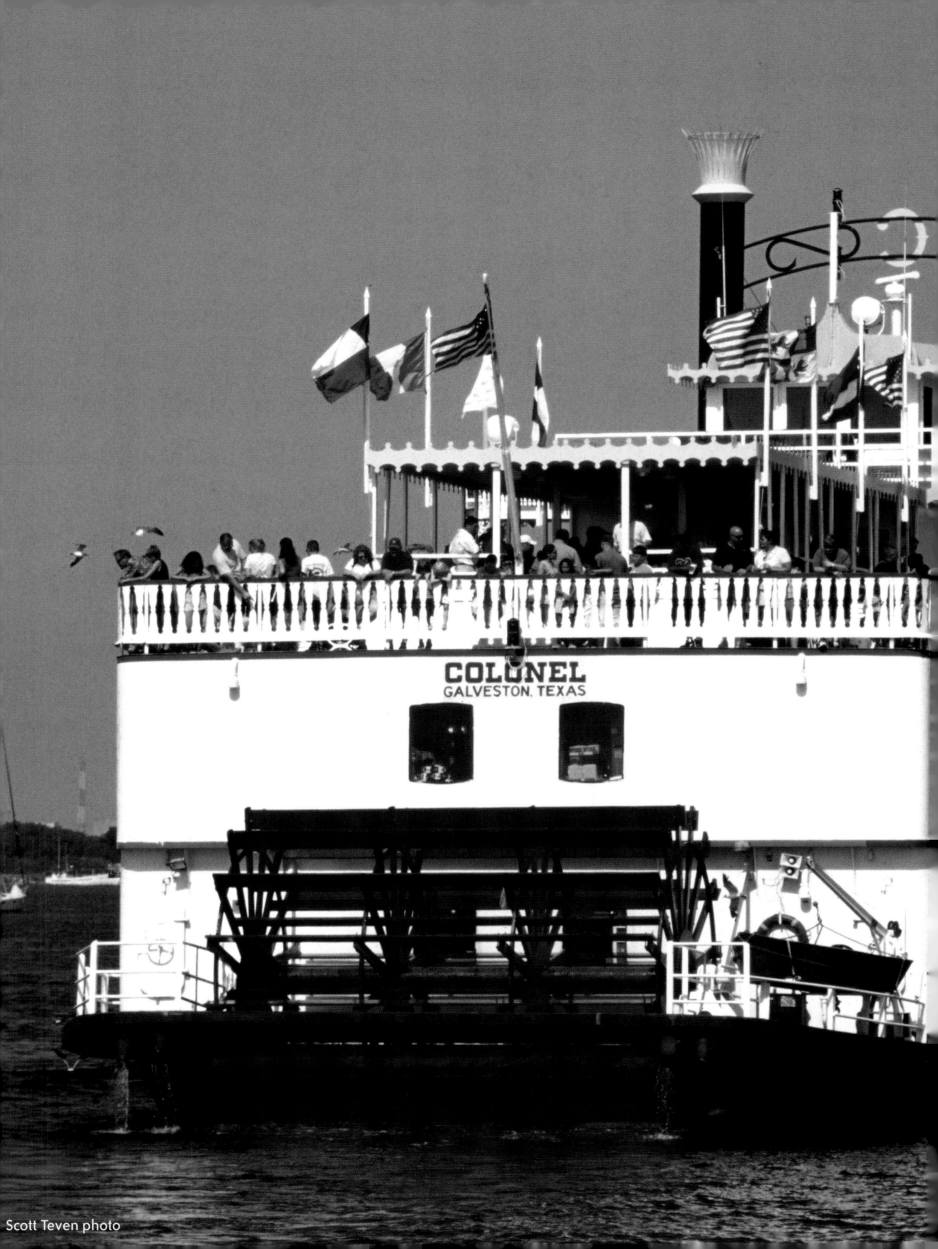

COLONEL
GALVESTON, TEXAS

Scott Teven photo

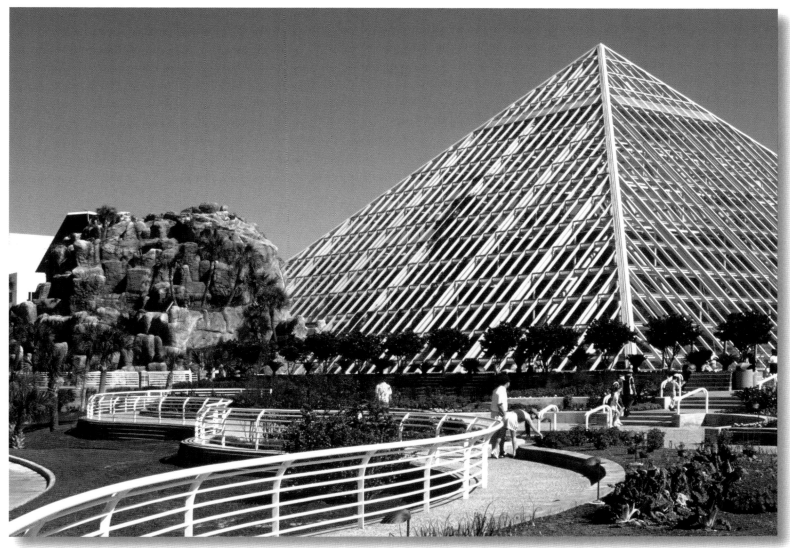

Inside the rainforest pyramid at Moody Gardens are crashing waterfalls, massive trees, and wild animals. This 10-storey greenhouse supports a tropical environment that is home to birds, tropical fish, and exotic mammals like ocelots and southern tamanduas. Free-roaming bats and butterflies also cavort under the glass canopy.

The Colonel Paddleboat epitomizes Victorian elegance. This triple-deck sternwheeler accommodates 750 people, making her one of the largest paddlewheelers to cruise the Houston/Galveston area. Graceful furnishings and a stately profile make this floating museum a perfect representation of old river steamboats. *(left)*

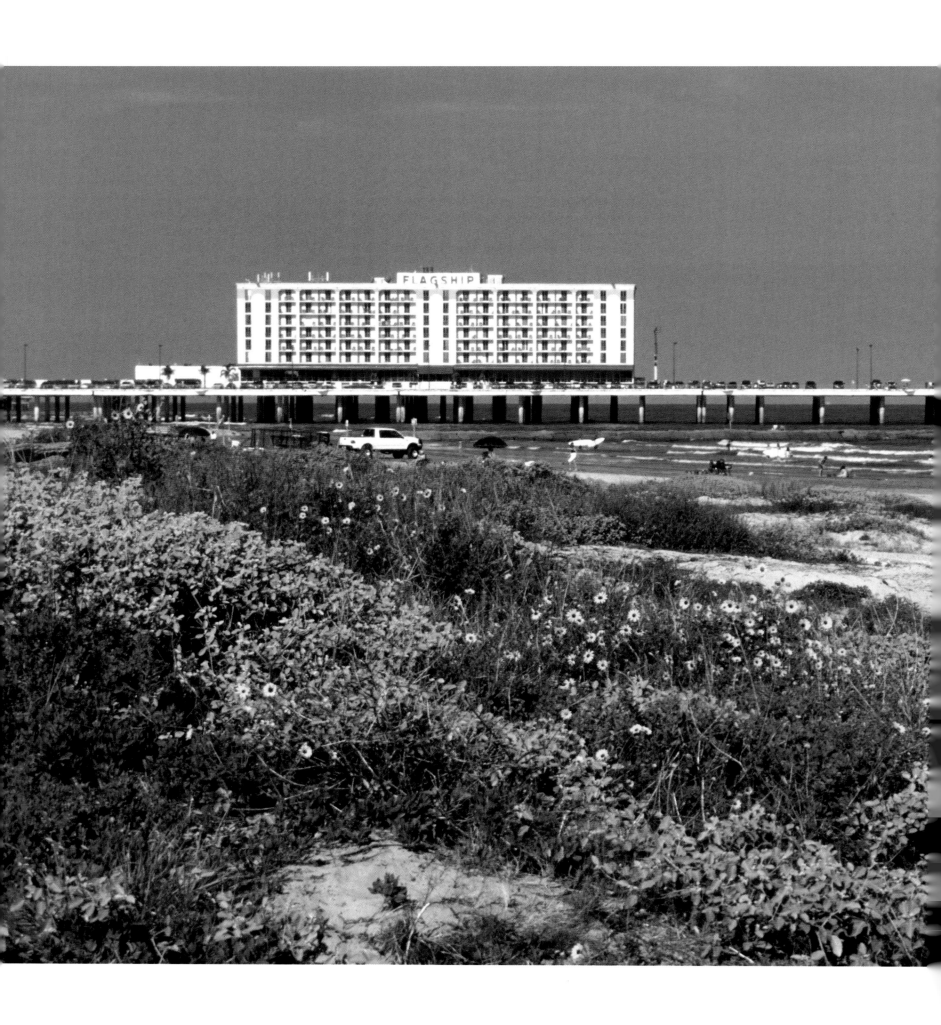

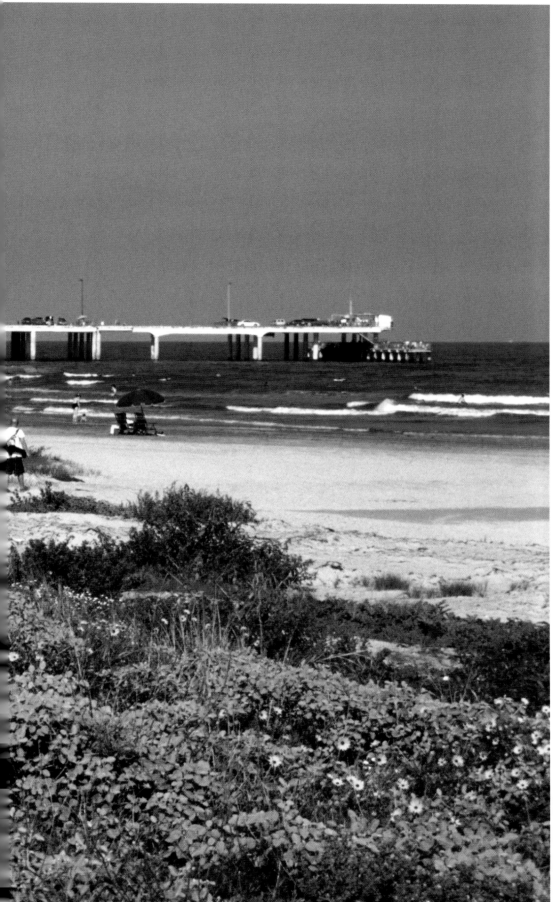

The Flagship Pier is one of Galveston's most famous landmarks. Stretching 1,000 feet out to sea it has earned itself the nickname Pleasure Pier for its panoramic views. Perched on the concrete pier, over the sparkling waters of the Gulf of Mexico, is the USS Flagship Hotel, the only hotel in North America built entirely over water.

Scott Teven photo

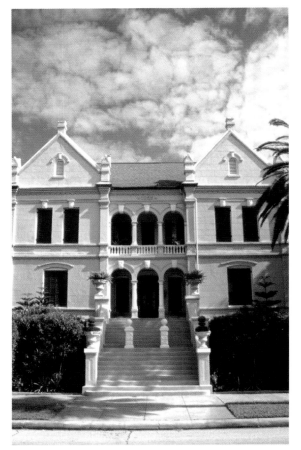

Many of Galveston's opulent historic homes, built by some of its founding citizens, have been lovingly restored to their 19th-century grandeur. These beautiful examples of Victorian architecture reflect the style of days gone by.

This old-fashioned streetcar complements the historic Galveston Strand's quintessentially unhurried atmosphere. Built in turn-of-the-century style, the trolleys careening around Galveston today are similar to the streetcars used in Galveston from the late 1800s to the mid-20th century. *(right)*

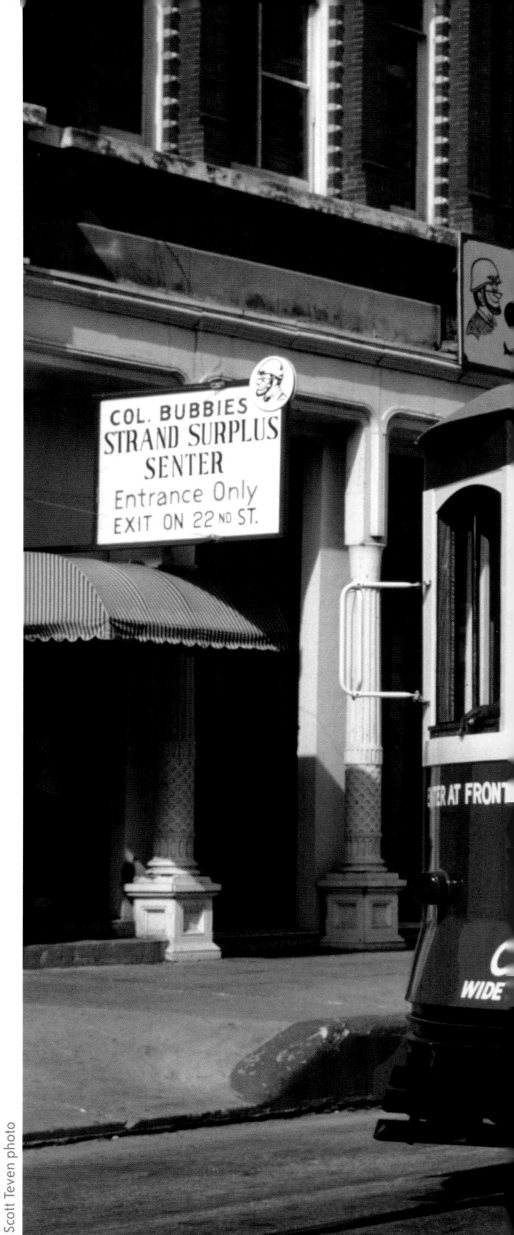

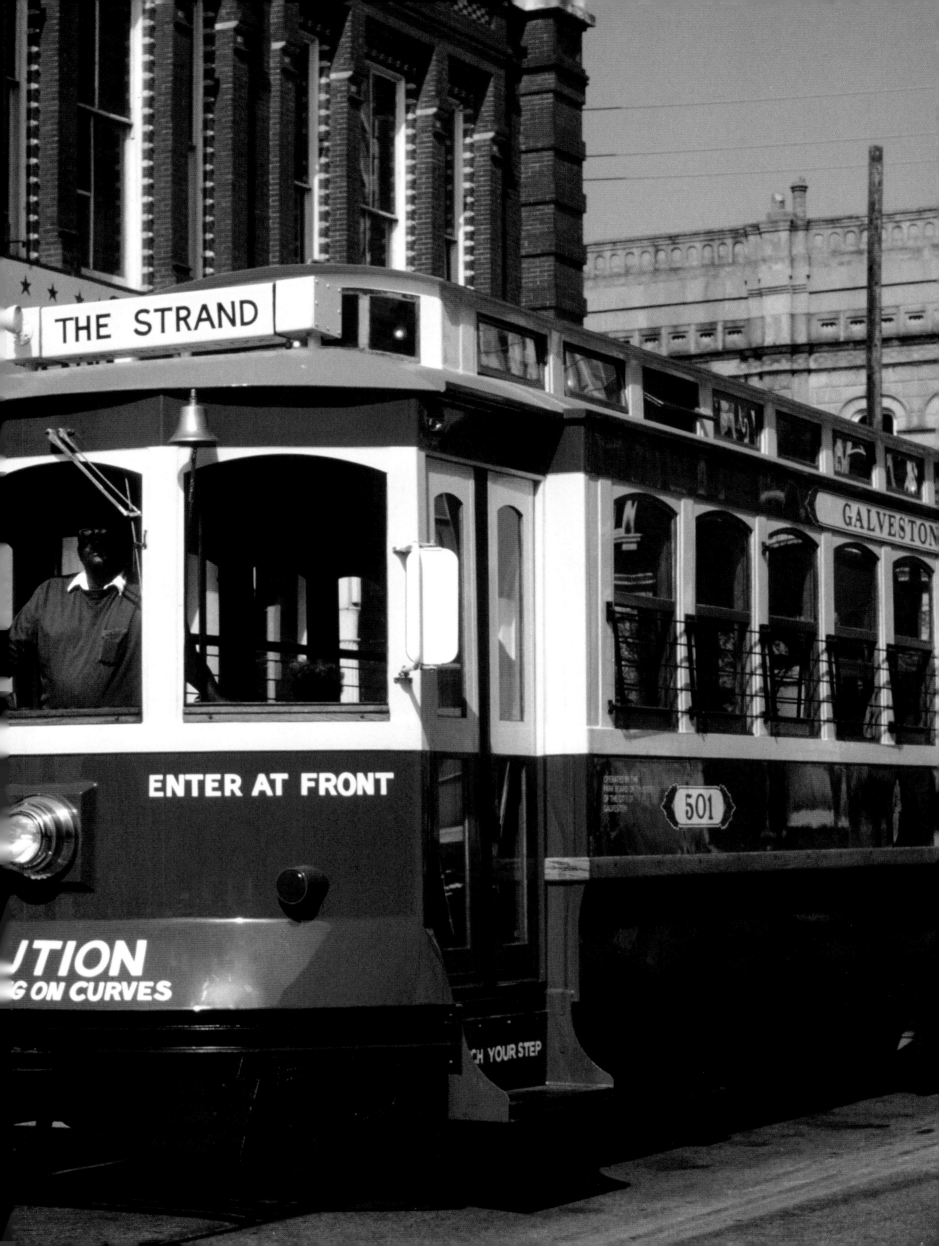

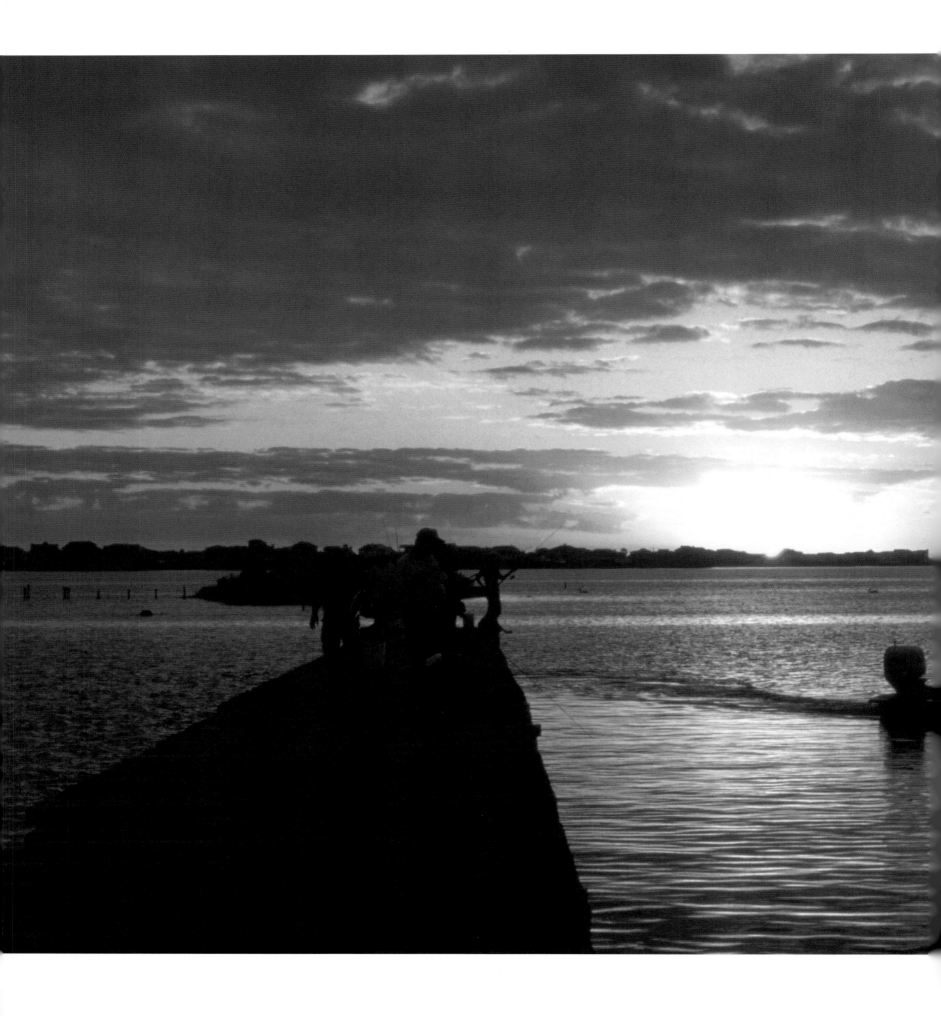

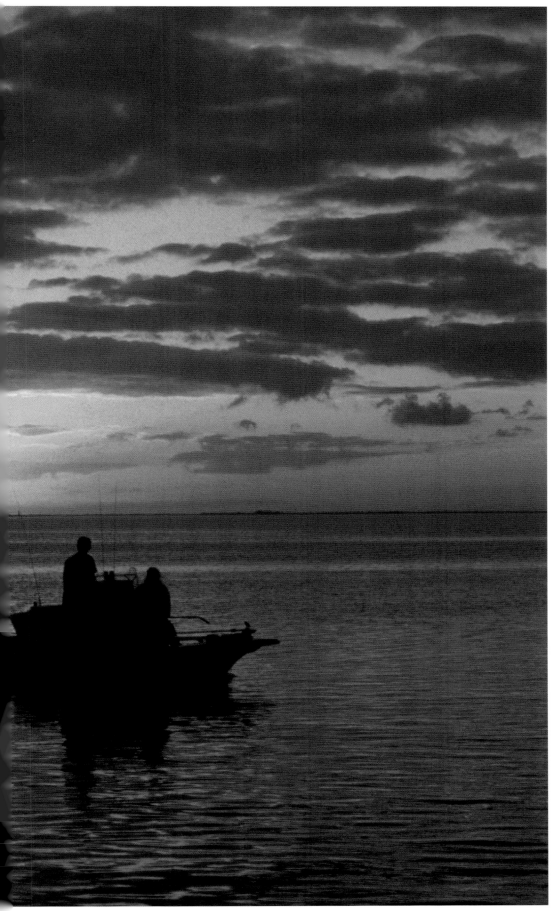

As another day of fishing draws to a close, the sun settles over Galveston Bay. Galveston is renowned for its beautiful sunrises and sunsets, and its inshore and bay fishing. Trout, flounder, and redfish are caught here all year round.

Scott Teven photo

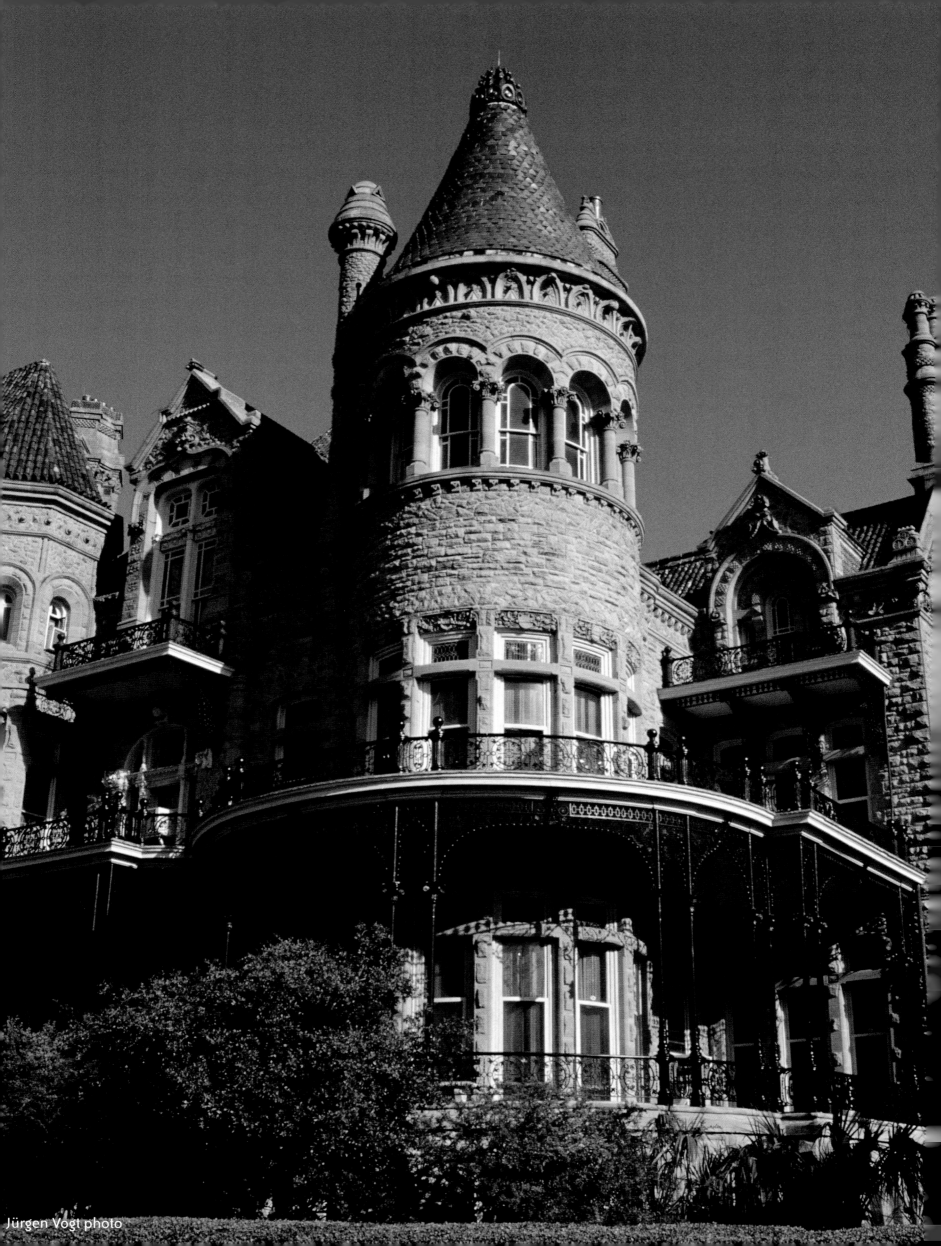

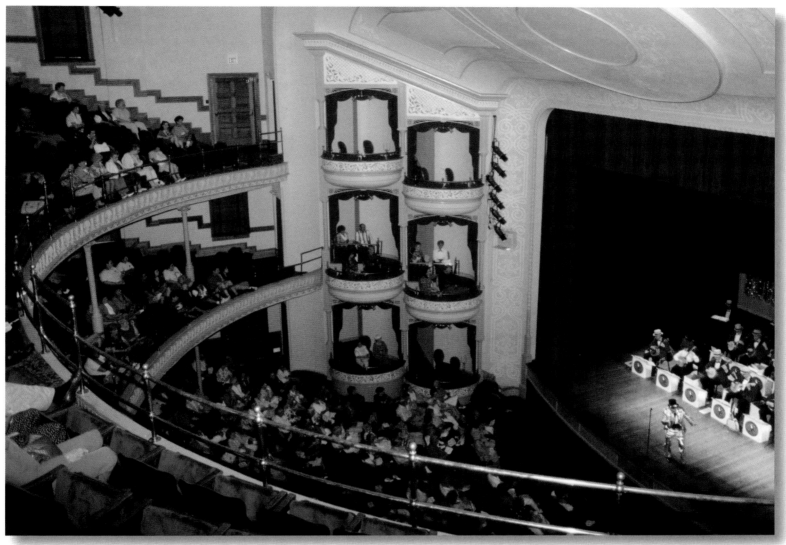

The 1894 Grand Opera House is a magnificent performing arts venue that has been painstakingly restored to its original beauty. One of the oldest opera houses in Texas, the Grand has survived several major hurricanes, including the Galveston Hurricane of 1900 during which it withstood winds of 135 miles per hour. The Texas Legislature recognizes the Grand as the Official Opera House of Texas.

The Bishop's Palace, one of the most opulent of Galveston's historic homes, features intricately carved ornaments, stained-glass windows, and rare woods.

Built as a home for lawyer and politician Walter Gresham during the mansion building boom of the late 19th century, the Bishop's Palace was purchased by the Catholic Diocese of Galveston in 1923 and used as the bishop's official residence. Only one bishop ever lived here, however, before the Catholic Church opened it to the public. *(left)*

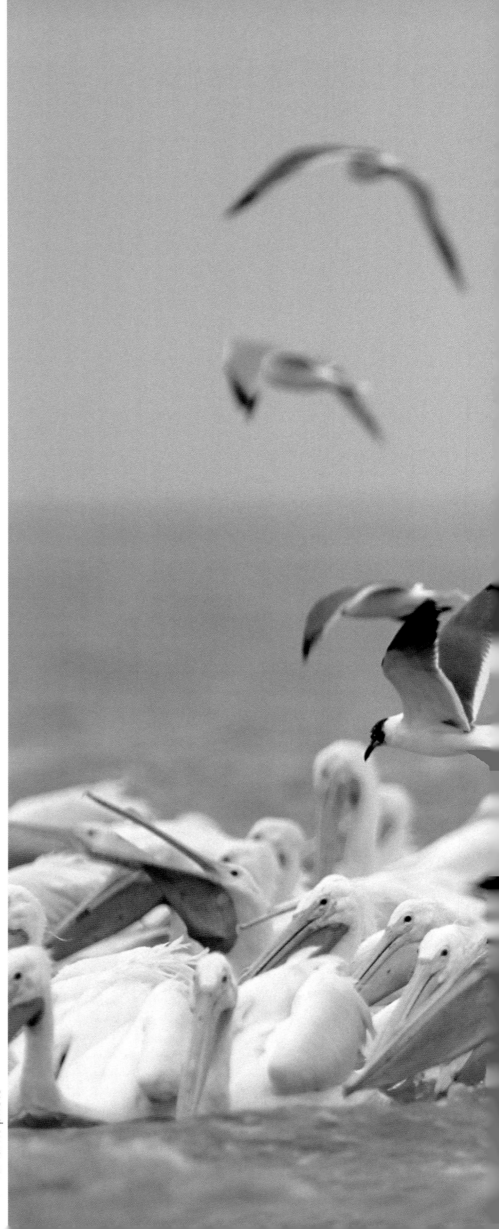

Tim Fitzharris photo

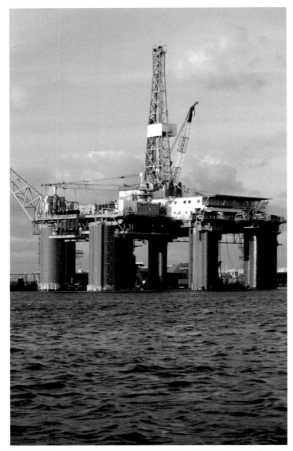

Scott Teven photo

An offshore oil rig sits in the water off the coast of Texas. The oil boom forever changed the economy of Texas. During its peak in 1972, Texas was producing three million barrels of oil per day. Today, Texas produces over 20 percent of the crude oil in America, more than any other state.

Pelicans and laughing gulls swoop through Galveston Bay. There are over 500 species of birds living in or migrating through Galveston Bay, the largest estuary on the Texan coast. *(right)*

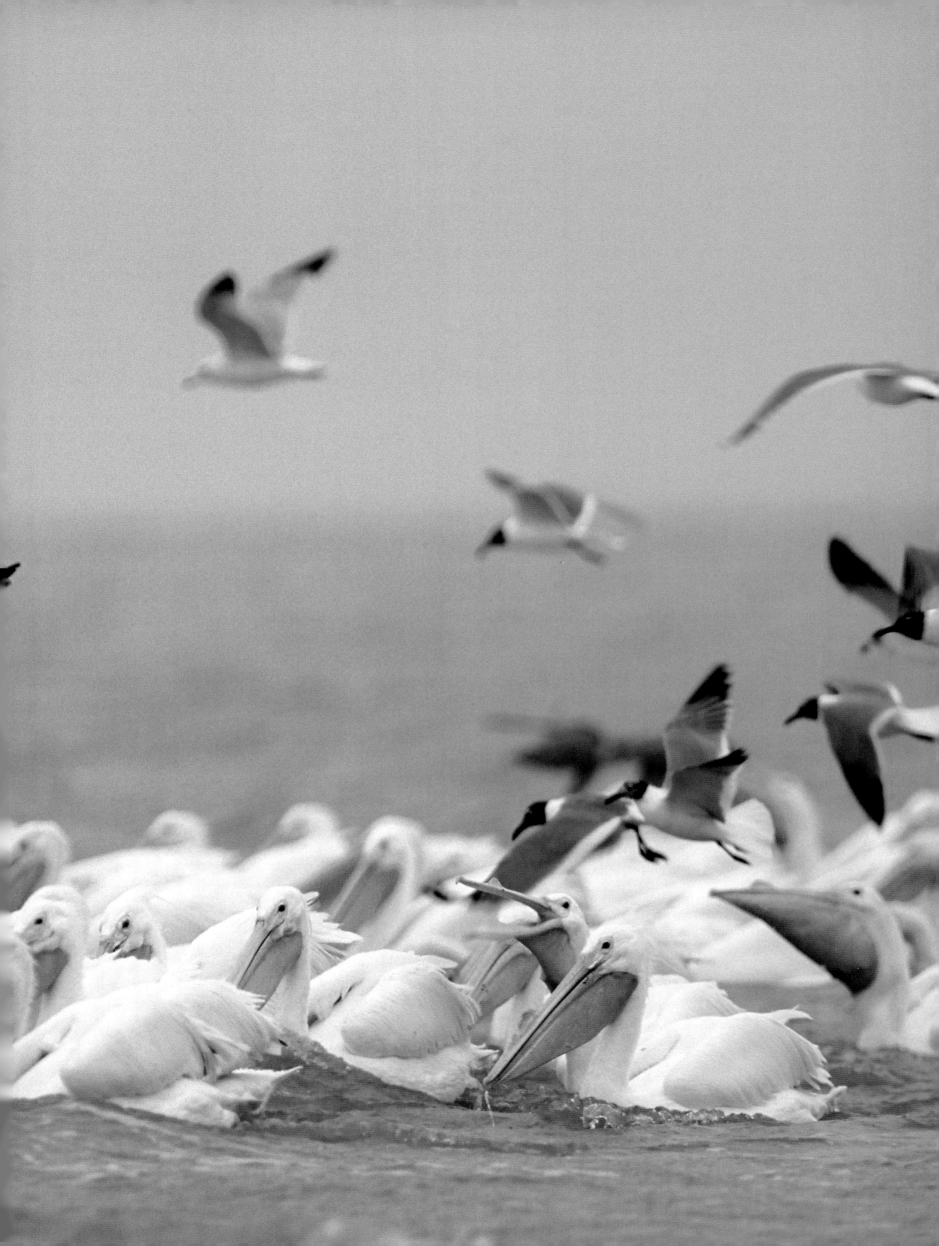

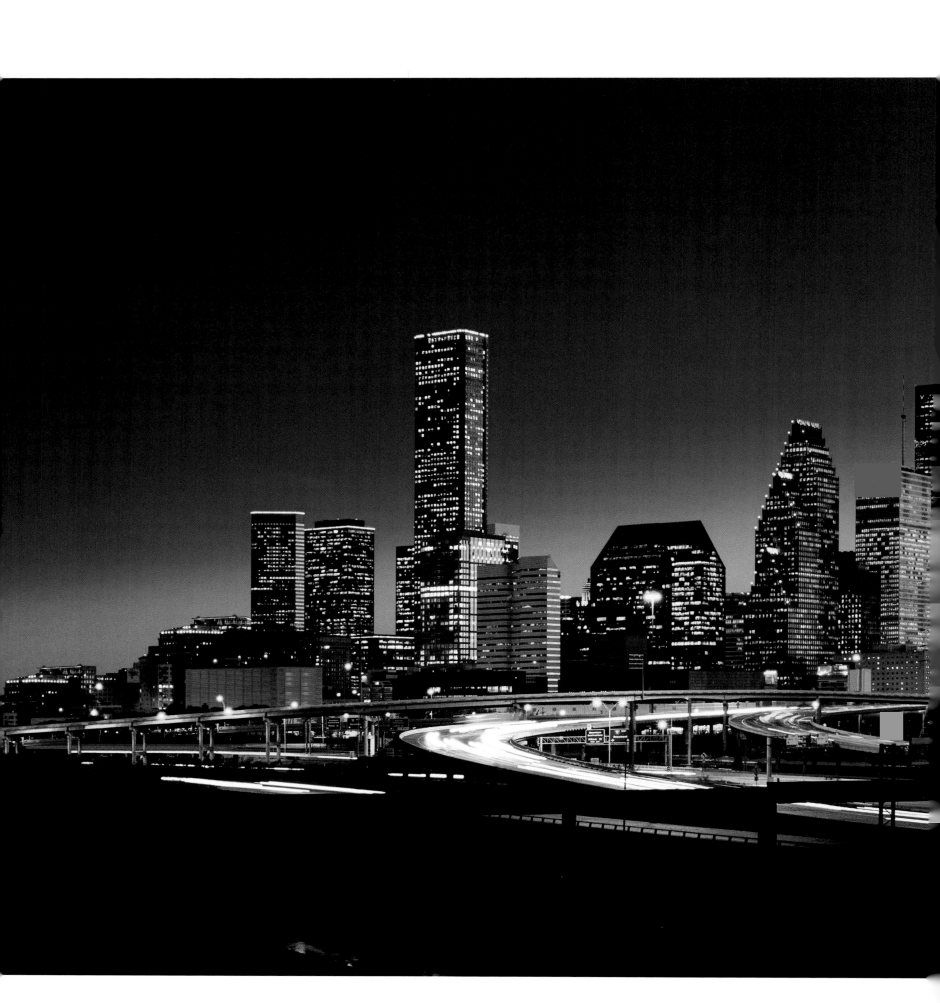

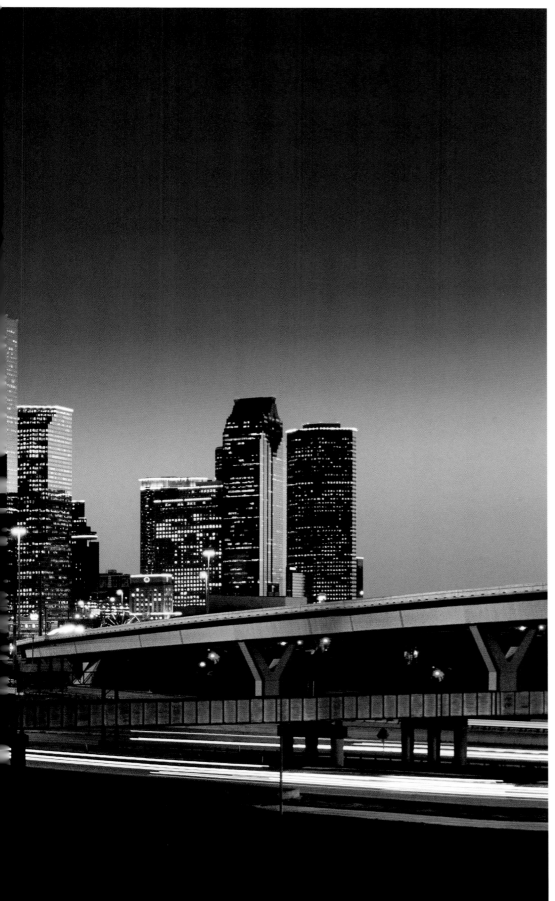

Houston is a dynamic, international city with a reputation for being ahead of its time. The city's namesake, General Sam Houston, was the first president of the Republic of Texas, and Houston was famously the first word uttered on the moon. The fourth largest city in America, Houston is also home to NASA's Mission Control Center, earning it the nickname Space City. Along with its scientific prowess, Houston also boasts a thriving world-class arts scene and a reputation for nurturing emerging artists.

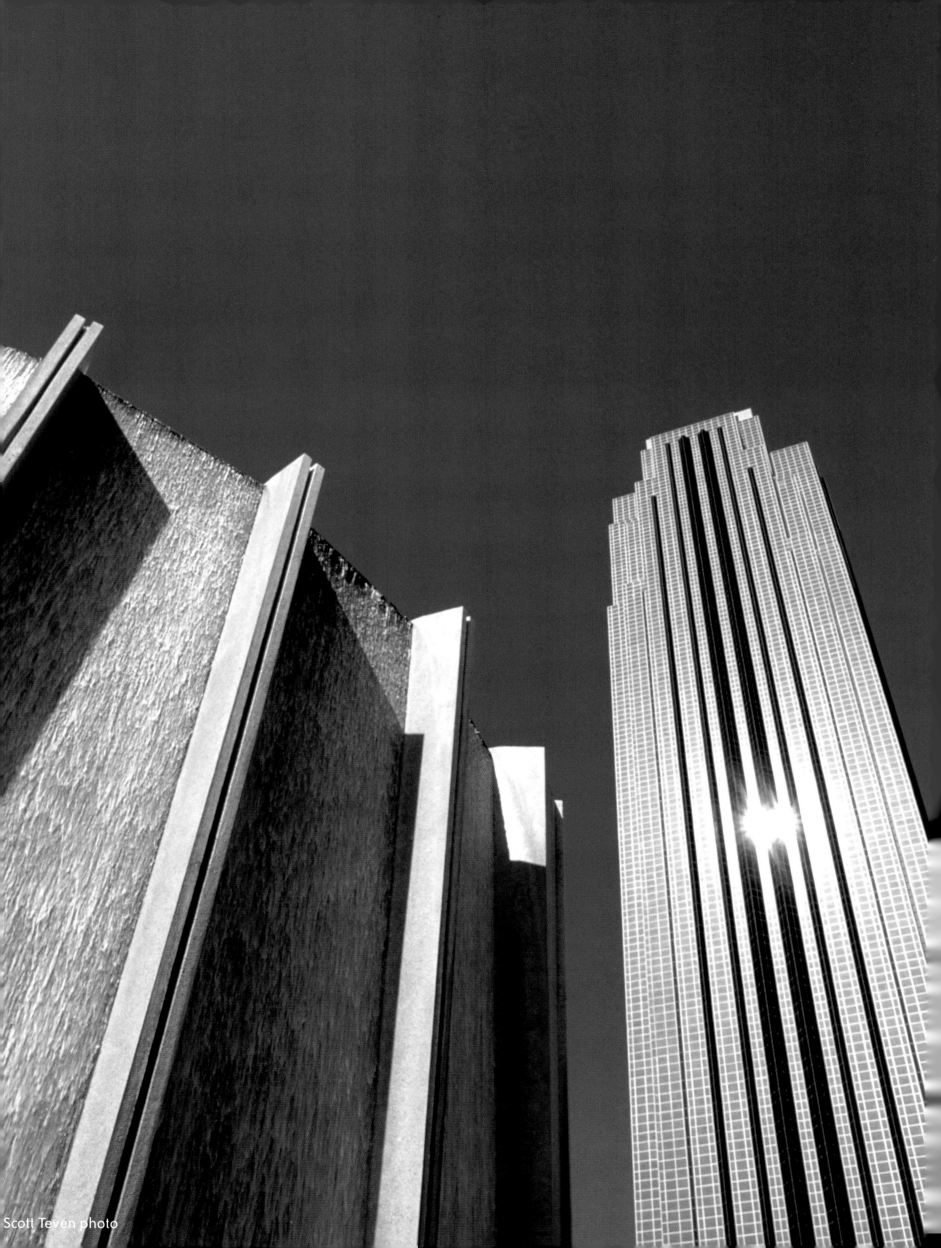

Scott Teven photo

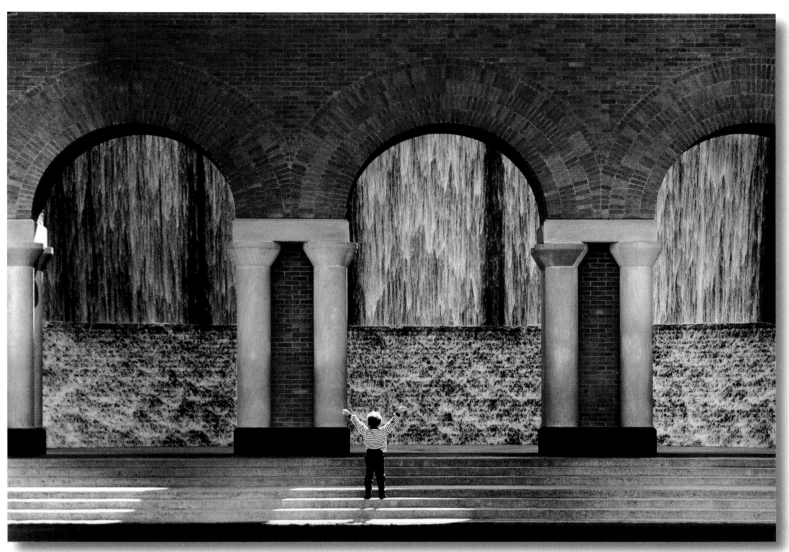

The spray from the monumental Water Wall fountain in Houston can be the perfect refresher on a hot Texan afternoon. About 11,000 gallons of water flow over both sides of this wall each minute. The surrounding park with its Texas live oak trees creates a little oasis within Houston's frenetic, urban space.

The massive Williams Tower and adjacent Water Wall in Houston make an imposing, futuristic duo. Built in 1983, the Williams Tower is the 4th tallest building in Texas and the 20th in the U.S. The Water Wall was built as a companion to the tower, bringing natural serenity to the tower's modern silhouette. *(left)*

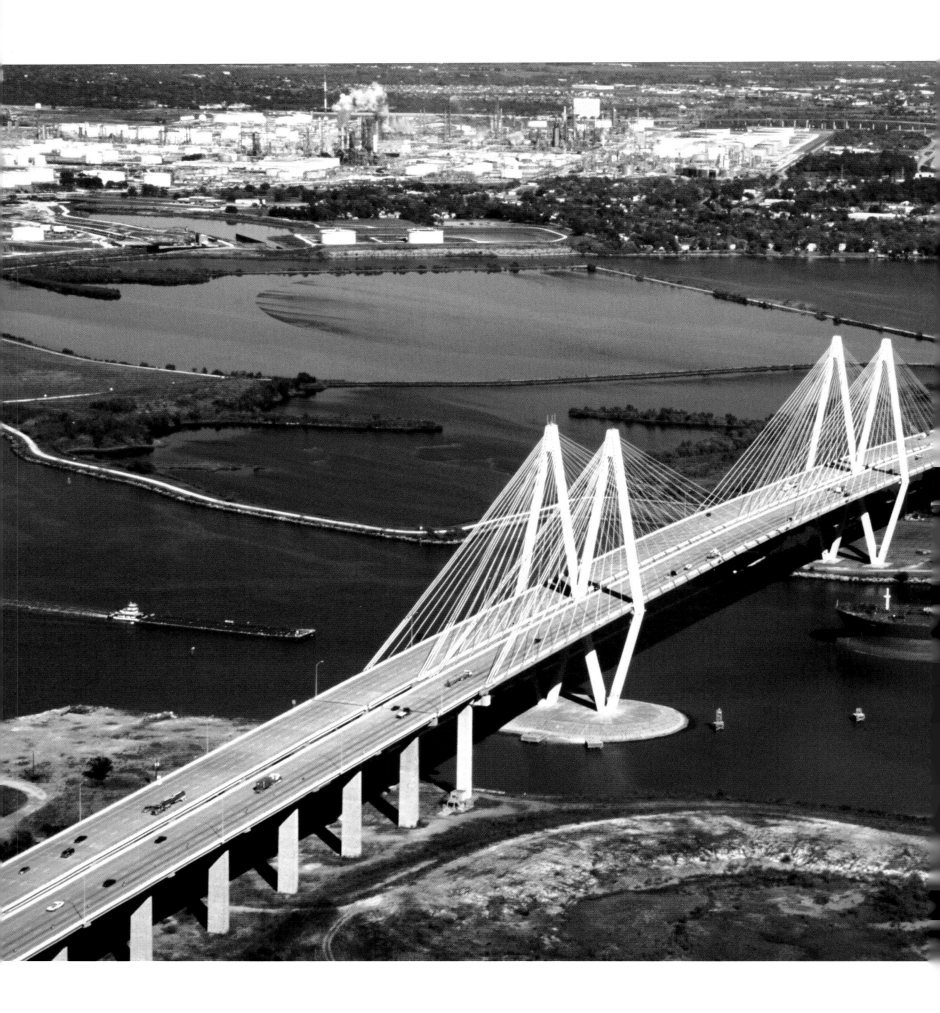

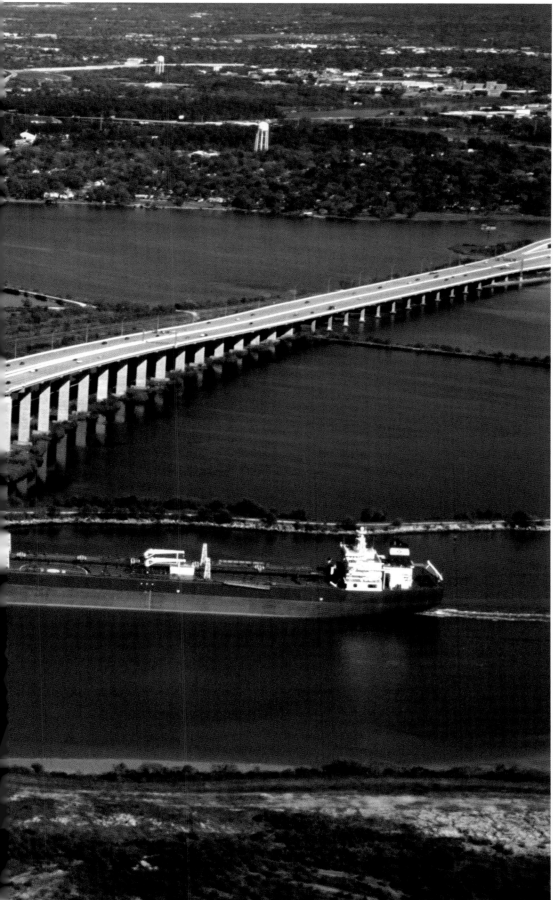

Stretching across the Houston Ship Channel, the Fred Hartman Bridge imposes technology on the landscape. A feat of engineering, this bridge is the longest cable-stayed bridge in Texas. Named for a former director of the Texas Department of Transportation, this 1,250-foot-long bridge was completed in 1992 for $117,500,000.

Scott Teven photo

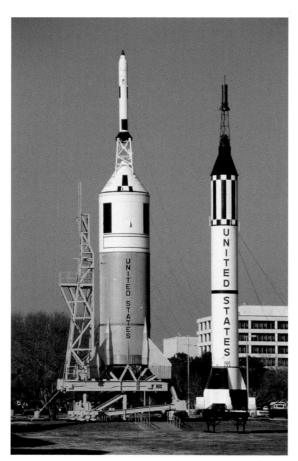

Scott Teven photo

The NASA rockets Little Joe 2 and Mercury Redstone are on display at the Johnson Space Center in Houston. The heart of the aerospace industry, the Center is also home to Mission Control, the NASA control center that coordinates and supervises all manned U.S. spaceflights.

Astronaut Charles Conrad wore this suit to the moon and back on the Apollo 12 mission. Undertaken in 1969, Apollo 12 was the second manned mission to the moon. The flags of 136 nations, the UN, and 50 American states took the trip with the three astronauts and tons of equipment. *(right)*

Jeff Greenberg / Folio photo

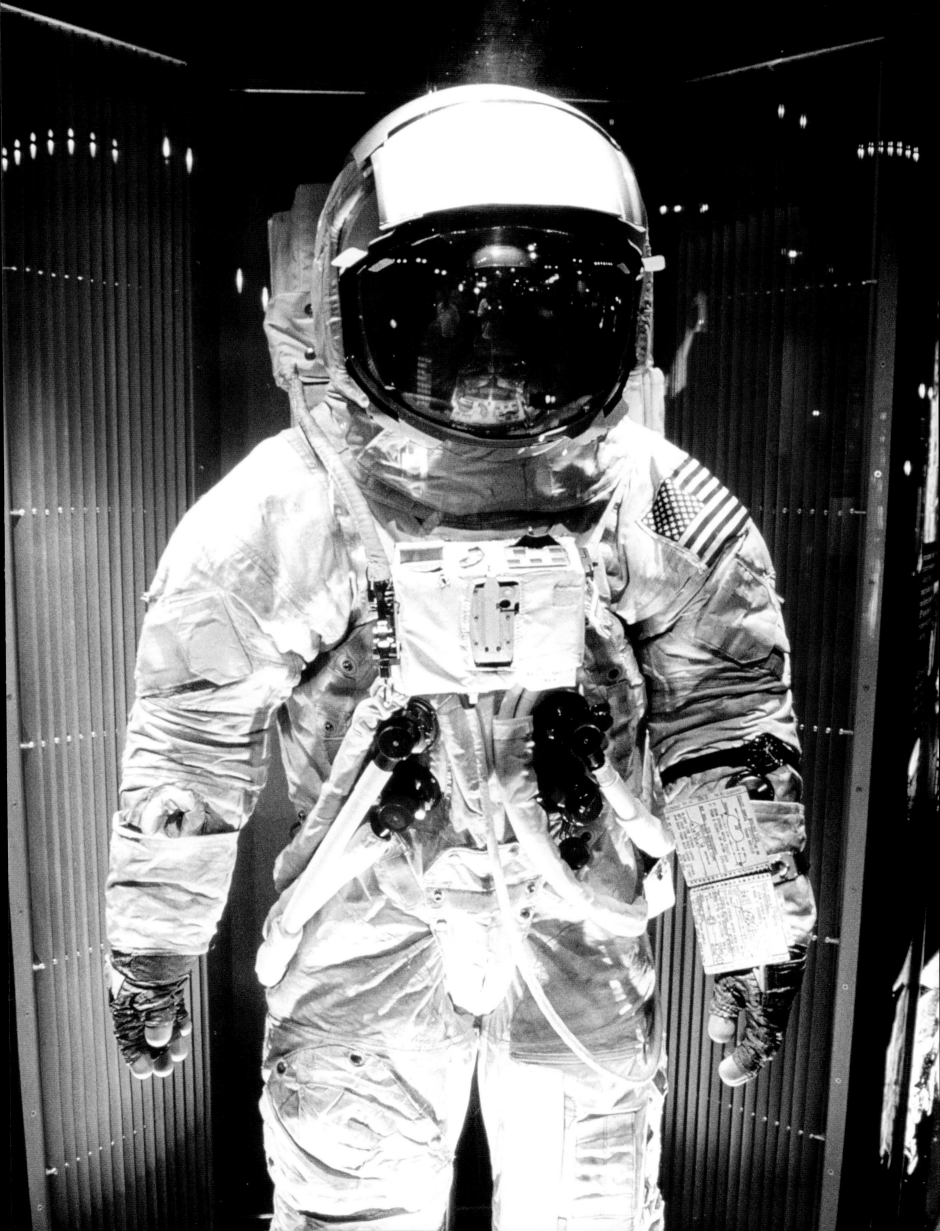

Christmas is a festive time at the Houston Galleria, one of the largest malls in the nation. Sitting in the middle of the mall's full-size rink, a Christmas tree reaching up to the glass atrium infuses the arena with holiday spirit. Housing three office towers, two hotels, and hundreds of stores and restaurants, the Galleria is an integral part of Houston's uptown district.

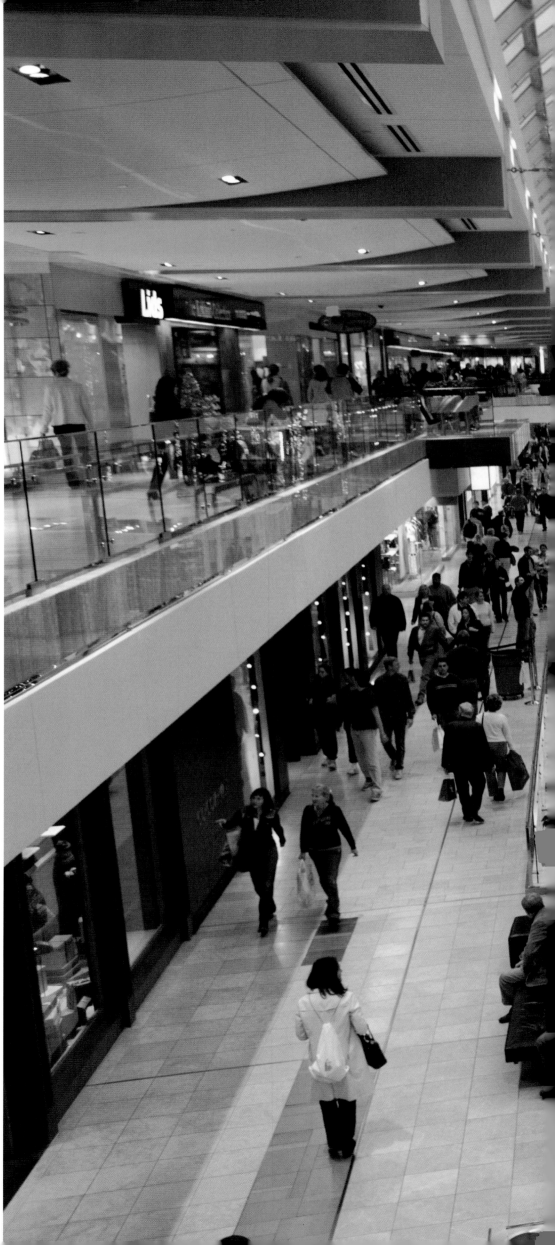

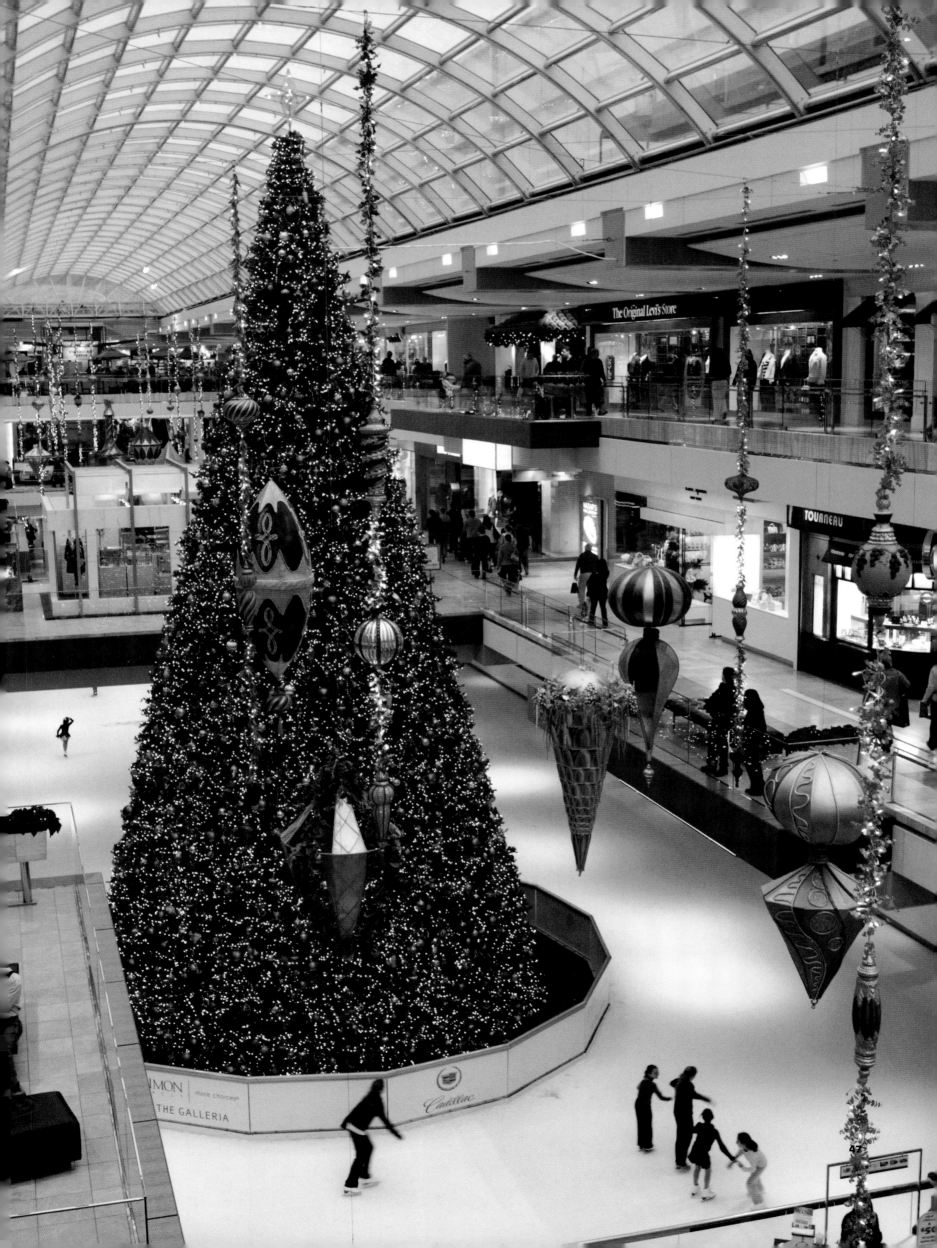

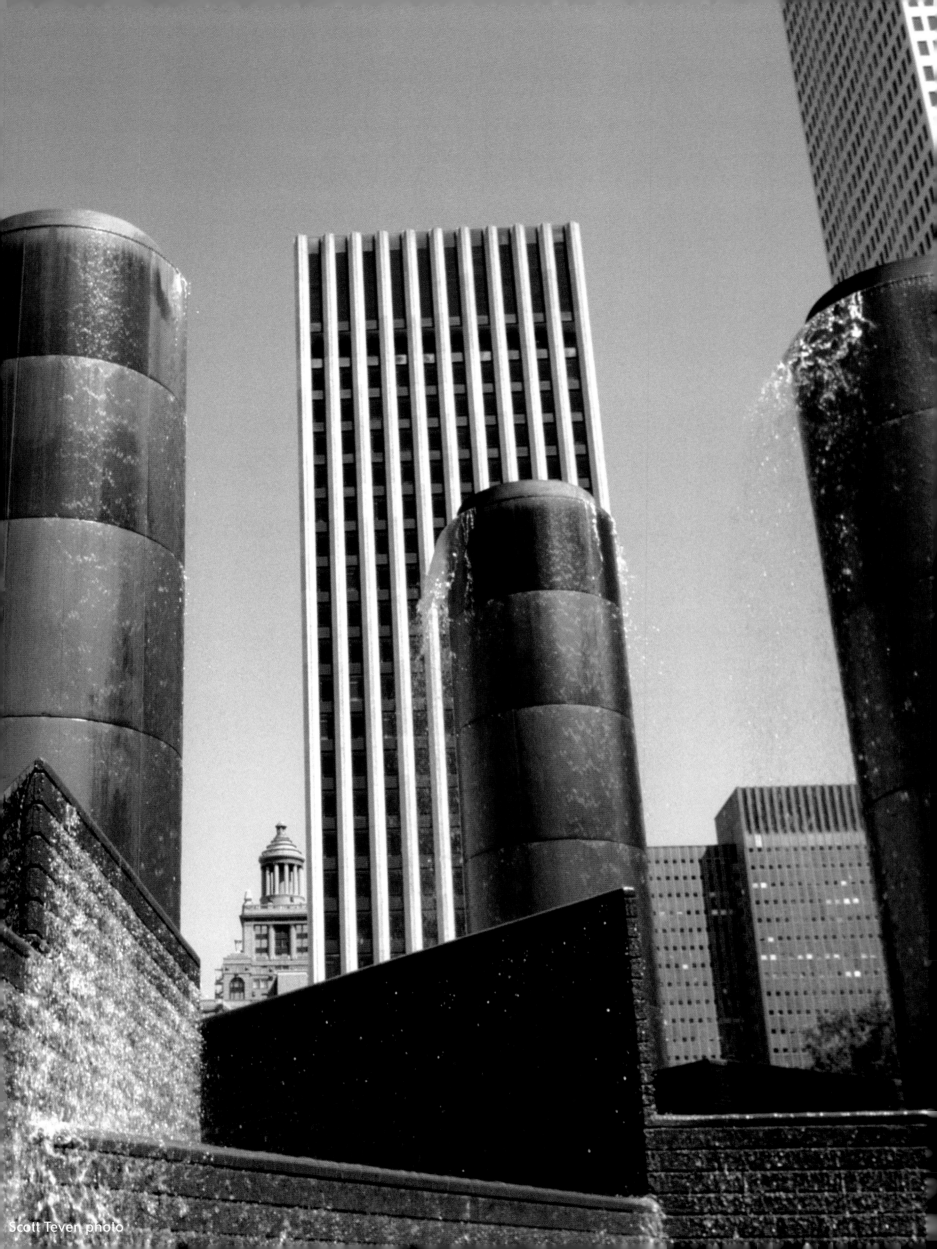

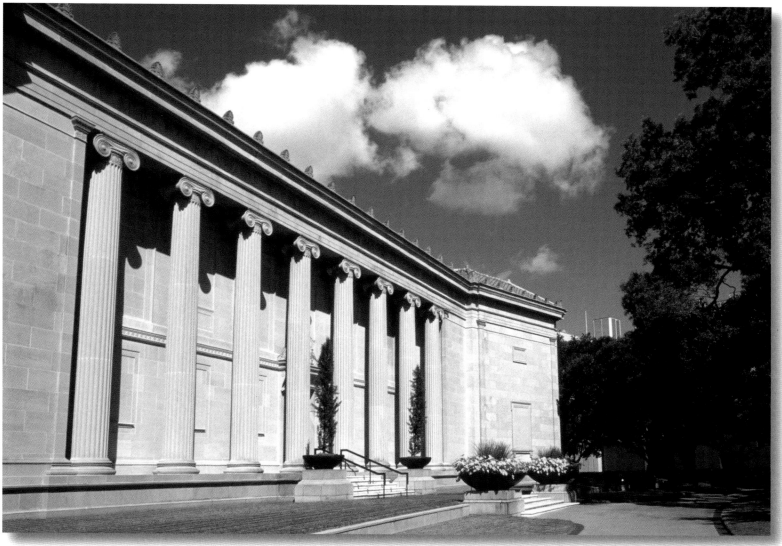

The Caroline Wiess Law Building is the beautiful neoclassical arm of the Houston Museum of Fine Arts. Its grand, open galleries display dazzling collections of Oceanic art, Asian art, Indonesian gold artifacts, and pre-Columbian and sub-Saharan African artwork.

Tranquility Park and Wortham Fountain are monuments to the Apollo Space program and the aerospace industry that is so vital to Texas. Spanning two blocks and evoking rockets, Wortham Fountain's stark, modern lines make an impressive impact on the Houston skyline. Named after the moon's Sea of Tranquility, Tranquility Park provides a natural haven in the middle of downtown.

Like a re-imagined Mount Rushmore, these busts of America's presidents cut a dignified image. Created by Houston sculptor David Adickes at about 12 times life size, these carvings are anything but little. This imposing dynasty includes over 40 presidents placed in chronological order. *(overleaf)*

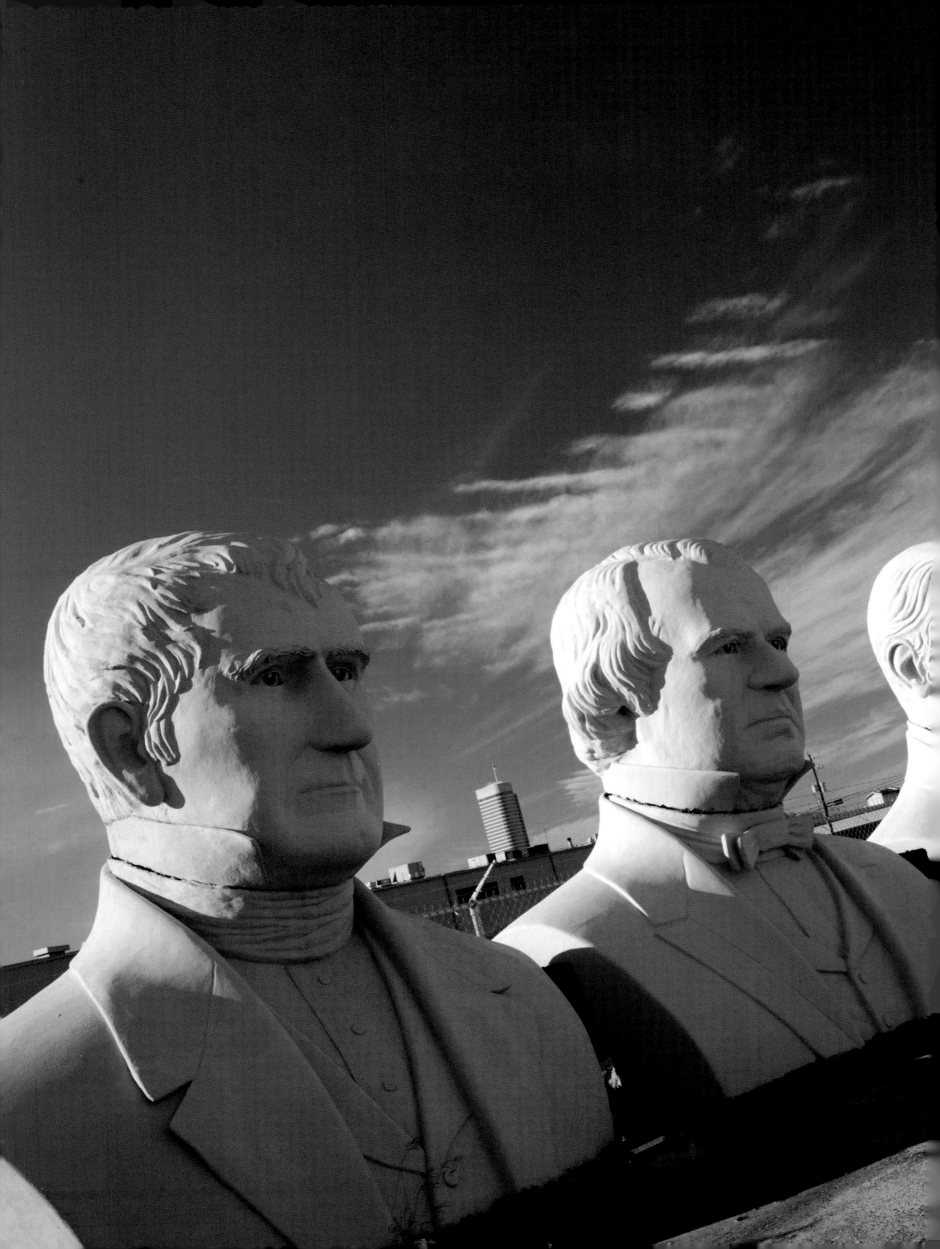

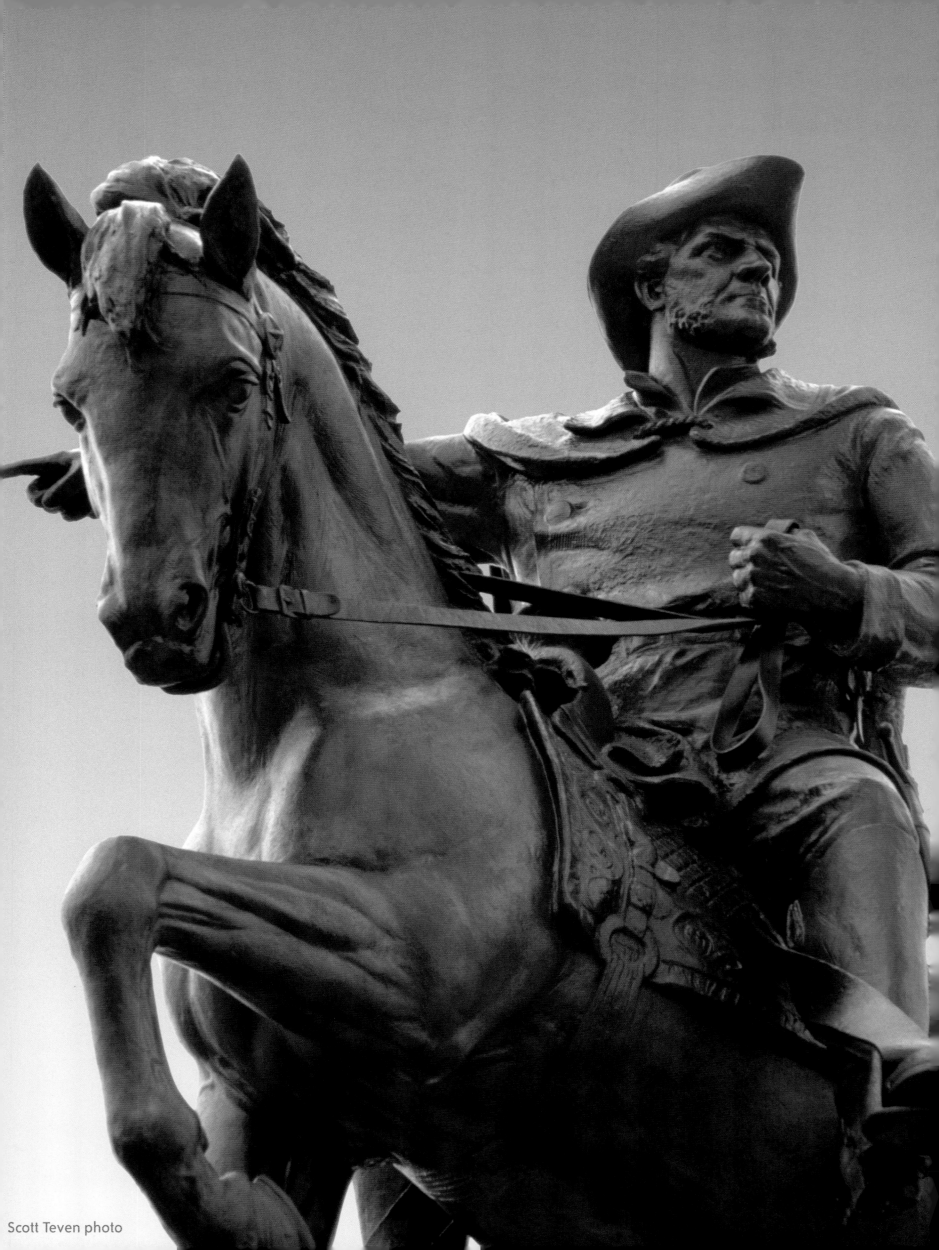

Scott Teven photo

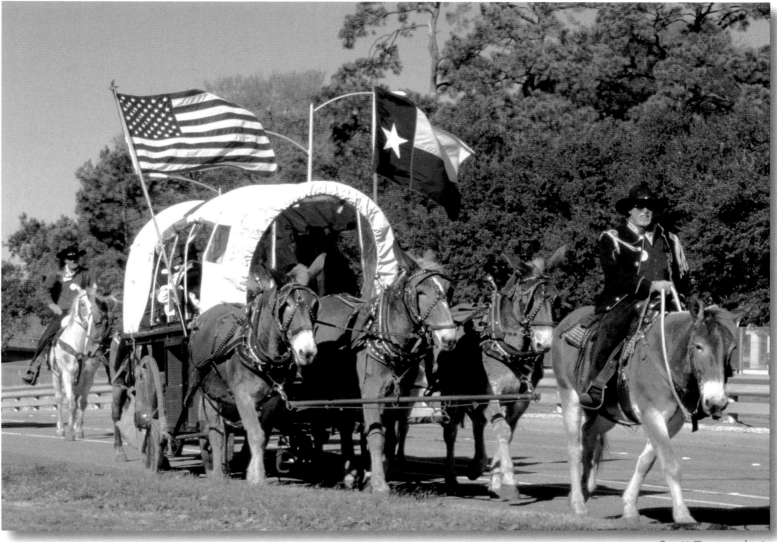

A mule team pulls an old-fashioned covered Conestoga wagon along the Houston Trail. Using the same mode of transportation as American pioneers used on their westward journey in the 1800s, these contemporary cowboys and cowgirls are en route to the Houston Livestock Show and Rodeo.

Sam Houston, the founding father of Texas, is honored all over the state. In this statue, Houston is depicted pointing towards the San Jacinto Battlefield where he led his troops to victory in 1836, gaining autonomy for Texas. After securing independence Houston served as the first President of the Republic of Texas. When Texas was annexed by the U.S. in 1845, Houston was elected to the senate. *(left)*

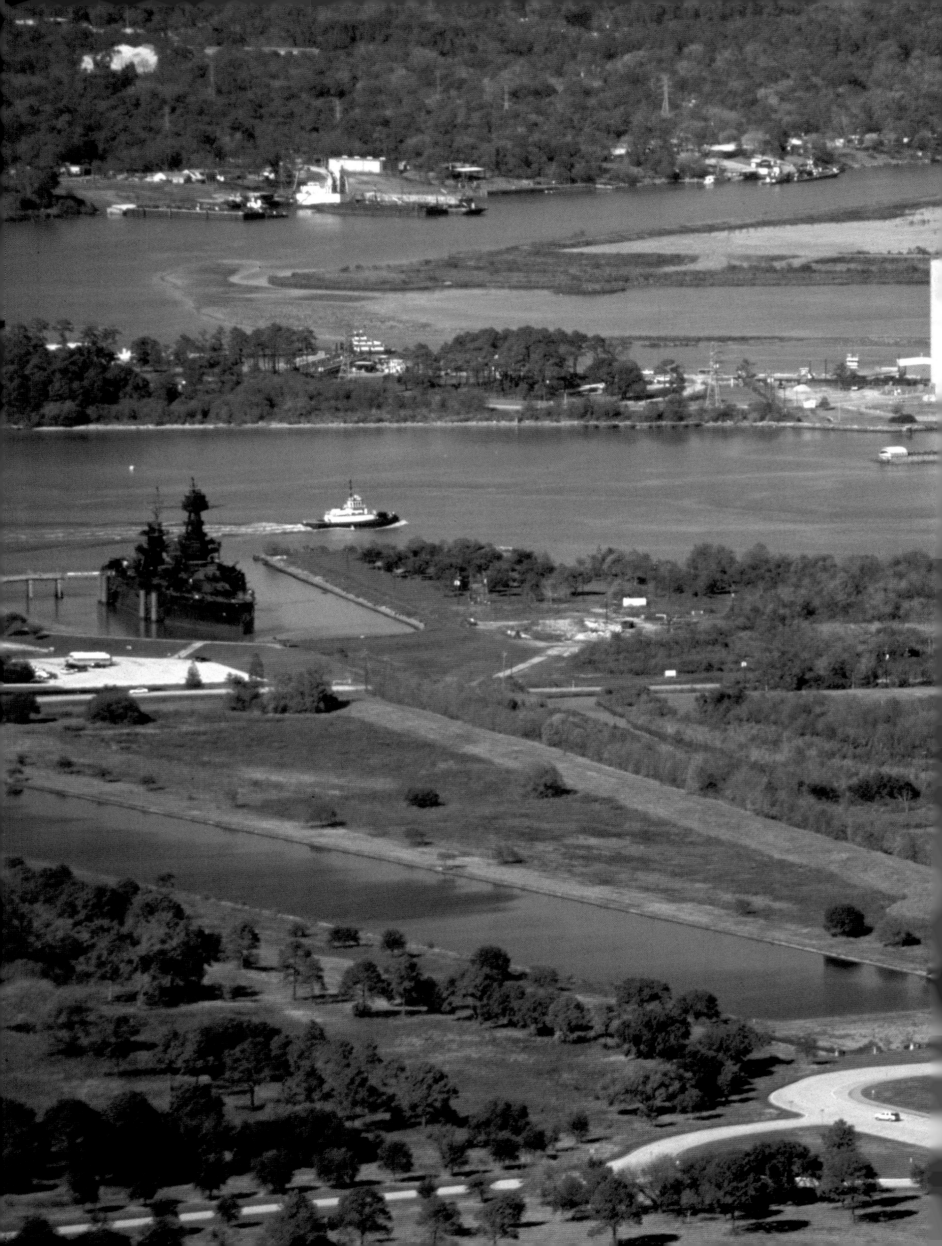

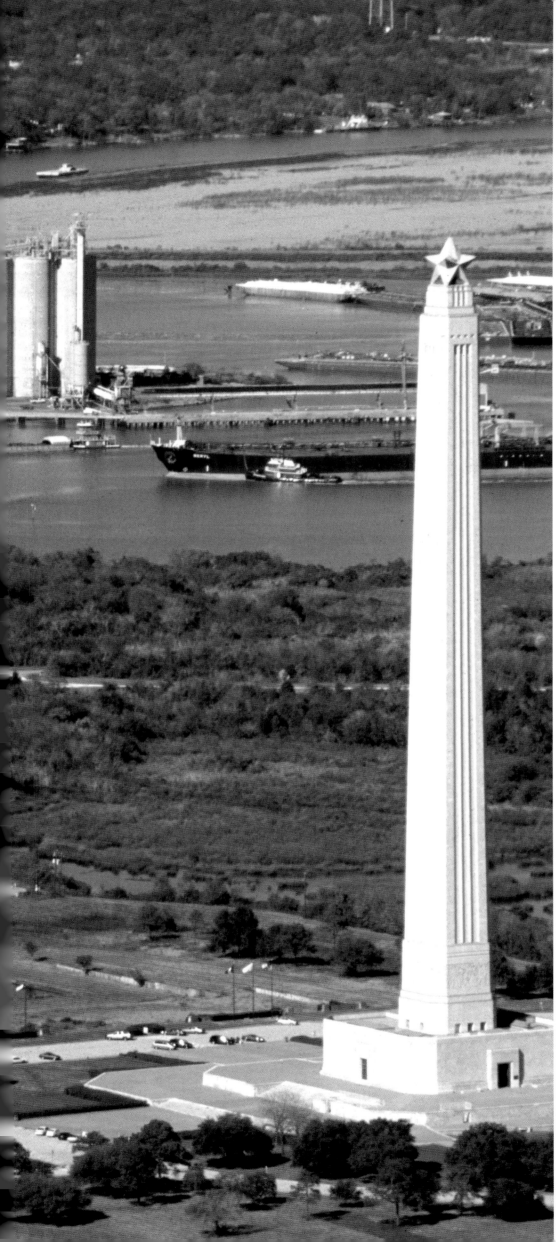

The San Jacinto monument is the world's tallest war memorial, built to commemorate the site of the Battle of San Jacinto, the final battle of the Texan Revolution. It was here that Sam Houston and his army defeated the Mexican army in 1836, winning Texas' independence. Crowning this 570-foot-tall monument is a 34-foot-tall, 220-ton lone star. The San Jacinto monument overlooks the battleship *Texas* and the Houston Ship Channel.

Scott Teven photo

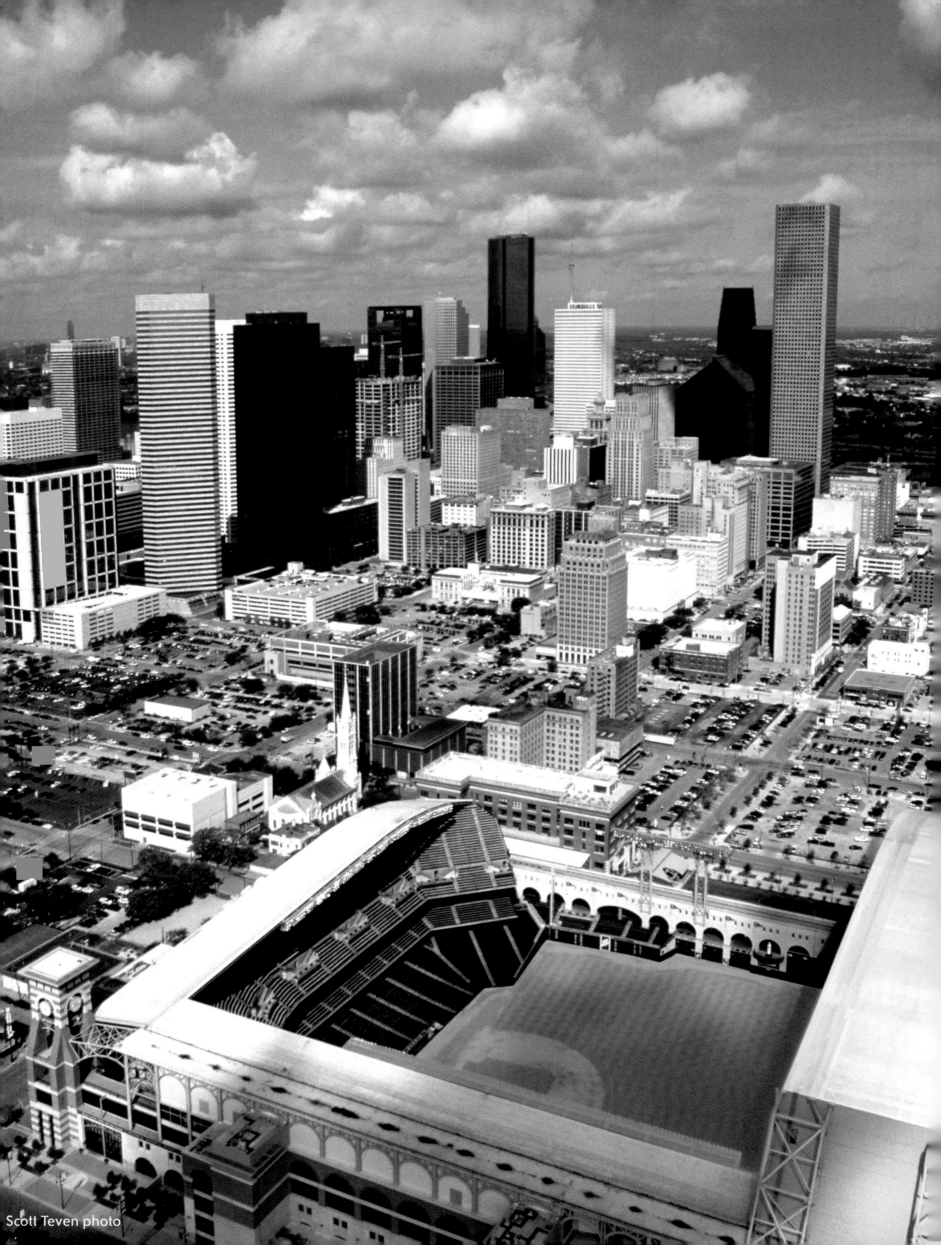

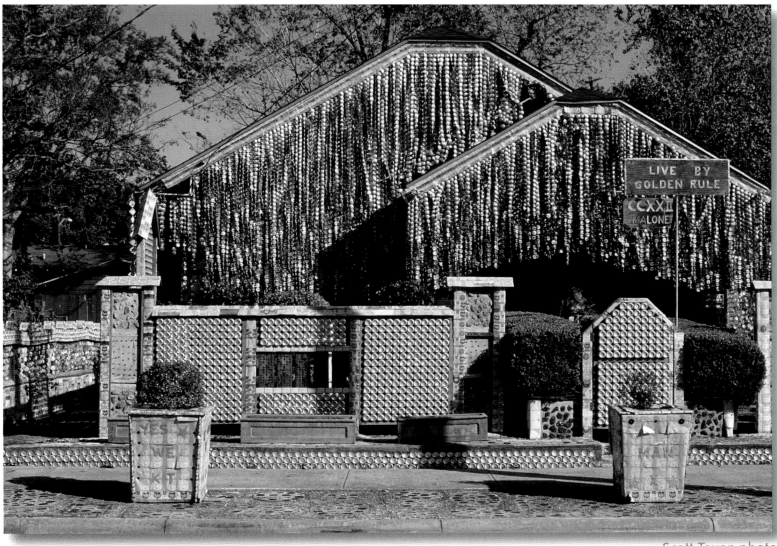

This distinctive Beer Can House pays tribute to both beer and folk art. Former resident John Milkovisch spent the 18 years he lived here decorating it with over 39,000 beer cans. He attached cans he'd collected through a six-pack-a-day habit to the exterior of the house and used the tops, bottoms, and pull-tabs to make wind chimes, sculptures, curtains, and mobiles.

The Minute Maid Park Baseball Field is tucked right into downtown Houston. Built in 2000 to replace the Astrodome as the home of the Houston Astros, this stadium has already undergone three name changes — from Astros Field to Enron Field and finally Minute Maid Park. Featuring natural grass and a 242-foot-high retractable roof, Minute Maid Park is engineered to provide optimum ball-playing conditions in the humid Texas climate. *(left)*

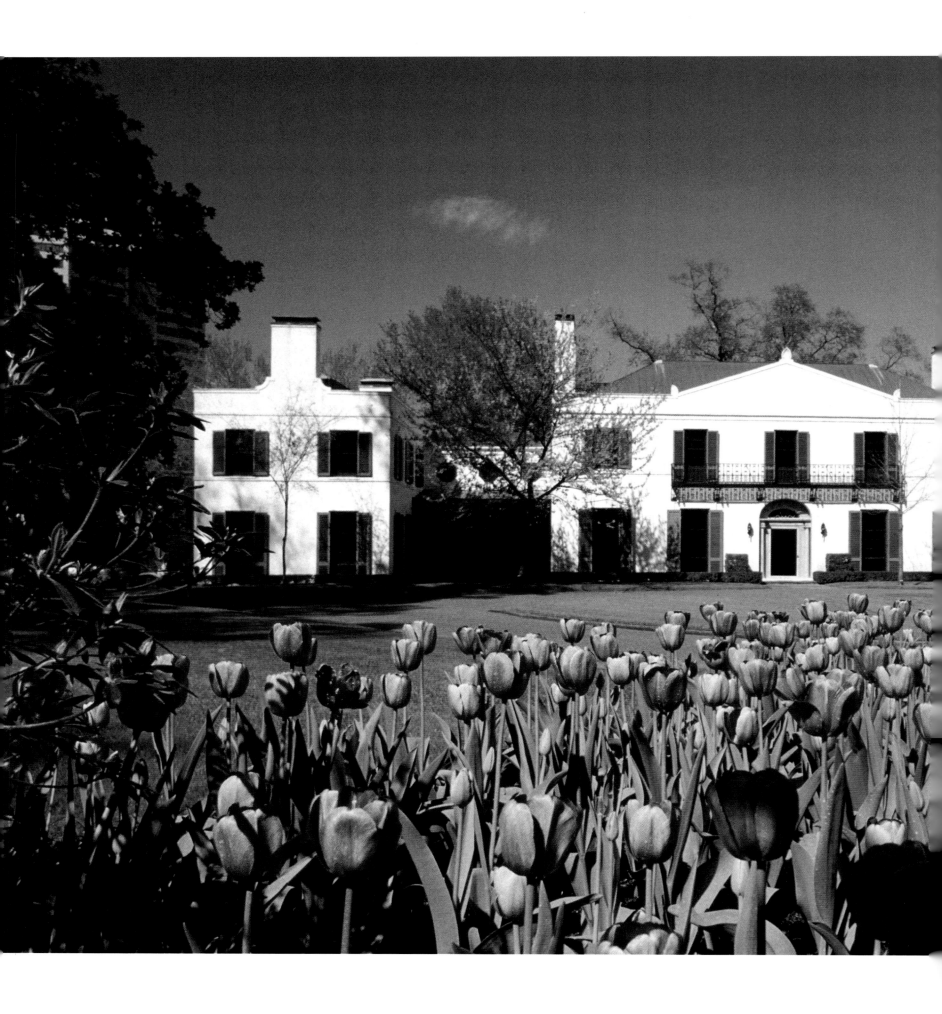

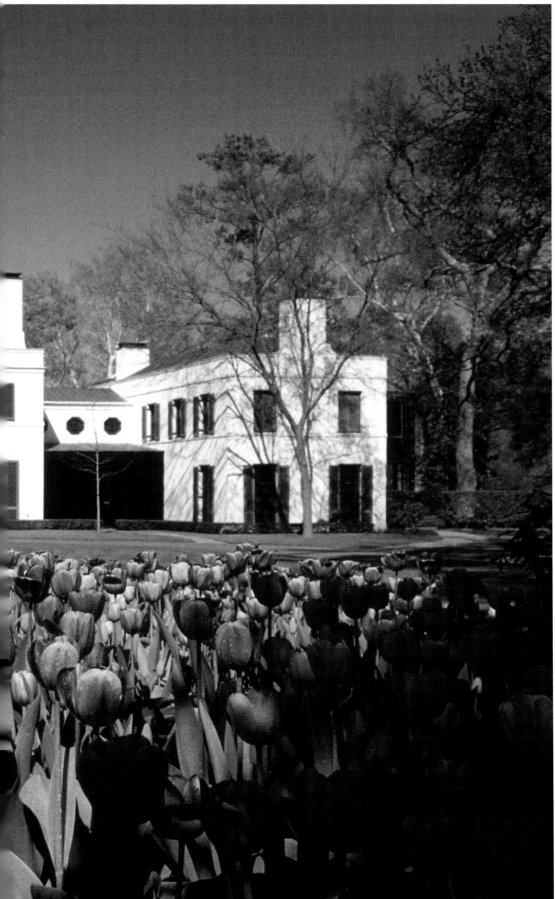

The Ima Hogg mansion at the Bayou Bend Garden is named after the woman who donated this stately home to the Museum of Fine Arts, Houston. The daughter of former Texan Governor James Stephen Hogg, Ima Hogg was admired throughout Texas as a philanthropist and artist. Among the many accomplishments that earned her the nickname The First Lady of Texas, Hogg founded the Houston Symphony Orchestra in 1913, the Houston Child Guidance Center, and the Hogg Foundation for Mental Health.

Scott Teven photo

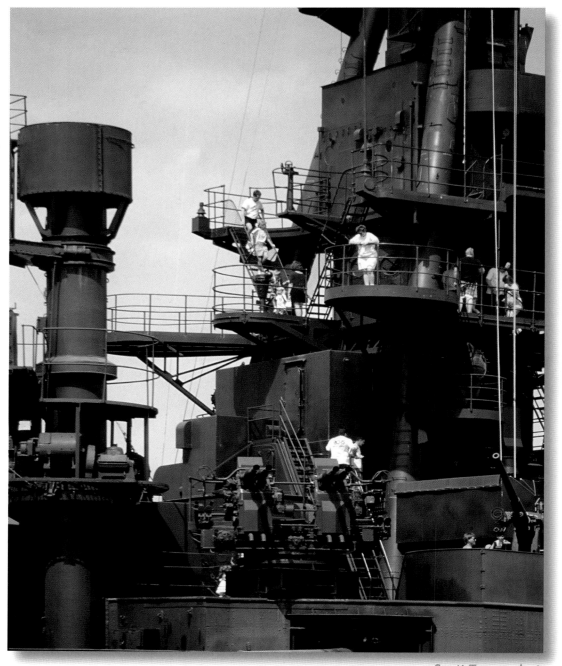

Scott Teven photo

Visitors explore the battleship *Texas*, a pioneering ship that raised the bar for the fighting capabilities of American battleships. Commissioned in 1914, *Texas* became the first American battleship to mount anti-aircraft guns in 1916. Three years later, she was the first battleship in the U.S. to launch an aircraft. Today, this massive ship is renowned for being the oldest remaining dreadnought in the world and one of two surviving ships that served in both world wars. After being decommissioned in 1948, the 573-foot-long *Texas* became a trailblazer once again as the first battleship converted into a museum.

The Harris County Civil Courthouse of 1910 is the fifth courthouse to stand on this Courthouse Square in Houston. Designed in the beaux-arts style, this granite and brick building was built between 1907 and 1910. *(right)*

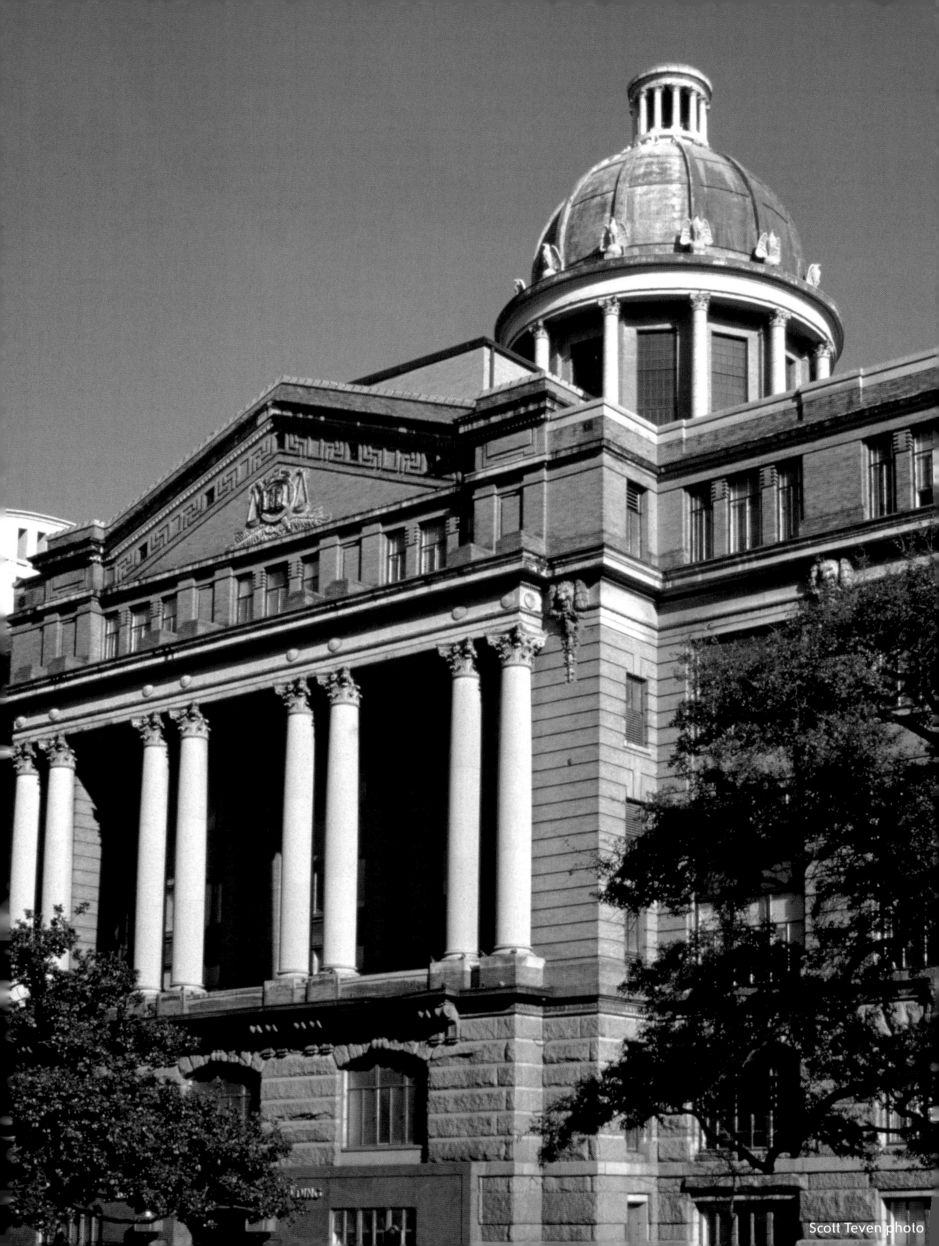

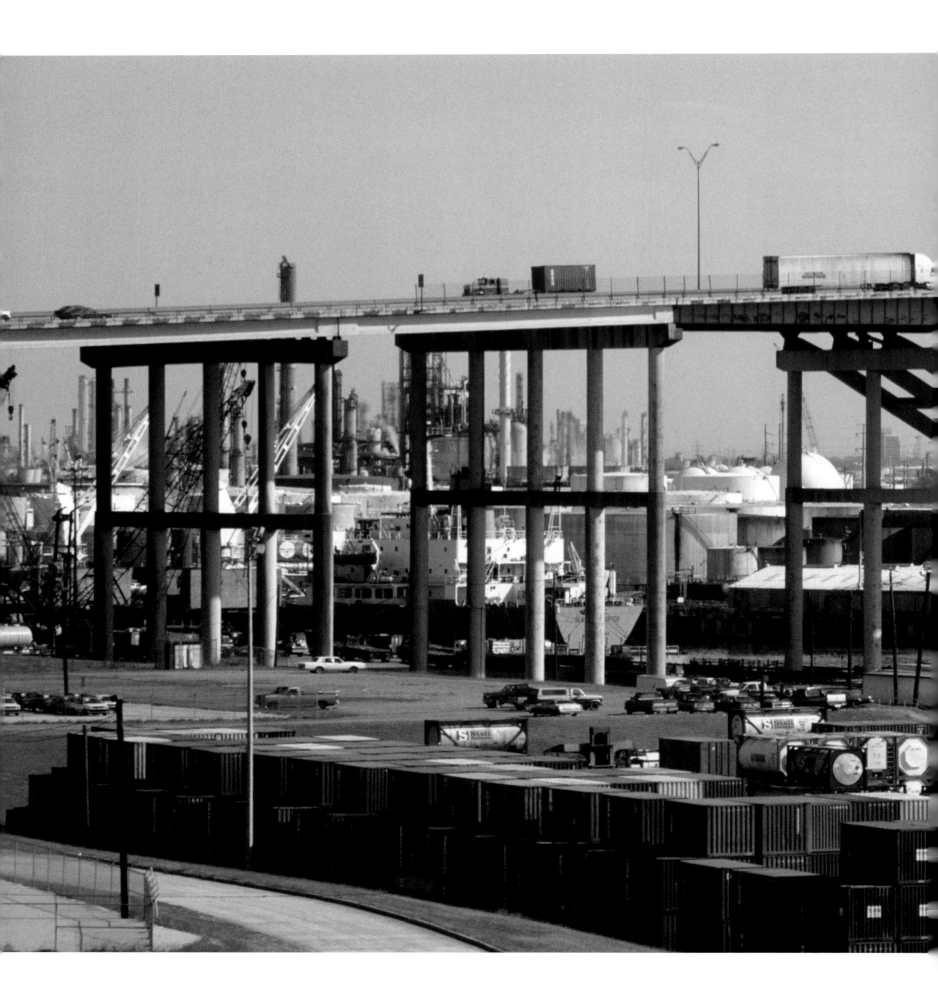

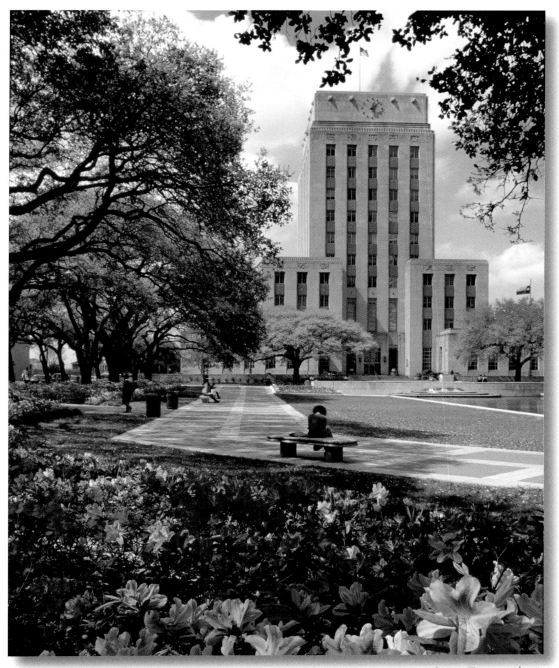

Scott Teven photo

The blooming azaleas in Martha Hermann Square frame this view of Houston City Hall. Completed in 1939, Houston City Hall, a classic of early 20th-century architecture, houses documents from that era. Laid in 1938, its cornerstone contains a time capsule with a copy of Texas' 1937 budget, issues of Houston's three daily newspapers from 1937, and a Bible.

A living history partnership project between the Fort Bend Museum Foundation and the George Foundation, the George Ranch Historic Park recounts Texas' storied history through costumed presenters. On this 23,000-acre working ranch, Texan history comes alive — from the state's days as part of Mexico to its era as an independent republic and eventual annexation by the U.S. *(right)*

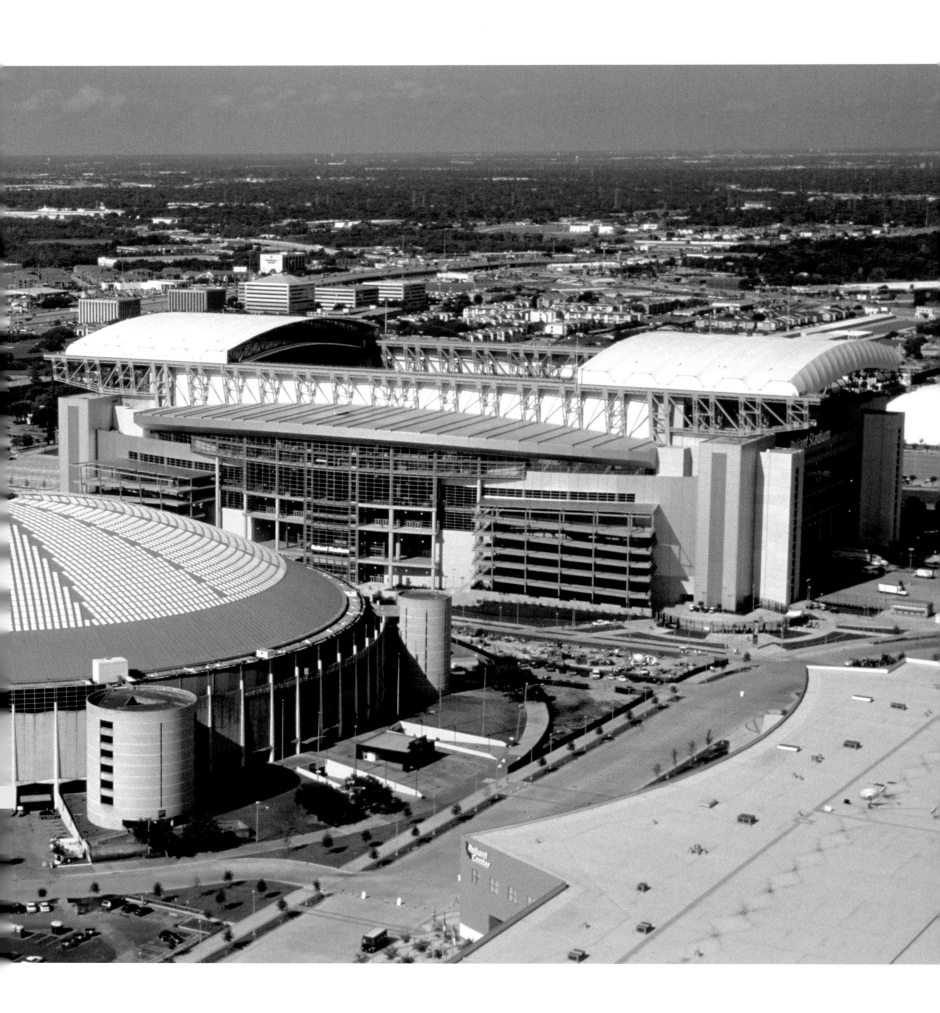

The first domed sports stadium in the world, the Houston Astrodome was once called the Eighth Wonder of the World. When it opened in 1965, this massive stadium was named the Harris County Domed Stadium but soon renamed the Astrodome after its home team the Houston Astros. The Houston Astros moved out in 1999, and this 18-storey stadium is now called the Reliant Astrodome. At 710 feet in diameter, this massive venue for concerts, trade shows, and sporting events provided shelter to thousands of New Orleans evacuees after Hurricane Katrina.

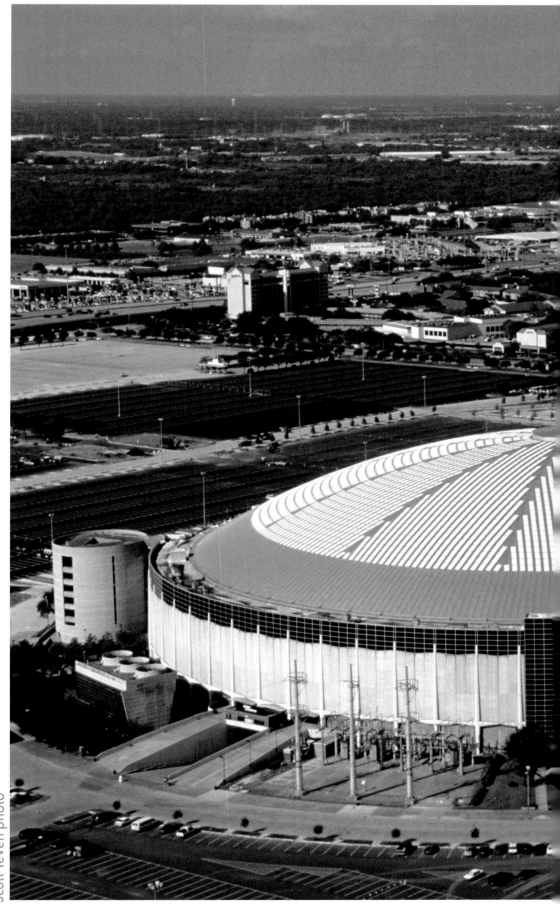

Scott Teven photo

The Sidney Sherman Bridge stretches over the Houston Ship Channel. Completed in 1973, this bridge is named after Sidney Sherman, who led troops at the Battle of San Jacinto in 1836. Considered instrumental in gaining Texan independence, Sherman was appointed colonel in the cavalry of the Republic of Texas. When Texas joined the U.S., Sherman bought a hotel in Galveston and became a businessman.

Scott Teven photo

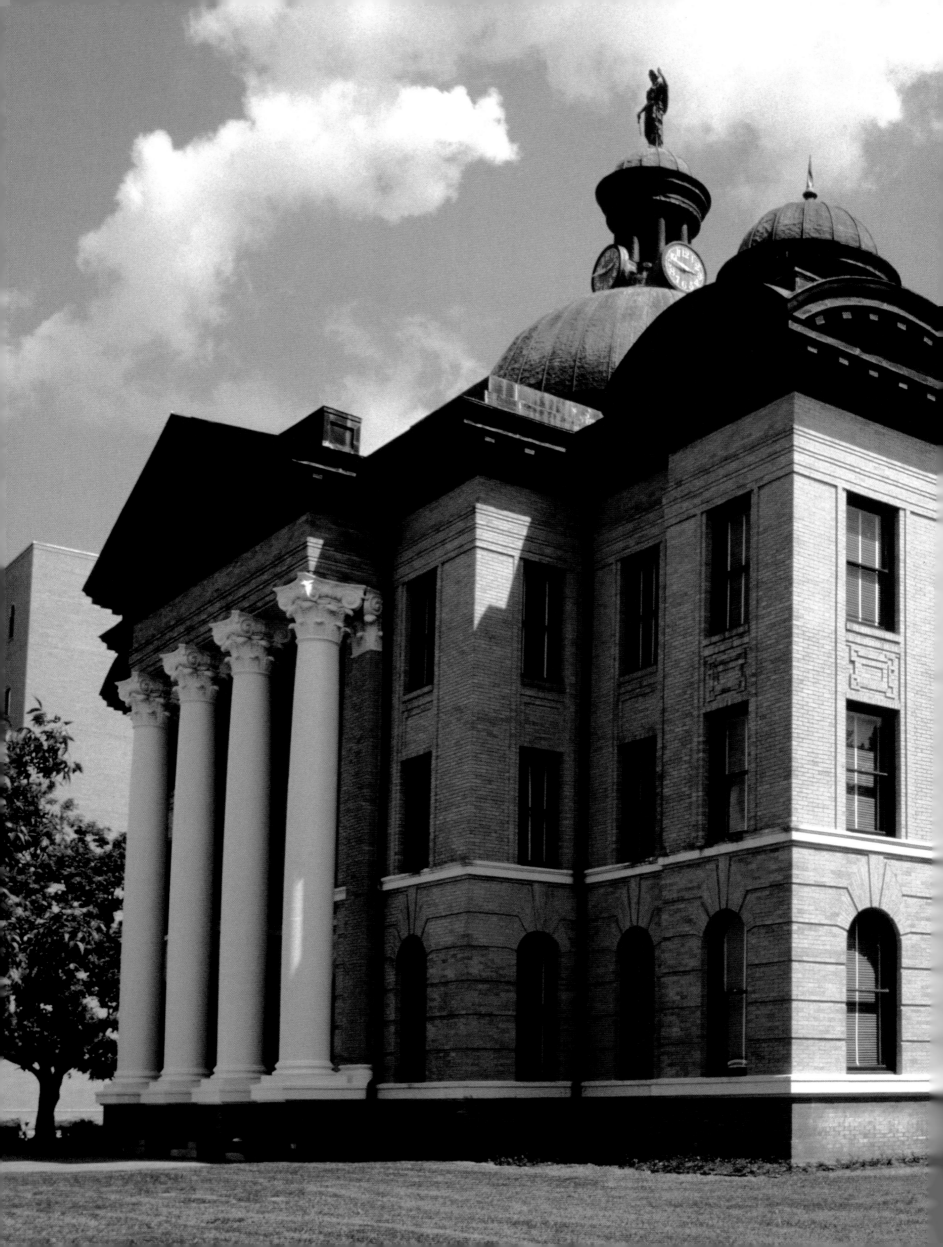

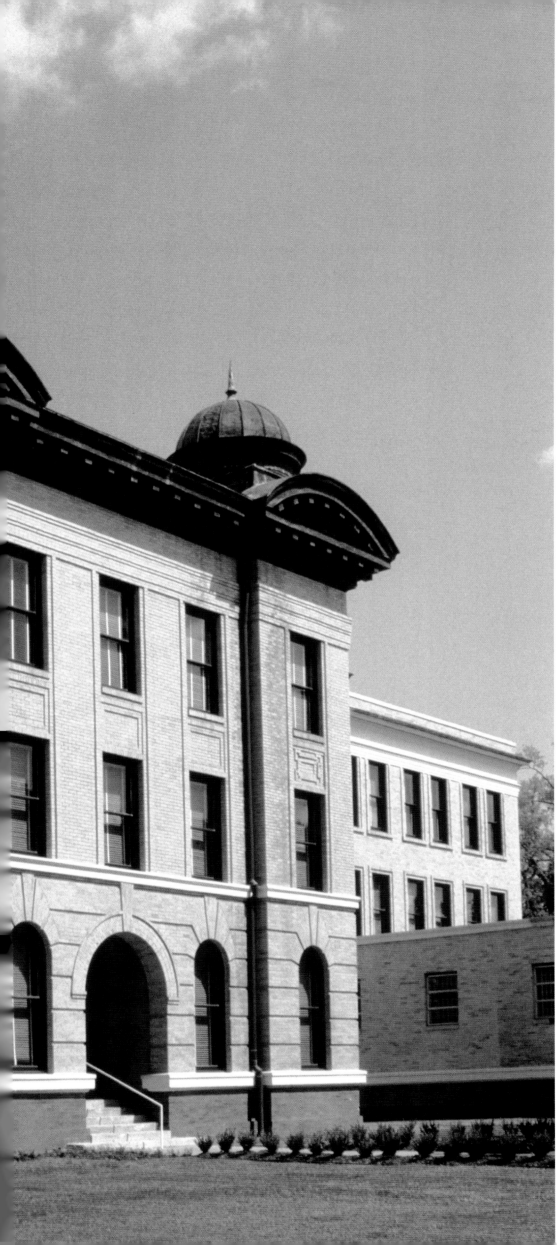

Built in 1908, the Fort Bend County courthouse boasts a striking silver dome and copper cornices. Restored in 1980 and added to the National Register of Historic Places, this courthouse is renowned for its mosaic floors and three-storey rotunda.

Scott Teven photo

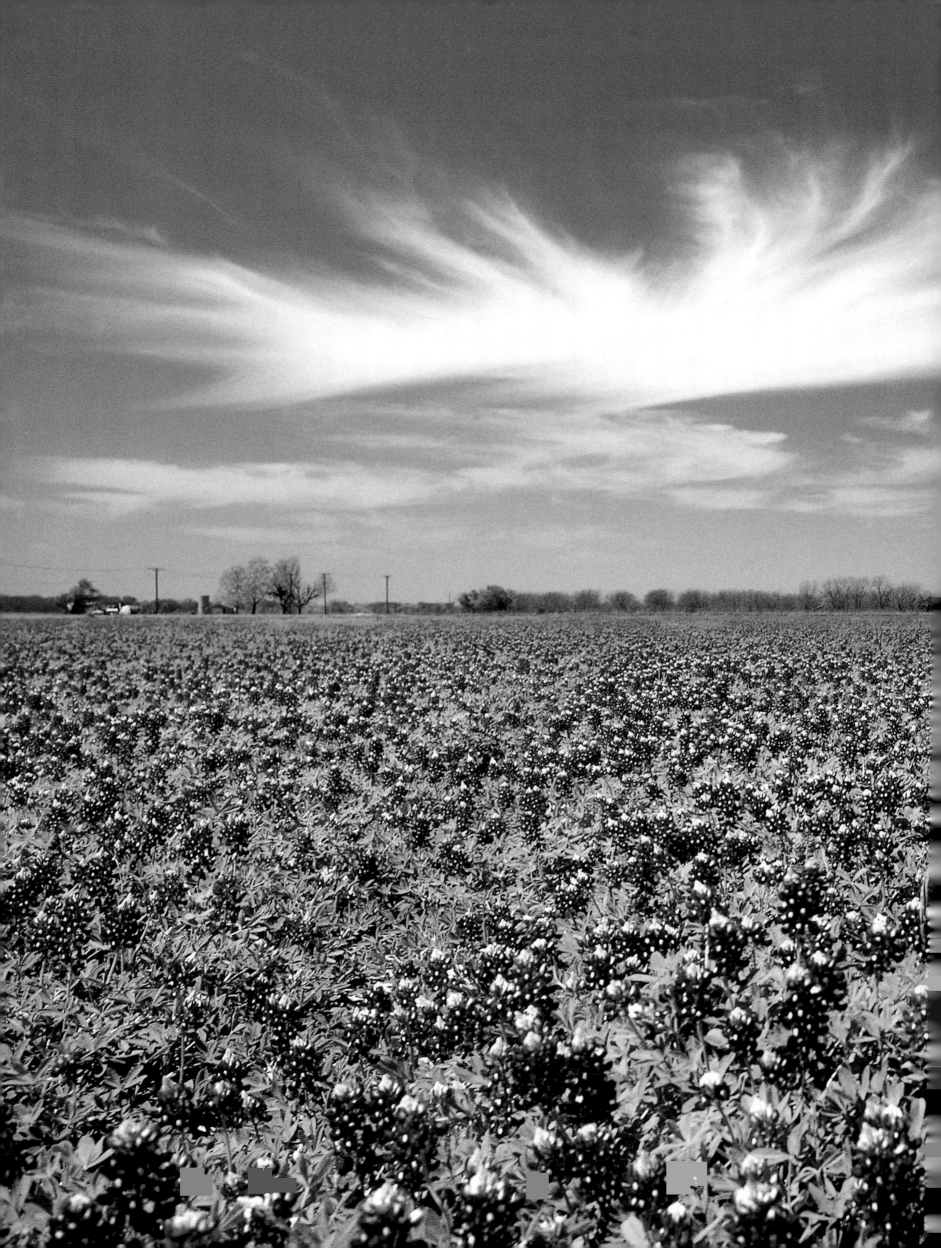

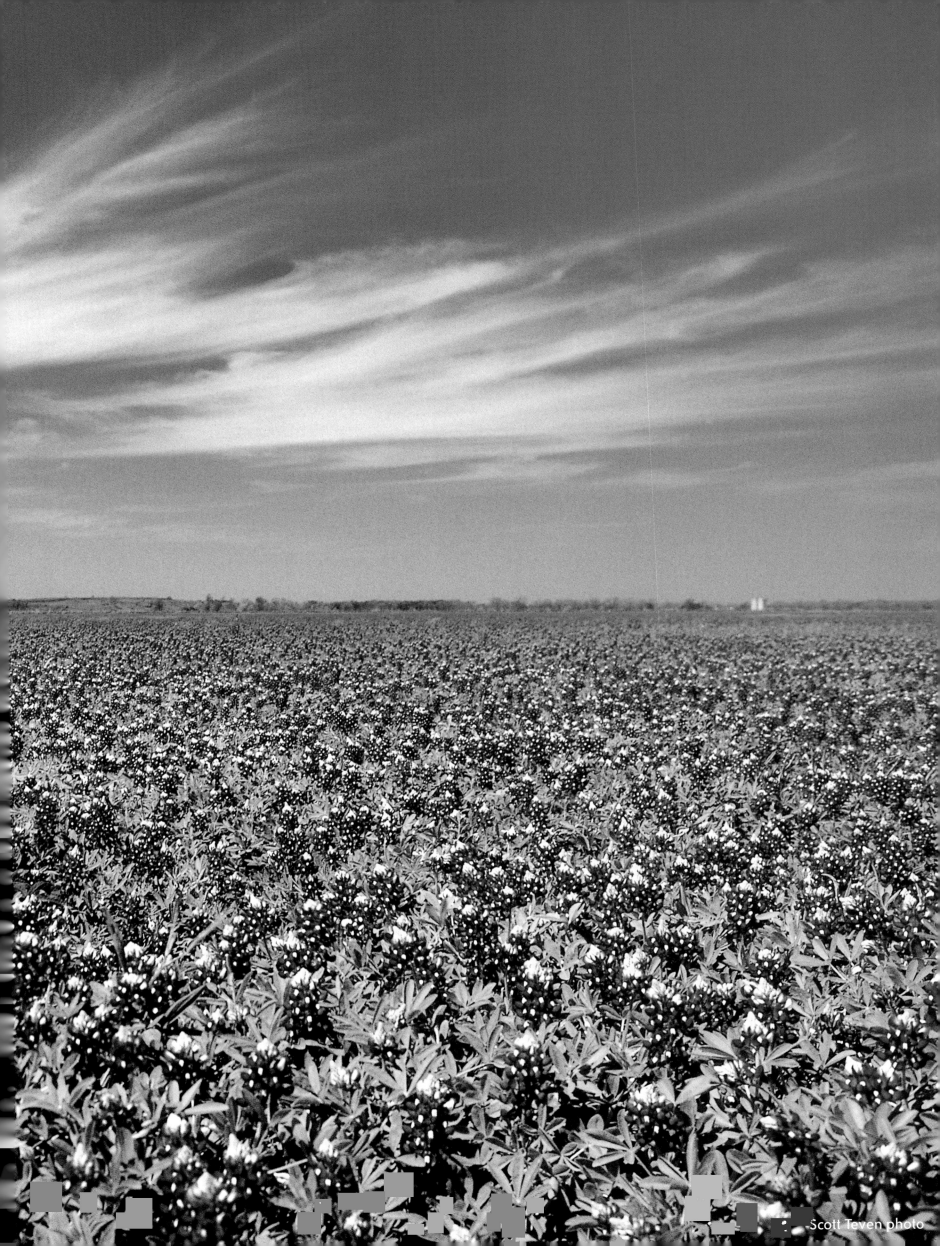

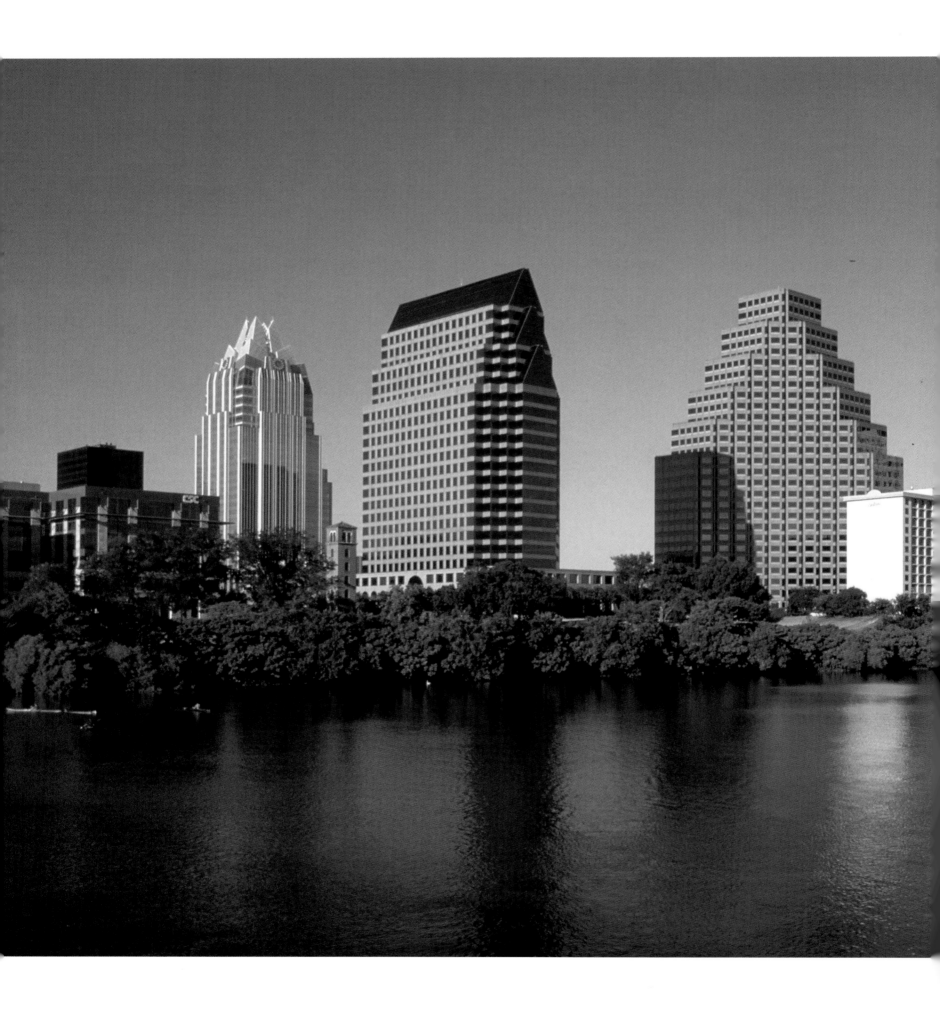

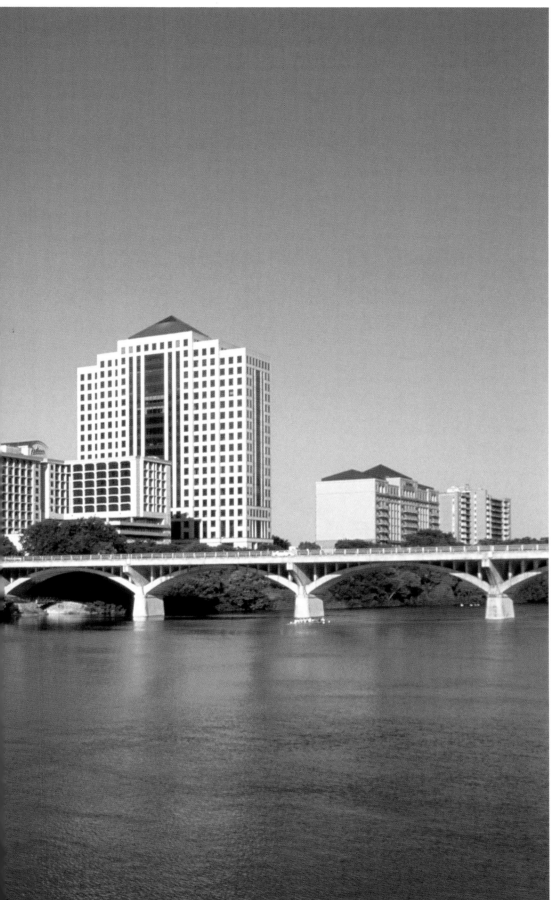

Scott Teven photo

Famously counter-cultural, Austin
has a reputation for a boisterous,
progressive live music scene. The
state capital of Texas, Austin hosts
numerous shows and festivals,
including South by Southwest,
one of the largest music festivals
in America, earning it the title of
Live Music Capital of the World.
A beautiful city dotted with lakes
and parks, Austin is home to an
exuberant and eccentric community,
confirming its residents' famous
slogan: Keep Austin Weird.

This field of blue flowers lies
in the heart of Central Texas'
Bluebonnet Region. As springtime
arrives in Columbus, the region's
many wildflowers paint the
countryside with brilliant colors.
Along with these bluebonnets,
Indian paintbrush, Indian blankets,
Drummond's phlox, yellow
coreopsis, Turk's cap, sunflowers,
Mexican hat, and evening primrose
bloom throughout the season.
(previous pages)

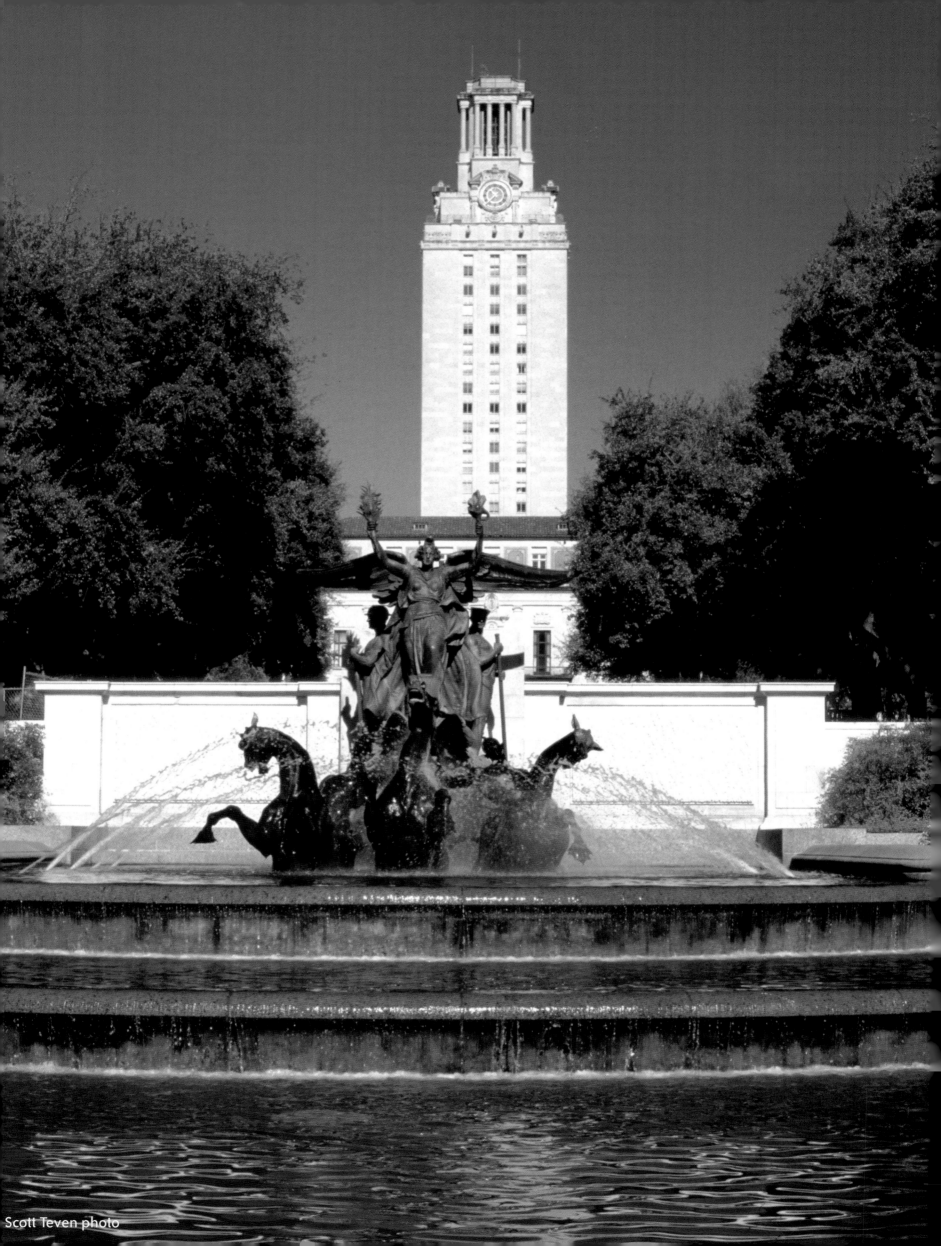

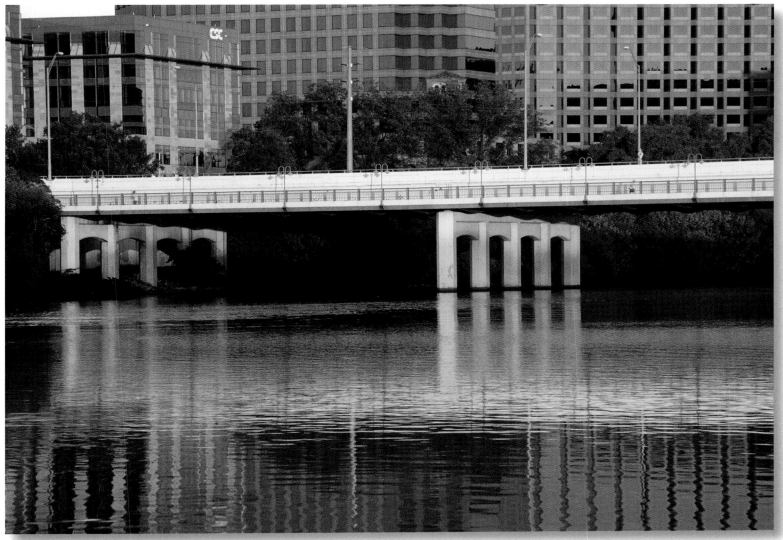

The First Street Bridge stretches over Town Lake in Austin, Texas. It is part of the network of hiking and biking trails in this area, which is famous for its wealth of outdoor activities. This bridge is one of the main venues in the city's renowned New Year's Eve festival, First Night Austin.

Since it was built in 1937, this 301-foot-tall tower has been the trademark of the University of Texas, Austin. It overlooks the many parks and fountains of the university's 350-acre campus, and can be see from almost any point in Austin. Since it was founded in 1883, the University of Texas has grown from one building to over 120 academic buildings. *(left)*

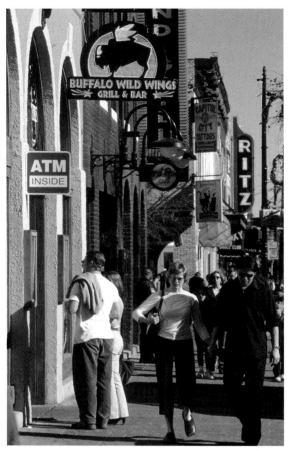

Scott Teven photo

The vibrant bars, restaurants, and shops along Austin's historic 6th Street are part of the city's entertainment district, and its many concert venues are essential to Austin's world-renowned music scene. Many music and film festivals and biker rallies take place along 6th Street, which is listed in the National Register of Historic Places.

Seemingly out of this world, the Inner Space Cavern outside Austin, Texas, provides a doorway into history and nature. This magical place — home to stalactites, stalagmites, and many more natural formations — is around 90 million years old. The Texas Highway Department discovered the cavern in 1963 after drilling through 40 feet of solid limestone. *(right)*

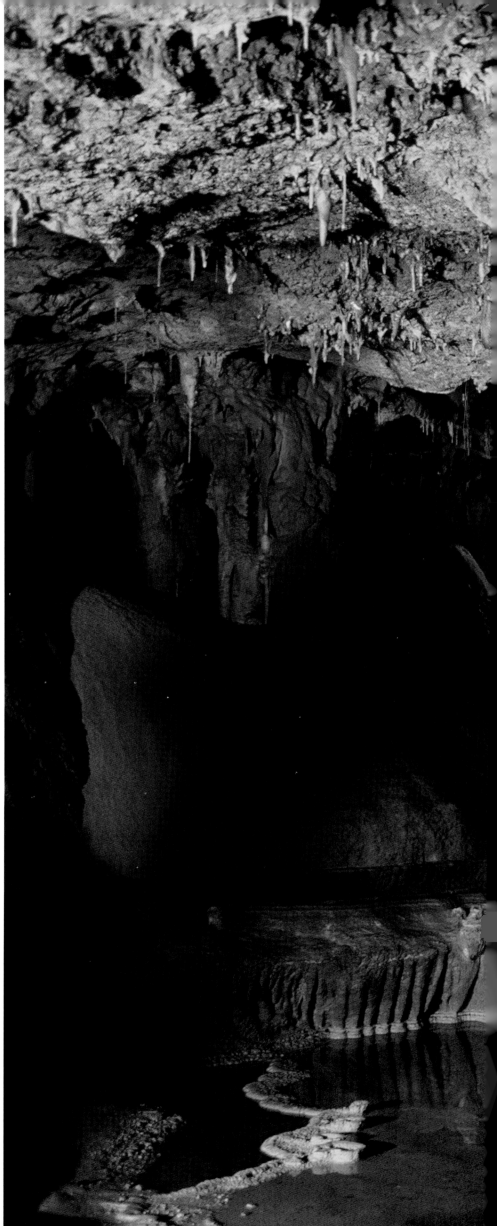

Richard Cummins/Folio photo

The Great Hills in northwest Austin provide a scenic backdrop to the Pennybacker Bridge across Lake Austin. Connecting the north and south loops of the 360 Highway, it is also called the 360 Bridge. Named for Percy Pennybacker, who designed bridges for the Texas Highway Department, this 1,150-foot-long bridge is considered one of Austin's most innovative architectural designs.

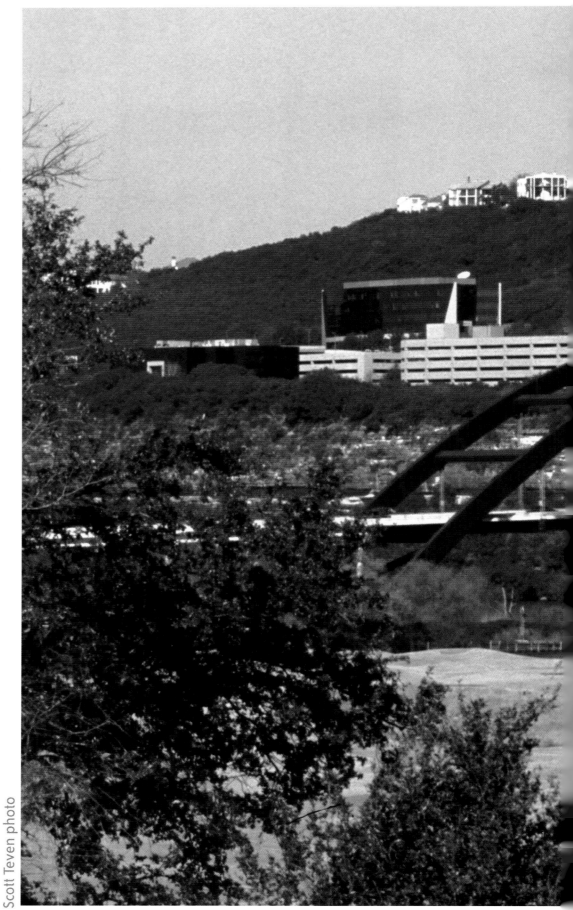

Scott Teven photo

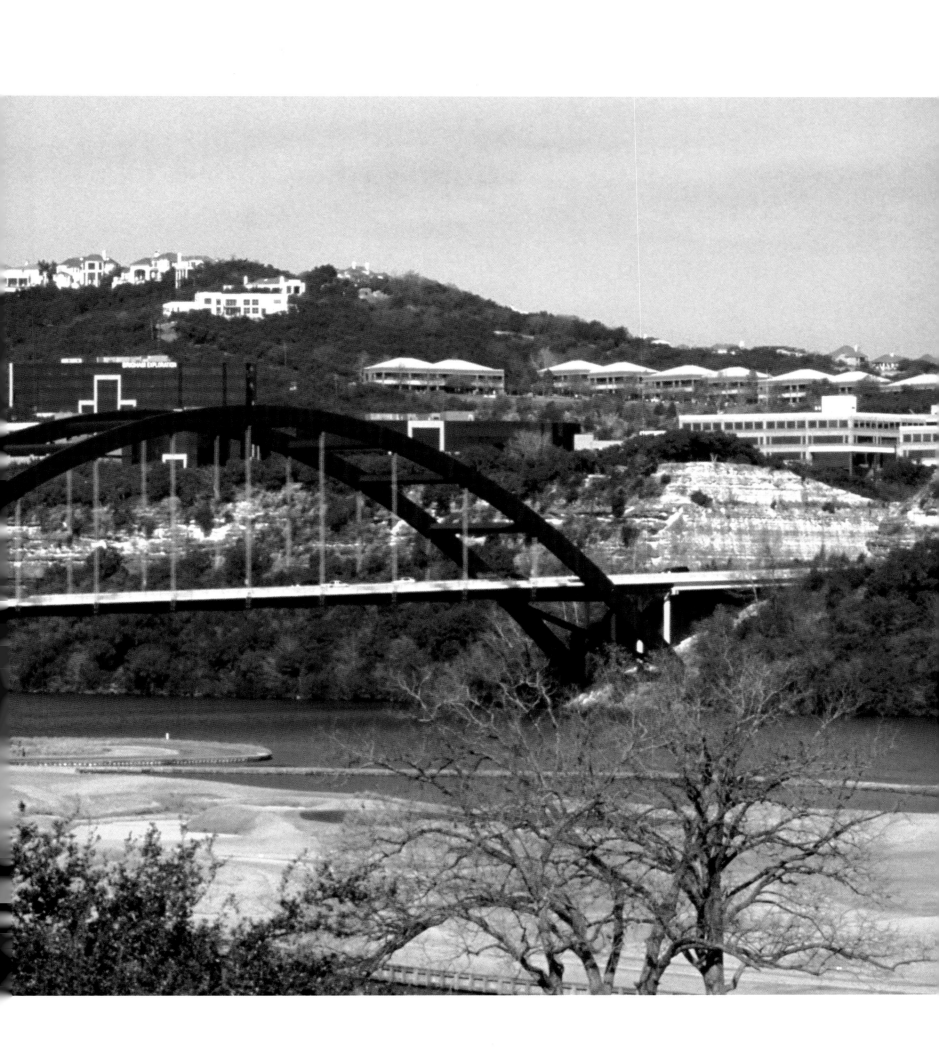

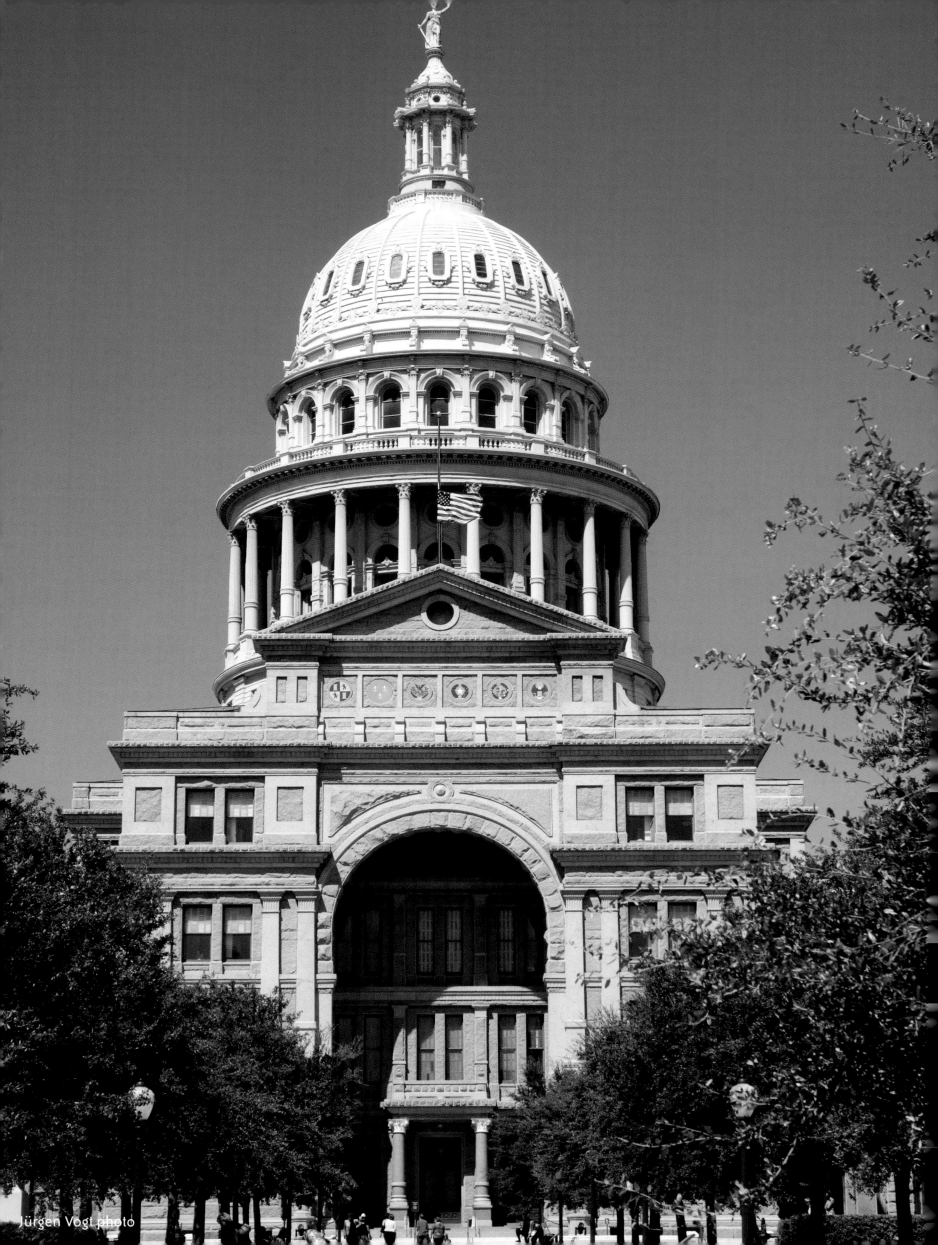

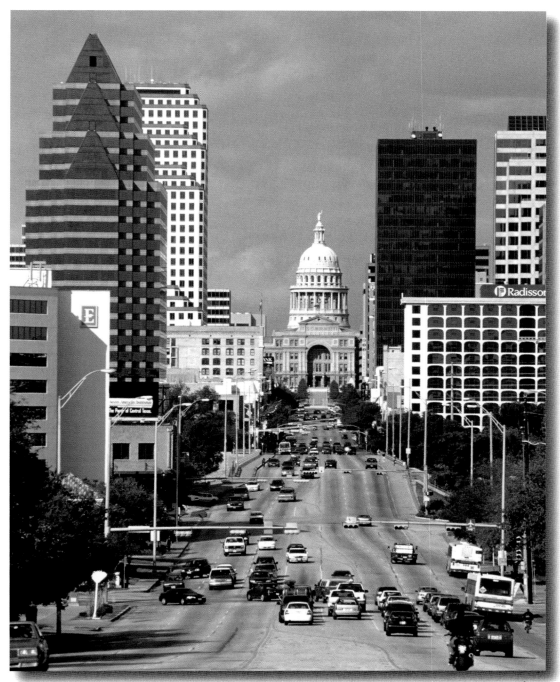

Tree-lined Congress Avenue in downtown Austin culminates at the distinguished Texas State Capitol building. A major thoroughfare with a high concentration of restaurants, boutiques, cafés, and bars, Congress Avenue was designed to be Austin's preeminent street. This eclectic strip of South Congress has been dubbed SoCo, because it's considered Austin's version of New York's famed SoHo neighborhood.

When the distinguished Texas State Capitol was completed in 1888, it was dubbed the Seventh Largest Building in the World. While no longer a contender for the world's largest, this building has more square footage than any other state capitol and is almost 15 feet higher than the National Capitol in Washington, DC. Exemplifying the Renaissance Revival style, this illustrious building became a National Historic Landmark in 1986. *(left)*

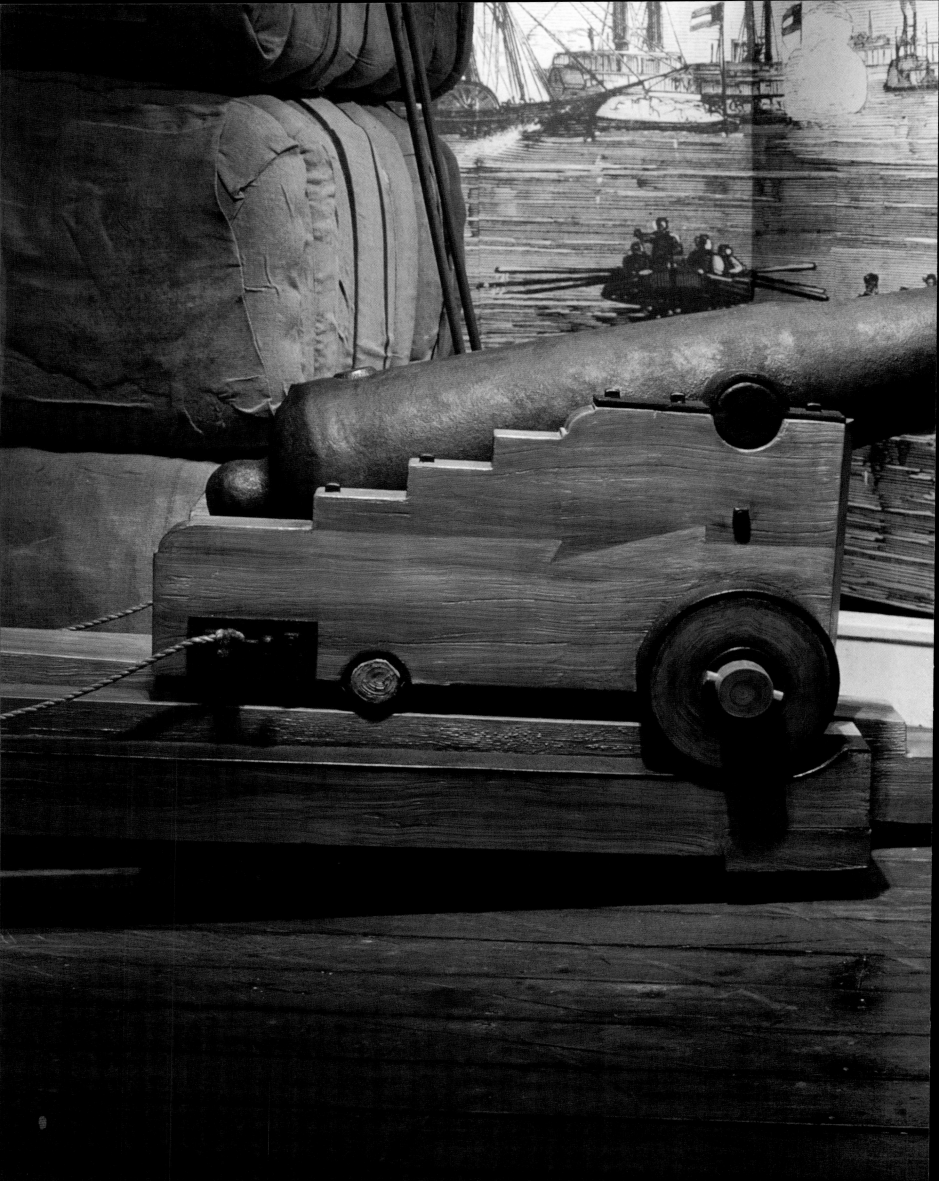

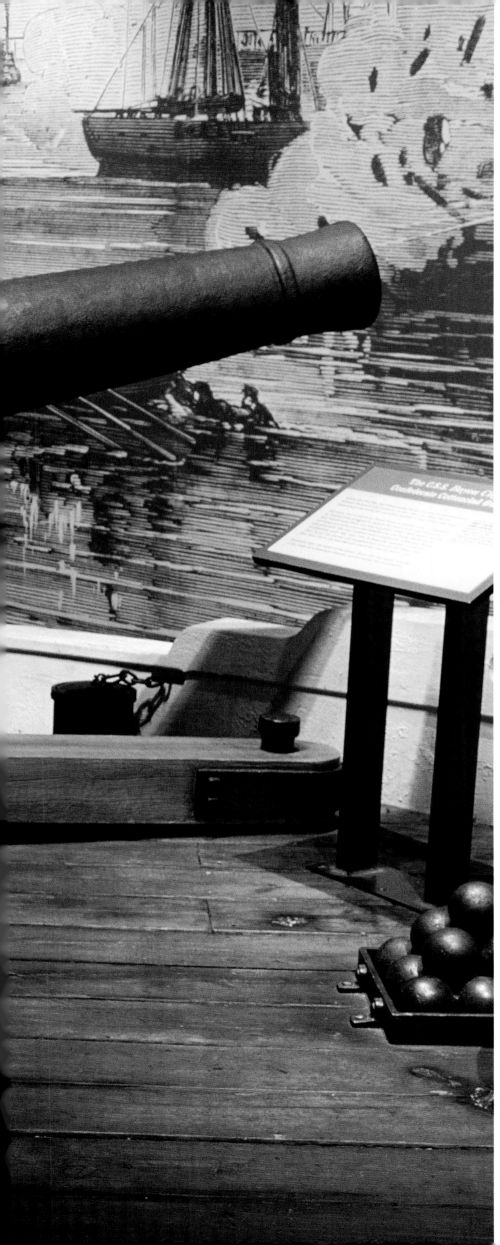

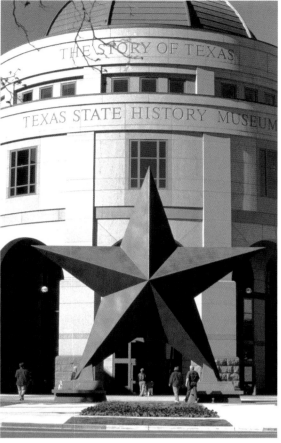

Scott Teven photo

A 35-foot-tall bronze lone star sits in front of the Bob Bullock Texas State History Museum, which chronicles the history of Texas through interactive exhibits. It was named after the former Lieutenant Governor of Texas, Bob Bullock, a highly influential force in the museum's establishment. Bullock died two years before this museum opened in 2001. A seven-foot-tall bronze statue on the second floor immortalizes his image.

This cannon on display at the Bob Bullock State History Museum comes from the CSS *Bayou City*. The 165-foot-long side-wheel steamer was originally used as a mail boat between Galveston and Houston. During the civil war, the *Bayou* sailed for Texas on the Confederate side. *(left)*

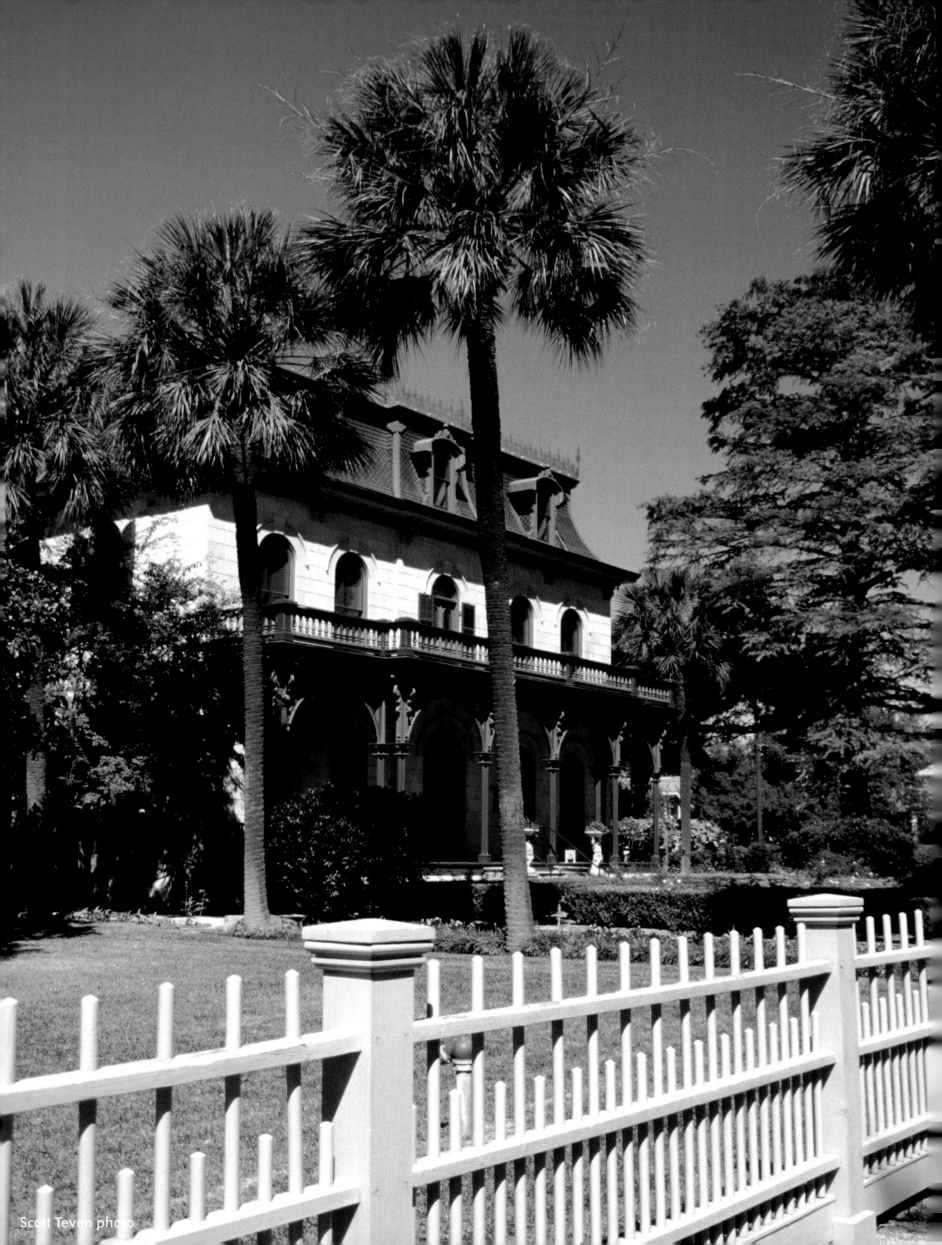

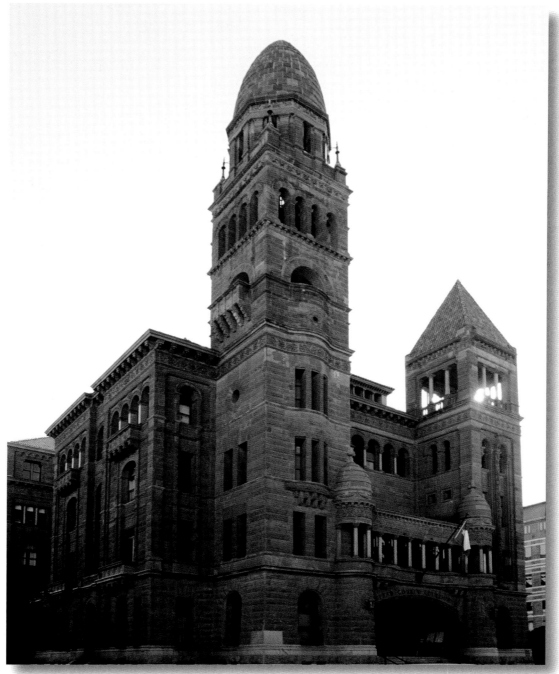

A stunning example of Romanesque Revival architecture, the Bexar County Courthouse is the largest county courthouse in Texas and the state's longest continually operated courthouse. The cornerstone of this red sandstone building was laid in 1892.

These tree-lined San Antonio streets in the charming, funky King William District feature buildings designed in the Greek Revival, Victorian, and Italianate styles of architecture. A large contingent of German immigrants, who named the main street after the King of Prussia, Kaiser Wilhelm, established this neighborhood in the 1870s. *(left)*

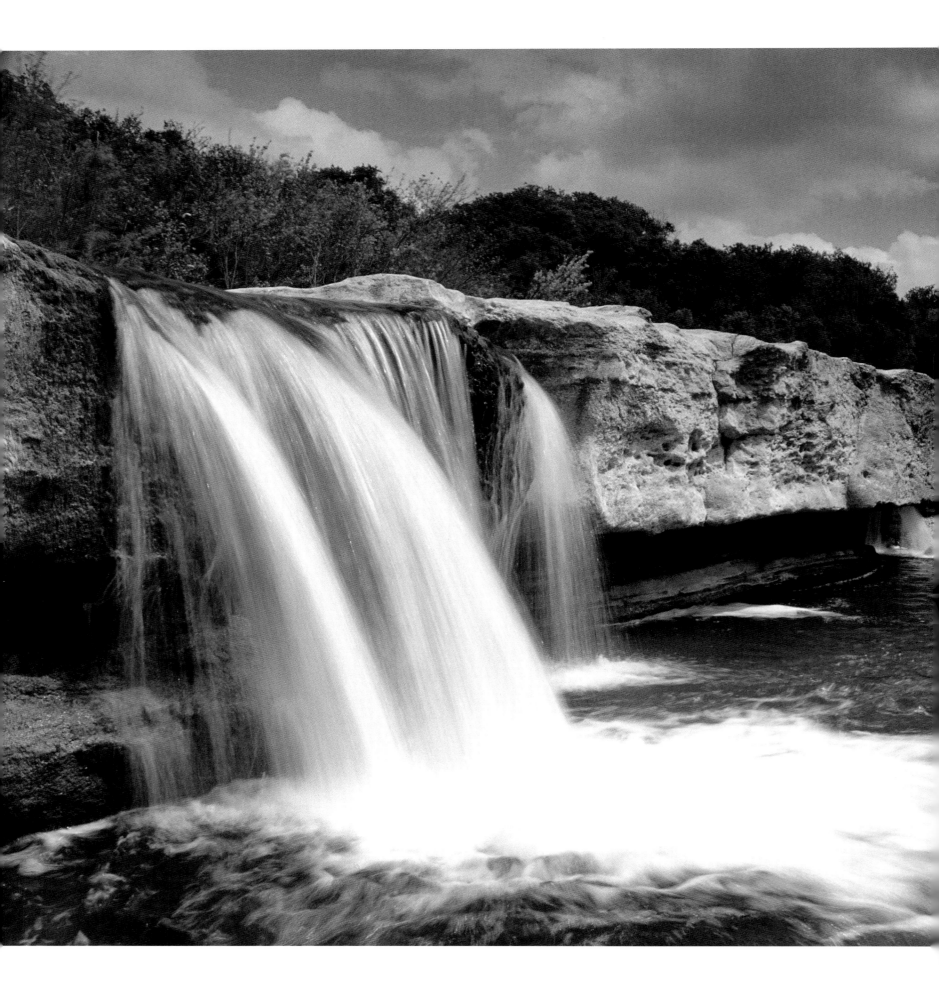

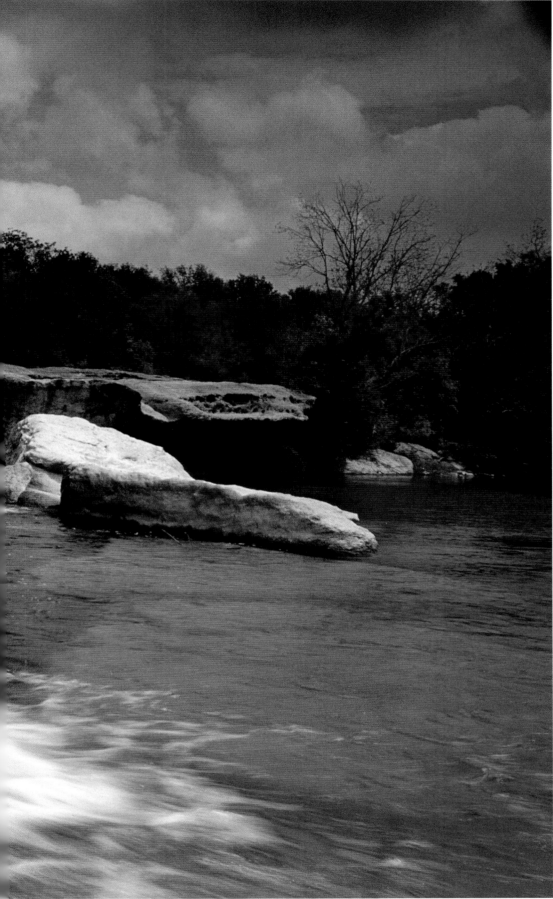

The Lower McKinney Falls are part of the 744 acres of McKinney Falls State Park in Travis County. A public park since 1974, this state park provides ample opportunity for camping, hiking, mountain biking, and fishing. This protected natural area is named after Thomas F. McKinney, who settled here in the early 19th century. McKinney was a prominent horse breeder who built the county's first flour mill.

This cow is neck deep in the bright blue petals of Texas' State Flower. A species of lupine, the Texas bluebell blankets the hills of the Lone Star State every spring. Texas boasts more than 5,000 wildflower species. The highest concentration of blossoms occurs in central Texas in the springtime.

Richard Cummins/Folio photo

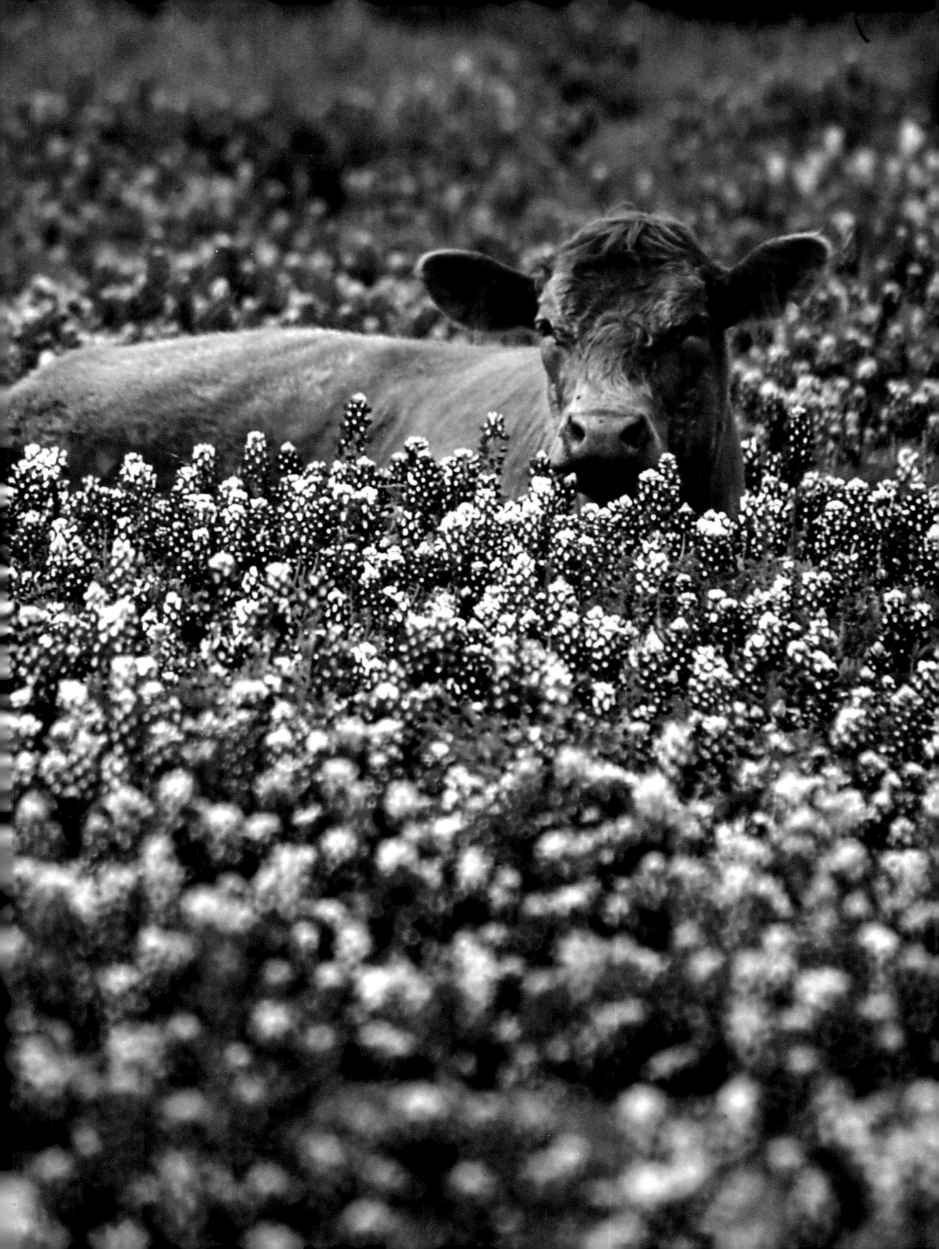

A windmill adorns the landscape here in Marble Falls, Texas. Located in the middle of the Highland Lakes area, the town is named for a waterfall that used to flow here before it was dammed to create Lake Marble Falls.

The rushing waters of Pedernales Falls create a fine mist in Pedernales Falls State Park, where the Pedernales River drops 50 feet over a distance of about 3,000 feet, flowing over layered limestone. Located in Blanco County, the 5,200 acres of the Pedernales Falls State Park opened to the public in 1971. *(overleaf)*

Tim Fitzharris photo

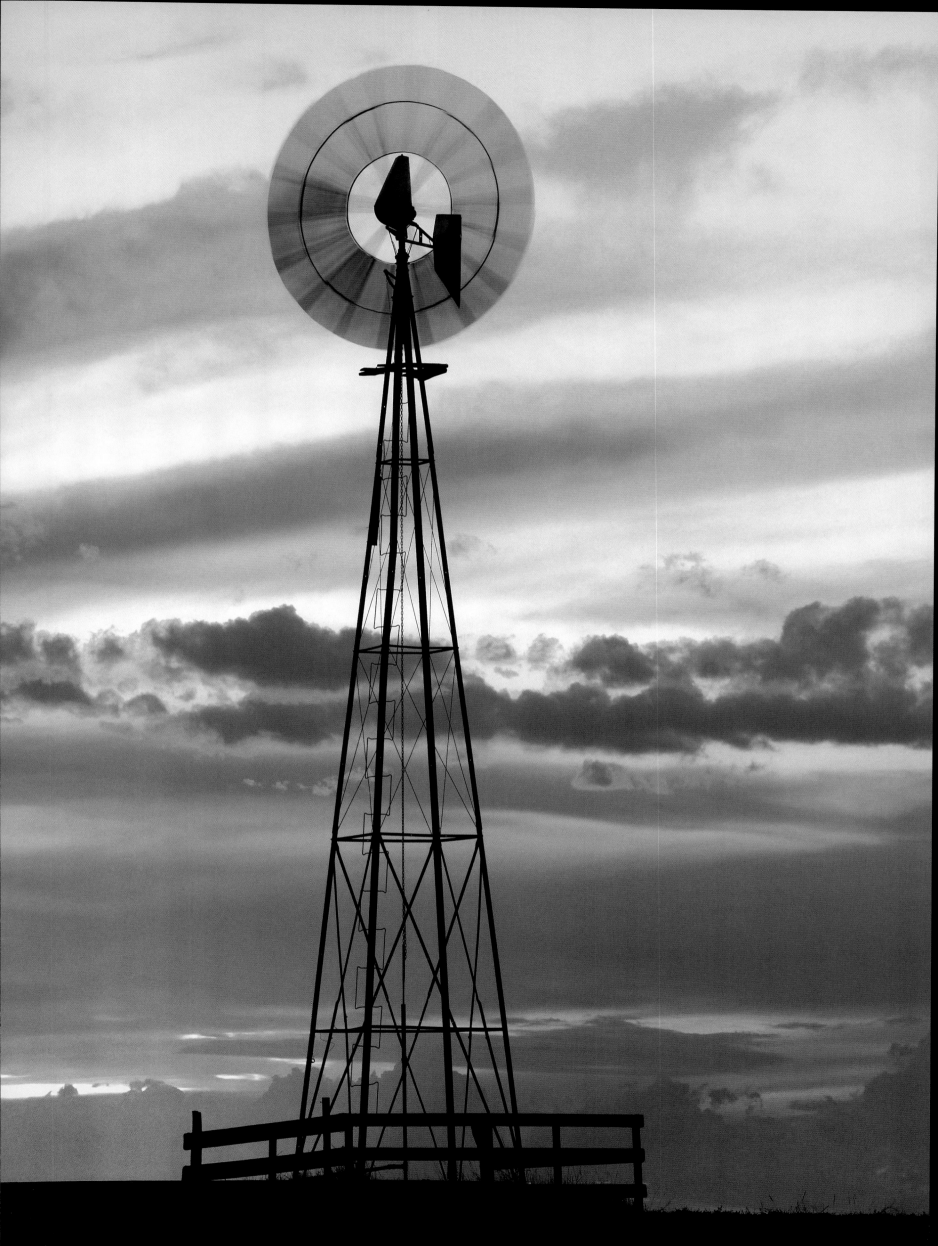

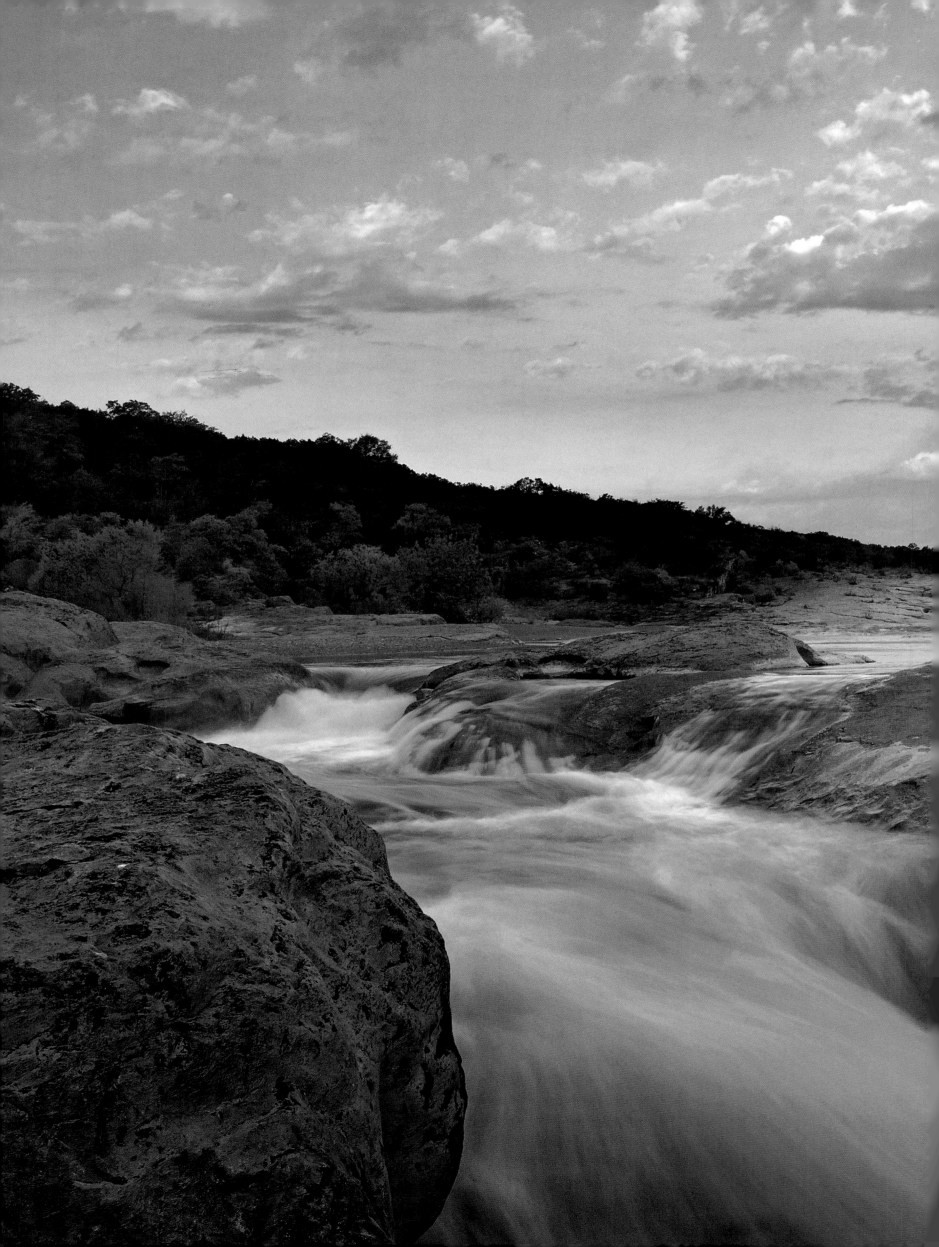

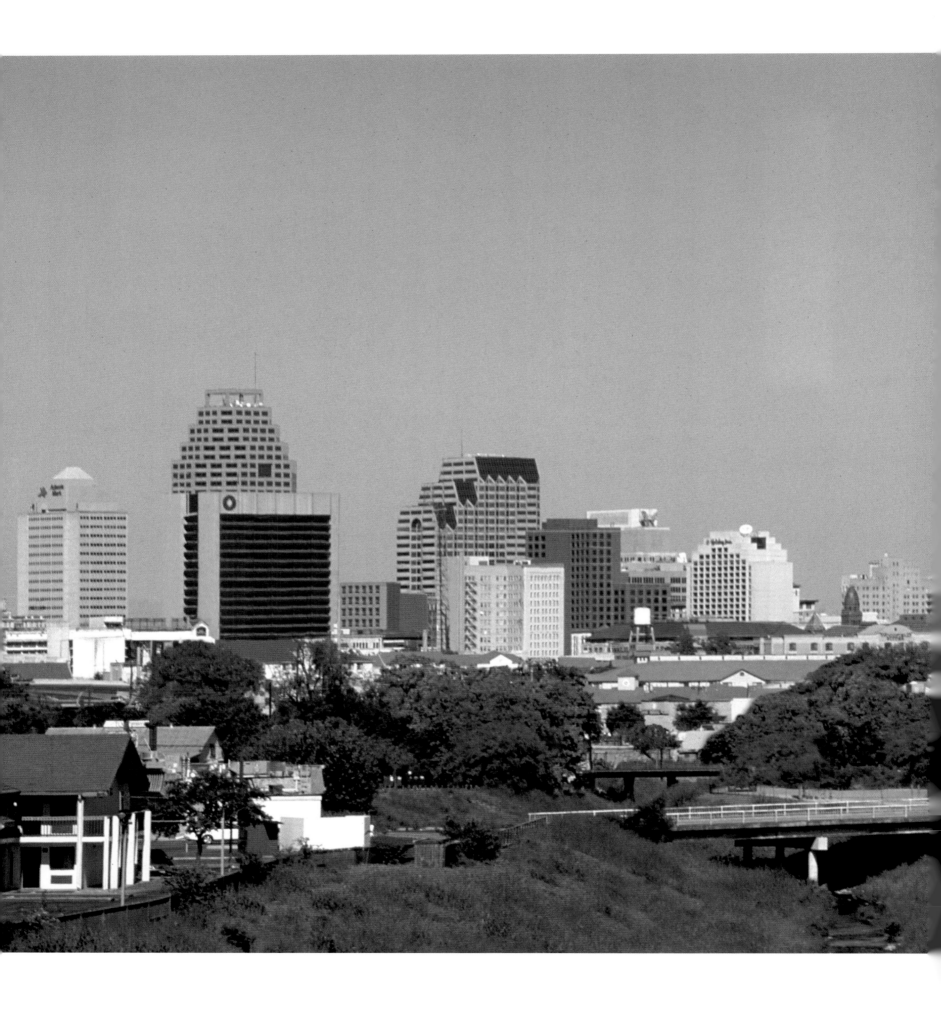

The sprawling metropolis of San Antonio was named after the Portuguese-born Saint Anthony of Padua, after the Spanish founded the city on his feast day in 1691. San Antonio has since grown into a vibrant city where the arts, the military, and cutting-edge medical research take center stage. Home to many museums, galleries, and festivals, San Antonio provided the first ever museum of modern art in Texas.

Scott Teven photo

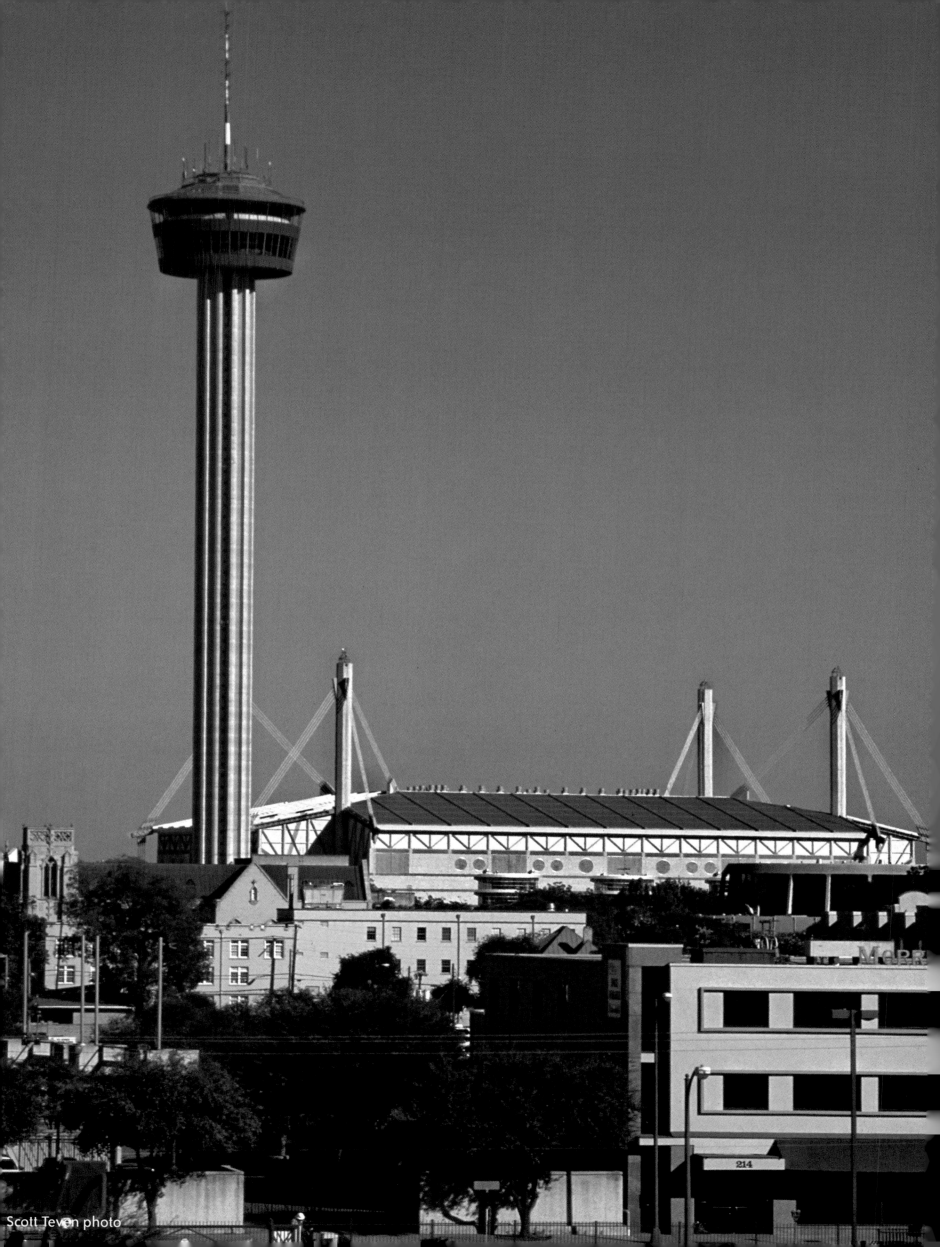

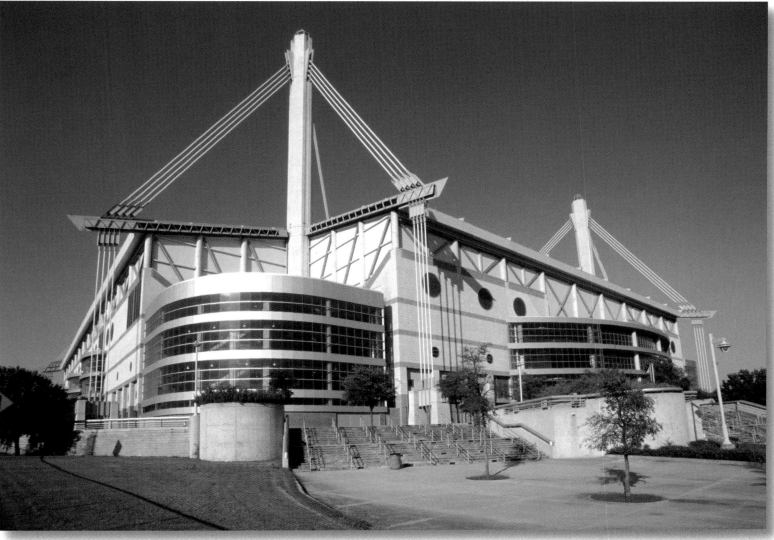

The Alamodome, which opened in 1993, hosted the NBA's San Antonio Spurs for nine seasons. This massive stadium, which holds up to 72,000 spectators, also served as home base for the NFL's San Antonio Texans. After Hurricane Katrina damaged the Louisiana Superdome in 2005, the Alamodome hosted three "home games" for the NFL's Louisiana Saints.

This 750-foot-tall observation tower was built as the theme structure for the 1968 World's Fair. Located in HemisFair Park in downtown San Antonio, the soaring Tower of the Americas offers exquisite views of the city. *(left)*

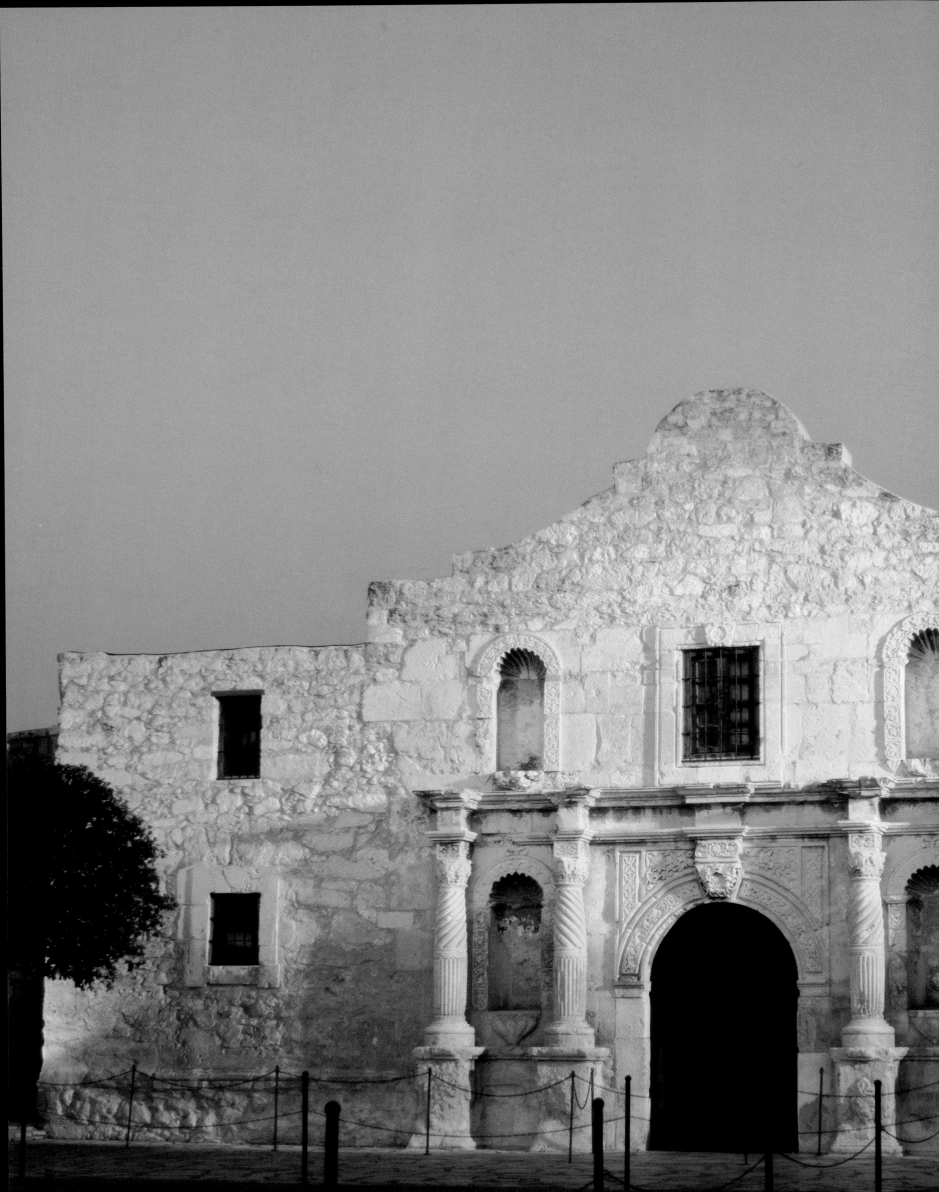

Once called the San Antonio de Valero Mission, the Alamo served as a Spanish mission for 70 years. It then became an important military fortress, hosting the Battle of the Alamo in 1836. Although the Mexican army took the Alamo site, and almost all the Texans defending it were killed or captured, the 13-day siege of the Battle of the Alamo is credited with stalling the Mexican army long enough to ensure Sam Houston's victory at San Jacinto, where Texan independence was won.

Jürgen Vogt photo

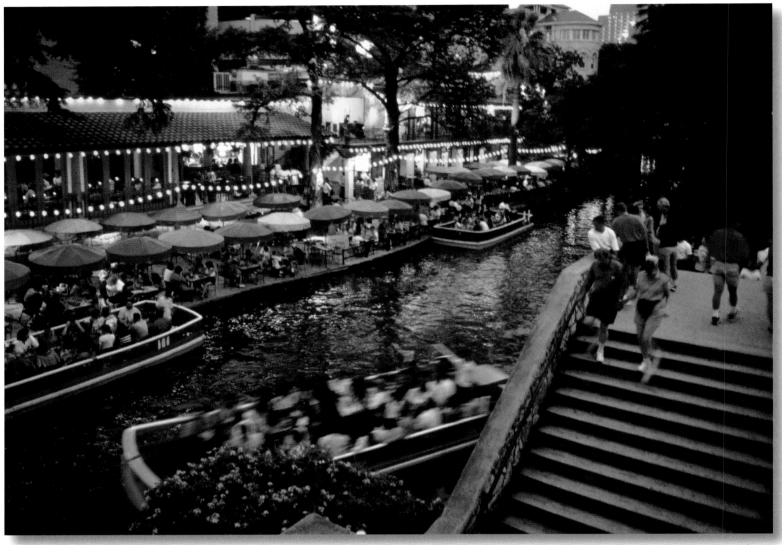

Scott Teven photo

San Antonio's River Walk, a popular entertainment district, comes alive at dusk. Its many restaurants and nightclubs make the scenic Paseo del Rio along the San Antonio River a bustling, fashionable area. Here, guests enjoy leisurely meals at the riverside cafés and restaurants, while boats meander down the river.

Colorful parasols line the scenic River Walk winding through downtown San Antonio. Also called the Paseo del Rio, this route along the San Antonio River provides an optimal place to sit and relax. Its many restaurants, bars, and cafés make Paseo del Rio a popular district. *(right)*

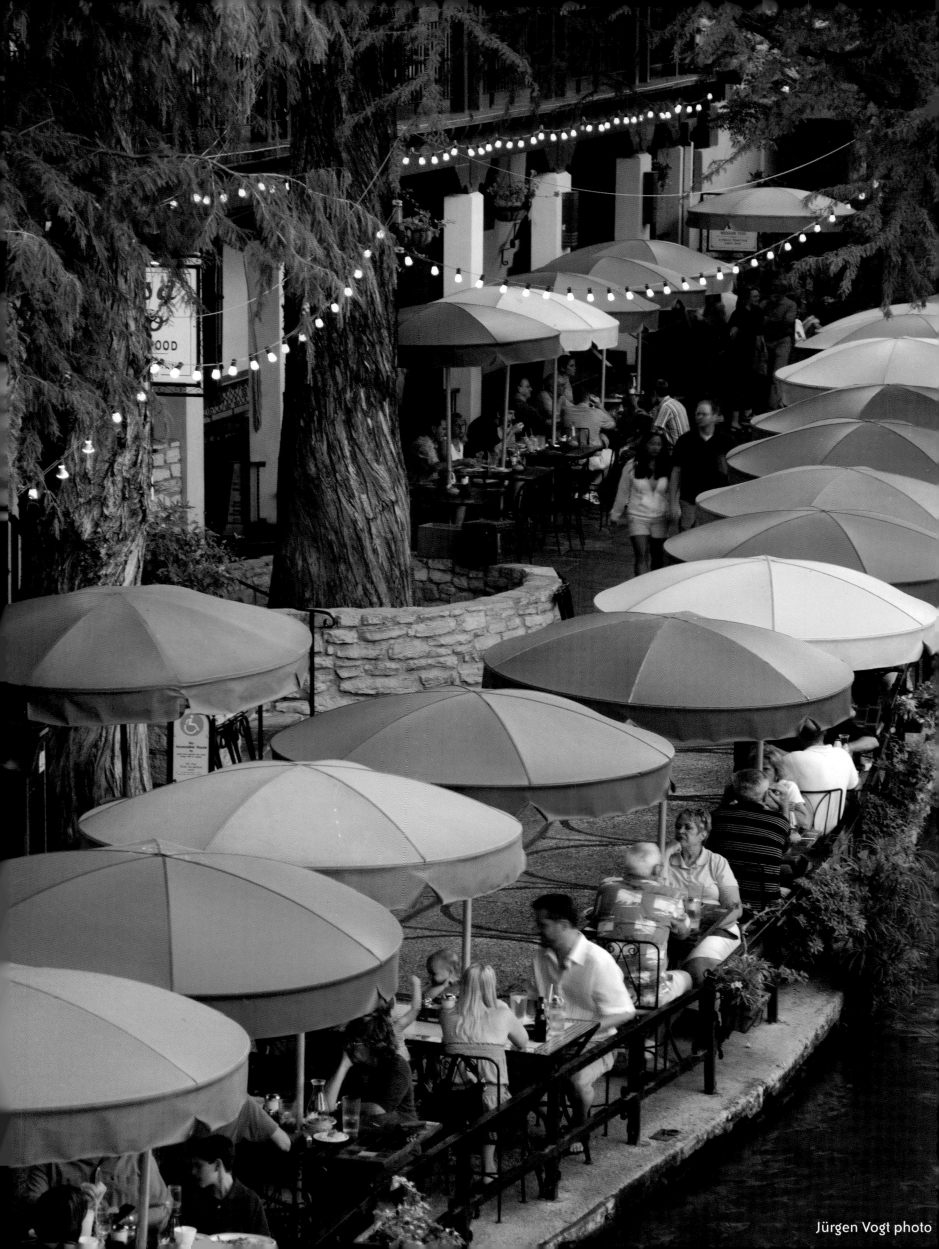

Jürgen Vogt photo

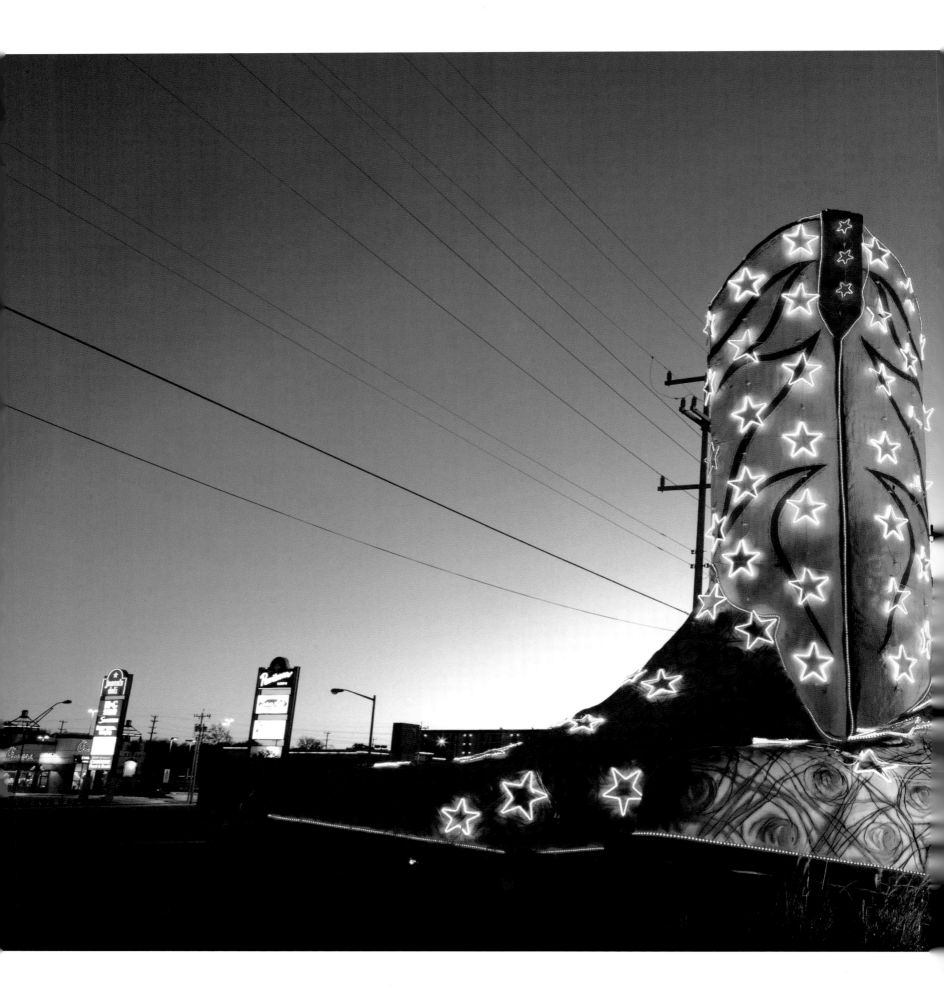

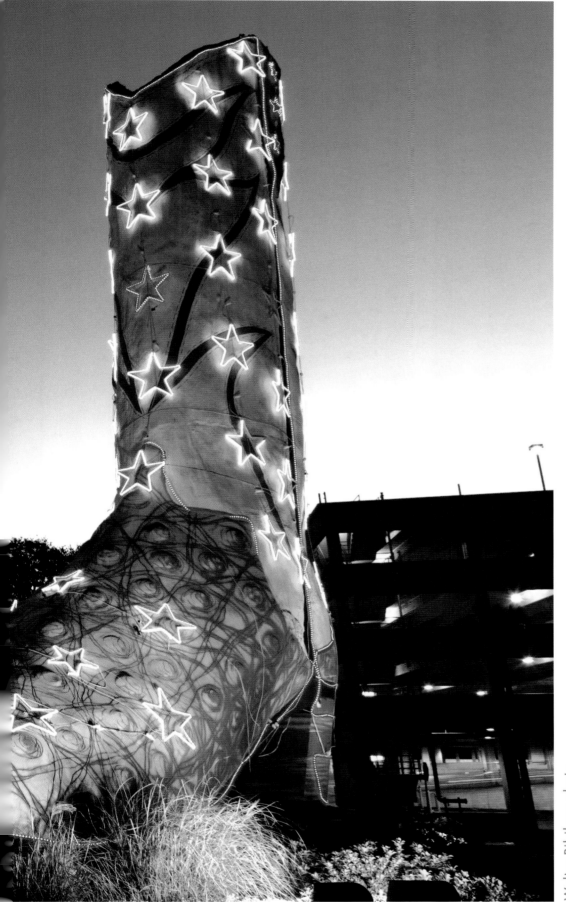

Giant stars on the world's biggest pair of cowboy boots illuminate the dusk. Standing their ground in front of San Antonio's North Star Mall, these massive boots measure 40 feet tall and 35 feet wide. Created by Bob "Daddy-O" Wade, this quintessentially Texan sculpture was installed in 1980.

Walter Bibikow photo

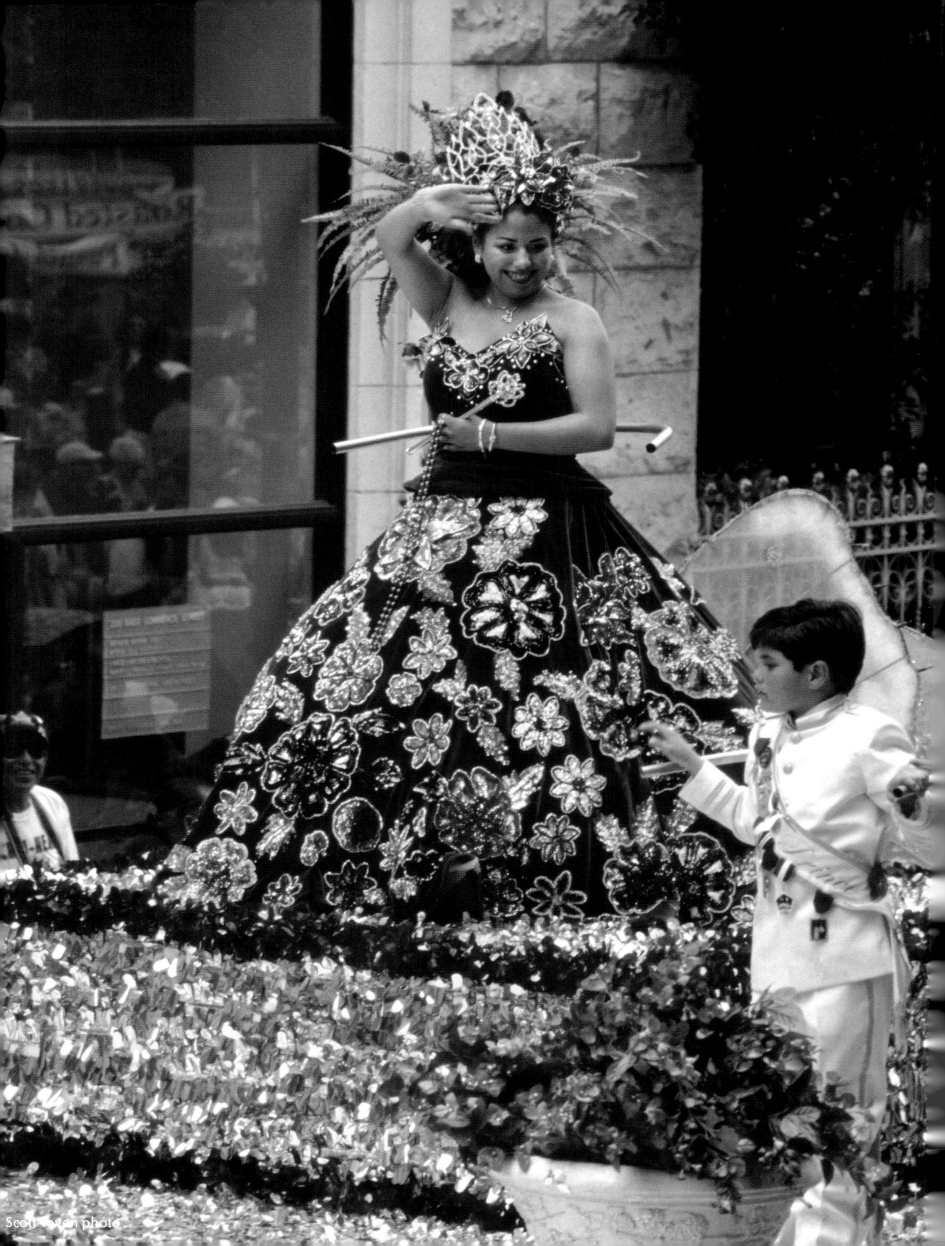

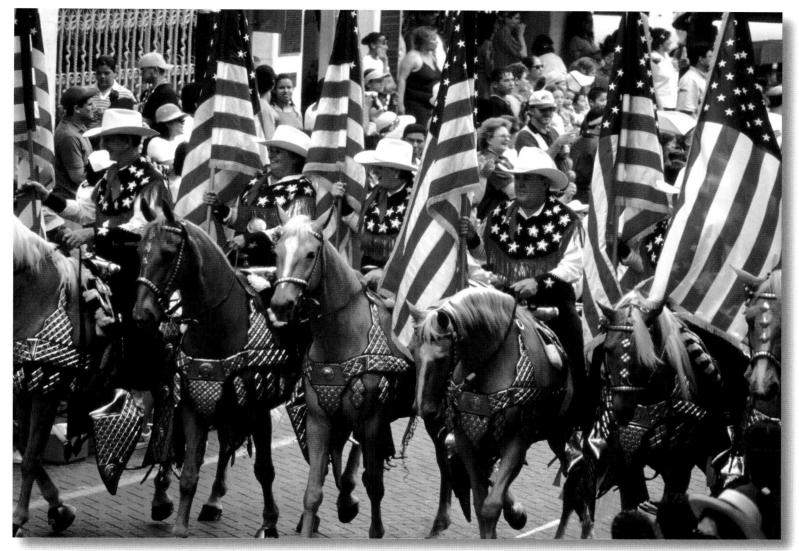

One of the main attractions during the Battle of the Flowers Parade at the Fiesta San Antonio is this dignified Bexar County Palomino Patrol. Sporting full regalia this cavalcade is a perennial favorite with the audience. Each horse in the patrol carries over 200 pounds of silver, including handmade saddles, bridles, breast collars, hip drops, and serapes.

Adorned with colorful flowers, this parade queen rides a float in the Battle of the Flowers Parade, one of the main attractions at the annual Fiesta San Antonio. This 10-day festival celebrates Texas' independence from Mexico and honors those who fought at the Battle of the Alamo and the Battle of San Jacinto. *(left)*

Prominent Mexican sculptor Sebastian created this 65-foot-tall bright red sculpture located in downtown San Antonio. Dedicated in 2002, the Torch of Friendship symbolizes the harmony between Mexico and the U.S. This modern artwork was given to the city of San Antonio by the Asociación de Empresarios Mexicanos en San Antonio, the Mexican General Consulate, and the Instituto Cultural Mexicano.

Richard Cummins photo

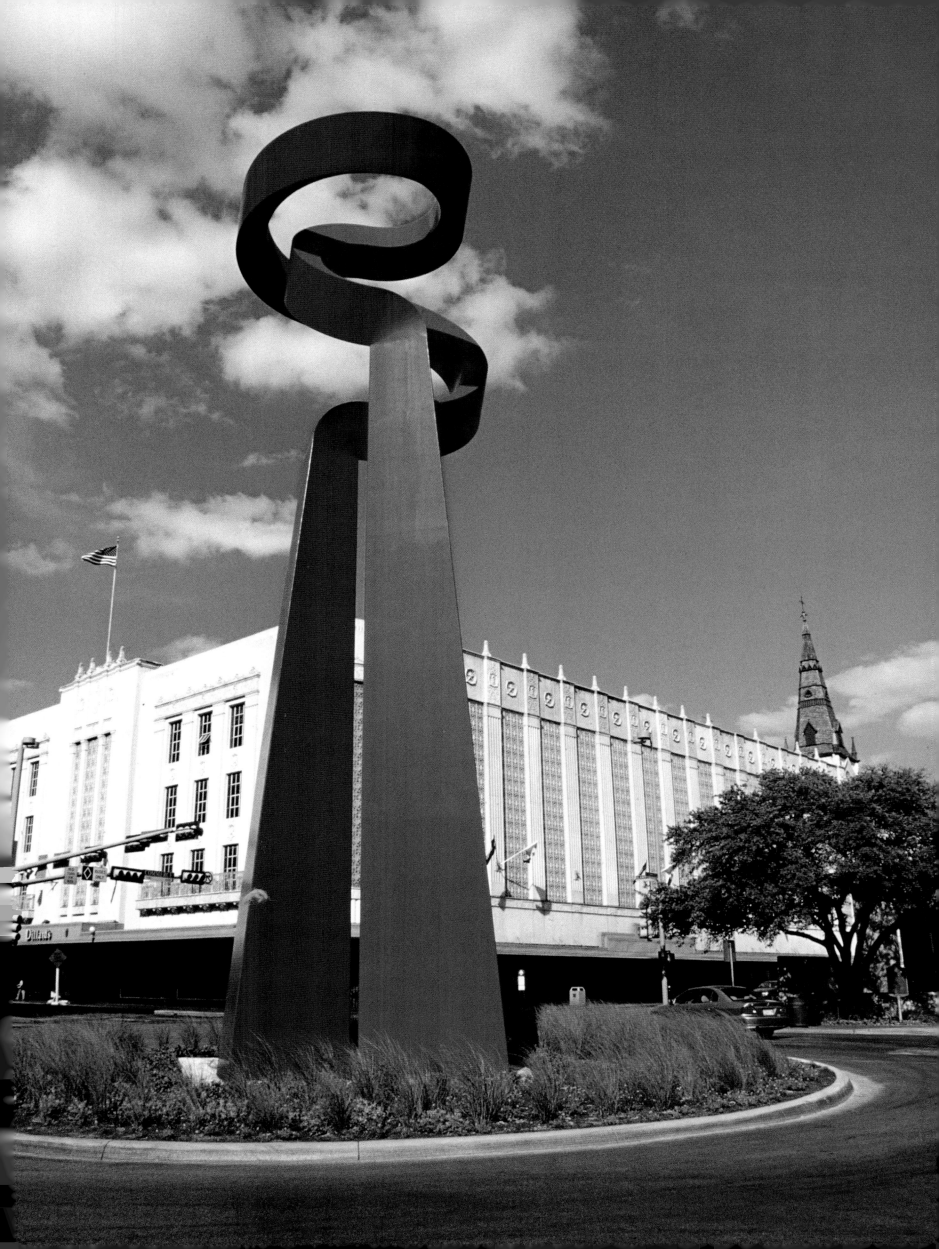

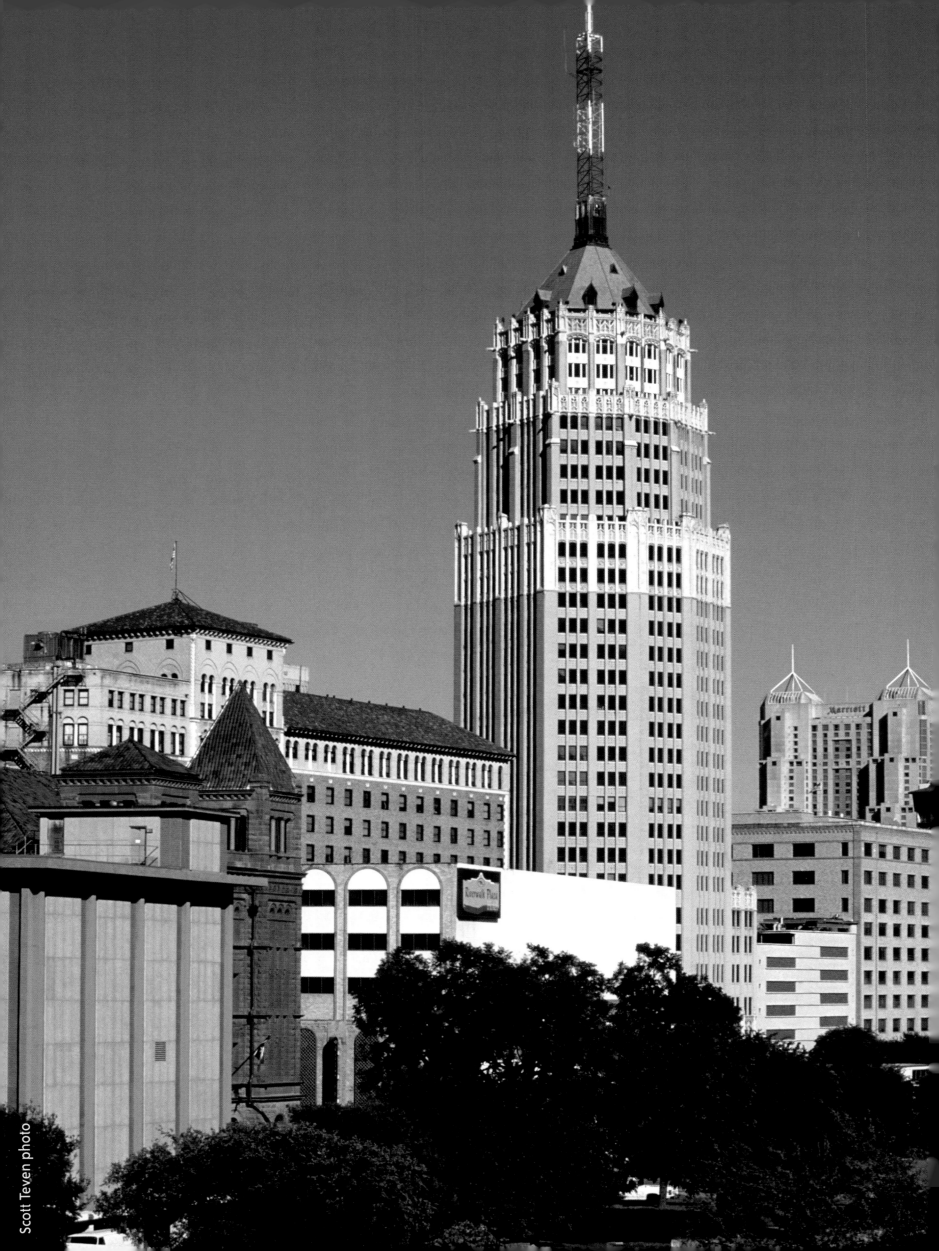

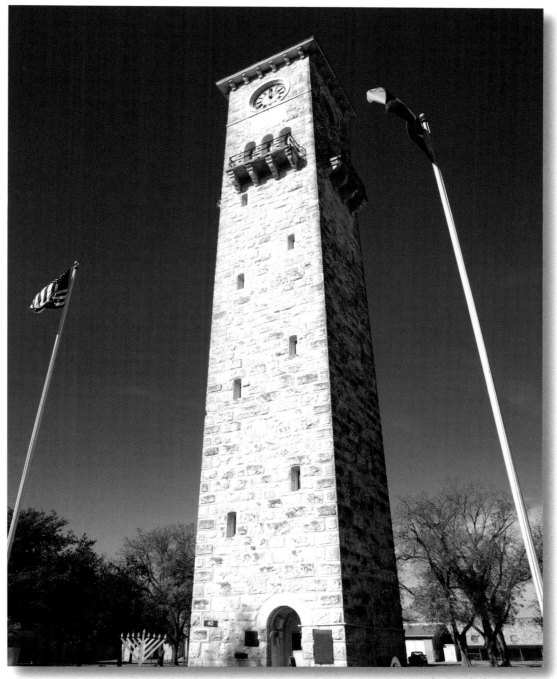

Walter Bibikow photo

This fort is the oldest building at the Fort Sam Houston in San Antonio. The tower was initially built in the late 1870s to hold a large water tank. The Seth Thomas Clock, a weight-driven clock that needs to be wound once a week, was added later. Today, Fort Sam Houston, designated a National Historic Landmark in 1975, is still used by the U.S. Army.

Once the tallest building in San Antonio, the Tower Life building cuts a stately profile in the city's skyline. Completed in 1929 and standing 404 feet tall with 30 storeys, this soaring edifice was San Antonio's highest structure for 59 years until the Marriot Rivercenter was built in 1988. The Tower Life building was placed on the National Register of Historic Places in 1991. *(left)*

Winding through downtown, this riverside walkway, known as the Paseo del Rio, features an extensive network of bike paths and pedestrian streets. The Paseo del Rio was built to avoid the risk of the San Antonio River flooding the city.

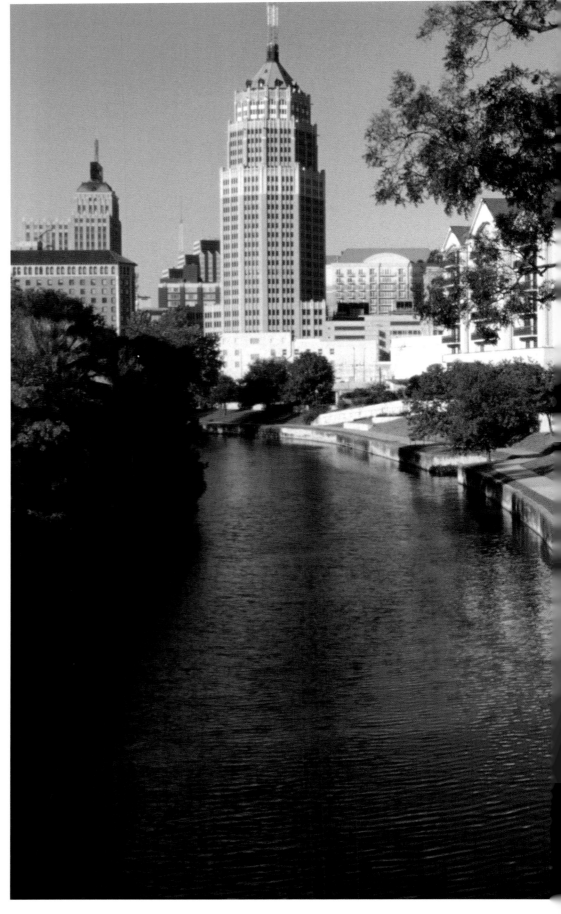

Scott Teven photo

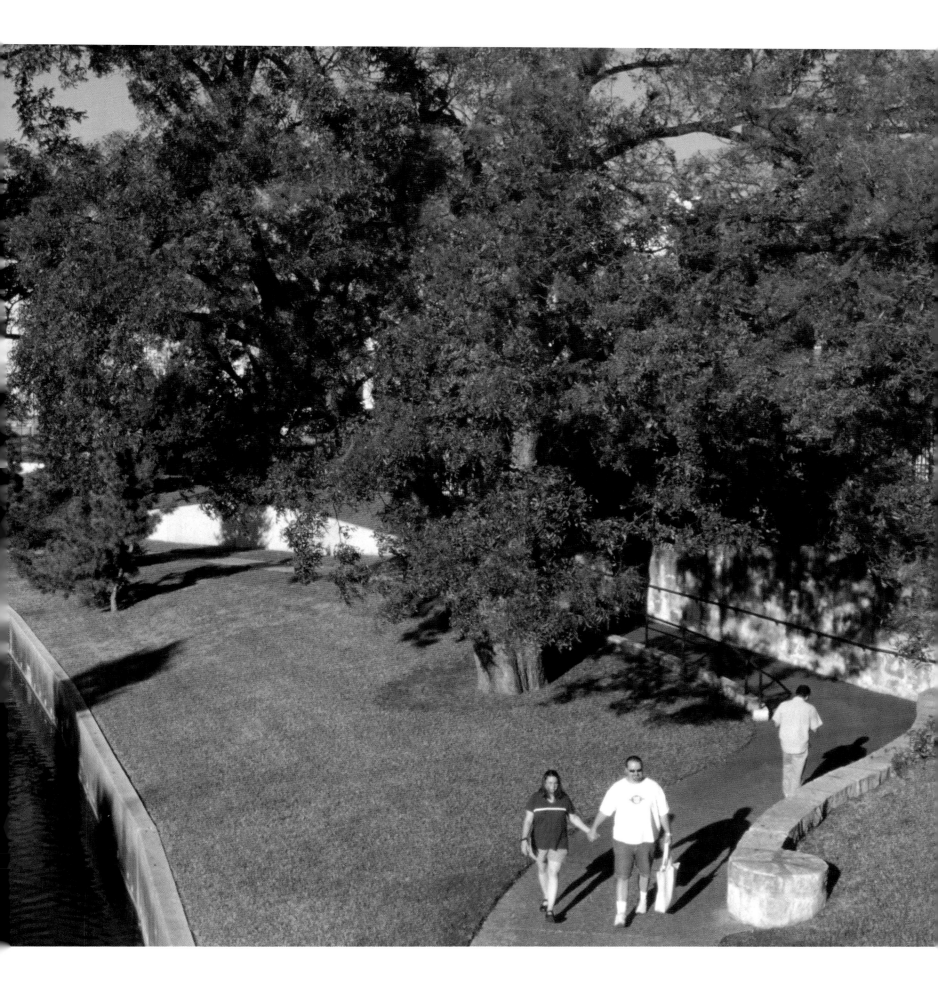

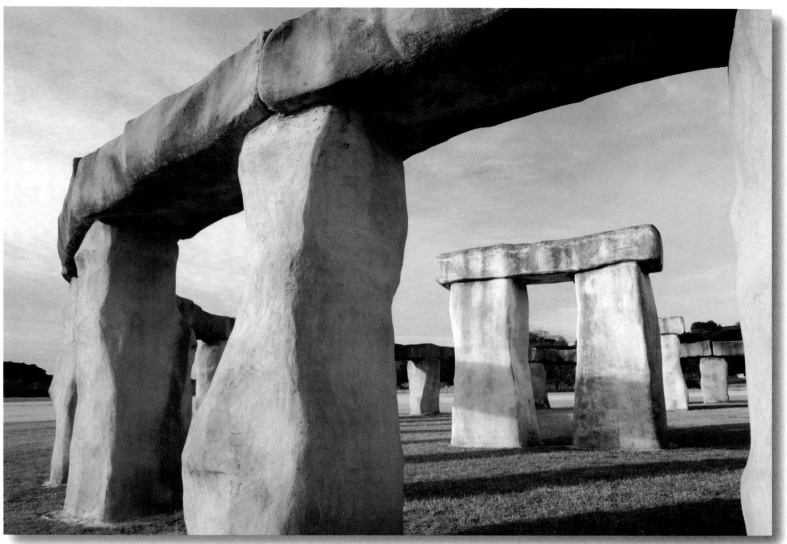

Stonehenge is one the world's great prehistoric mysteries. With more obvious origins, this replica in Hunt, Texas, is much younger than its namesake. Retired oilman Al Sheppard built Stonehenge II after he was given a slab of limestone for his birthday. It's the only piece of stone in the Stonehenge replica and its neighboring busts of the Moai heads of Easter Island. The rest is made of steel, metal mesh, plaster, and cement.

Although this site looks like Easter Island, Chile, it's actually a backyard replica located in Hunt, Texas, of the Moai heads at Rapa Nui. Sitting on the same site as another monumental reproduction, Stonehenge II, this 13-foot head was built with steel, metal mesh, plaster, and cement. *(left)*

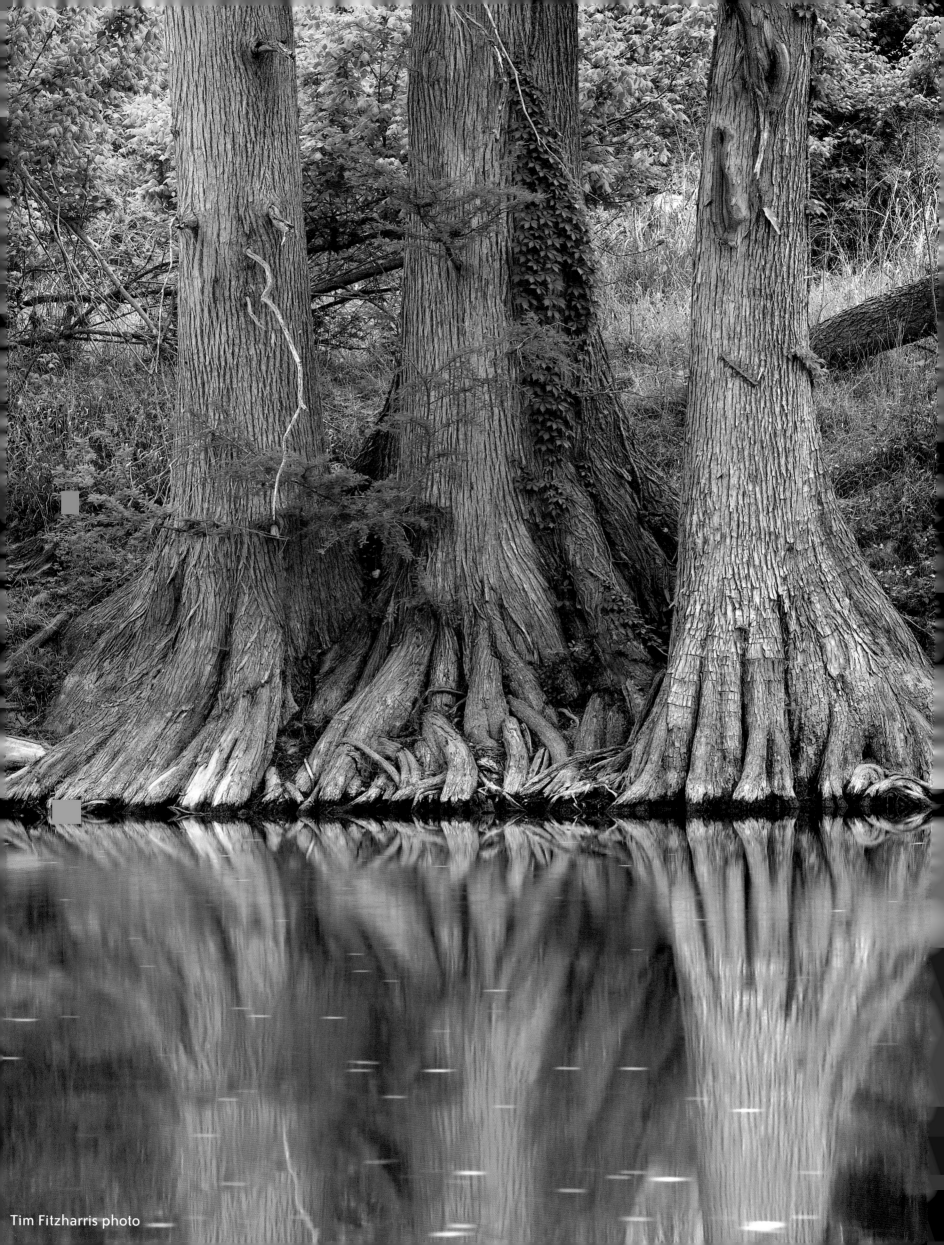

Tim Fitzharris photo

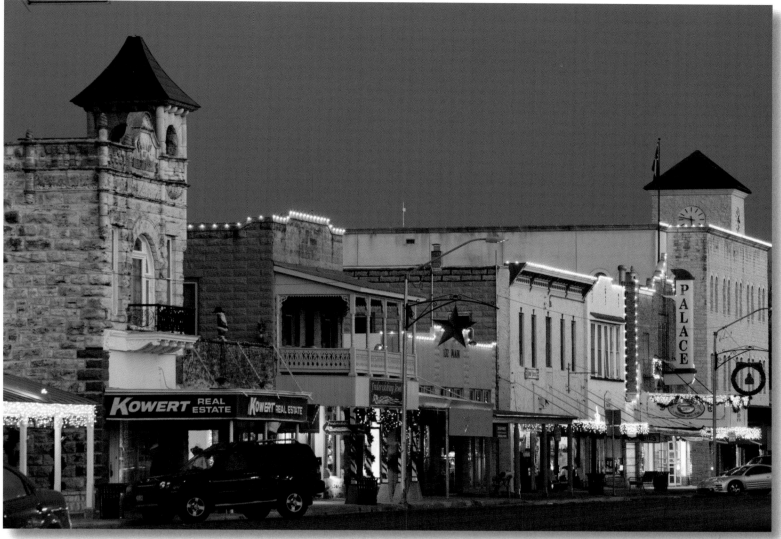

The origins of Texas German can be traced back to the quaint little town of Fredericksburg. Invented by the area's first settlers, the now-extinct language was a fairly even blend of English and German. These settlers are also remembered for refusing to own slaves and for signing the only Indian-Anglo treaty that is still in existence today.

Massive bald cypress trees line the banks of the Guadalupe River. Other trees that flank this river as it flows through Guadalupe River State Park are sycamore, elm, basswood, pecan, walnut, persimmon, and willow. Opened to the public in 1983, this park's 1,900 acres, home to many species of flora and fauna, are known for their rugged beauty. *(left)*

Over 2,000 acres of beautiful, rugged terrain are preserved here at Lost Maples State Park, opened to the public in 1979. This park's landscape ranges from jagged limestone canyons and grasslands to forests and clear streams. Before this area was settled in the 19th century, the Apache, Lipan Apache, and Comanche peoples roamed here freely.

These stately bald cypresses at Caddo Lake State Park are just part of the area's rich tapestry. The lush terrain around Caddo Lake is home to alligators, turtles, frogs, snakes, raccoons, minks, and white-tailed deer. Caddo Lake, which supports over 70 species of fish, was the only natural lake in Texas until it was dammed in the early 20th century for flood control. *(overleaf)*

Tim Fitzharris photo

There is much more to Dallas than the big hair, oil barons, and cowboy hats made infamous by the hit TV series "Dallas," which aired from 1978 to 1991. In fact, Dallas is a burgeoning metropolis that combines industry with world-class culture. A hub of the oil industry, telecommunications, computer technology, and transportation, Dallas also boasts an outstanding culinary scene and a first-rate arts district. The third largest city in Texas, versatile Dallas lives up to its slogan — Live Large. Think Big.

Jürgen Vogt photo

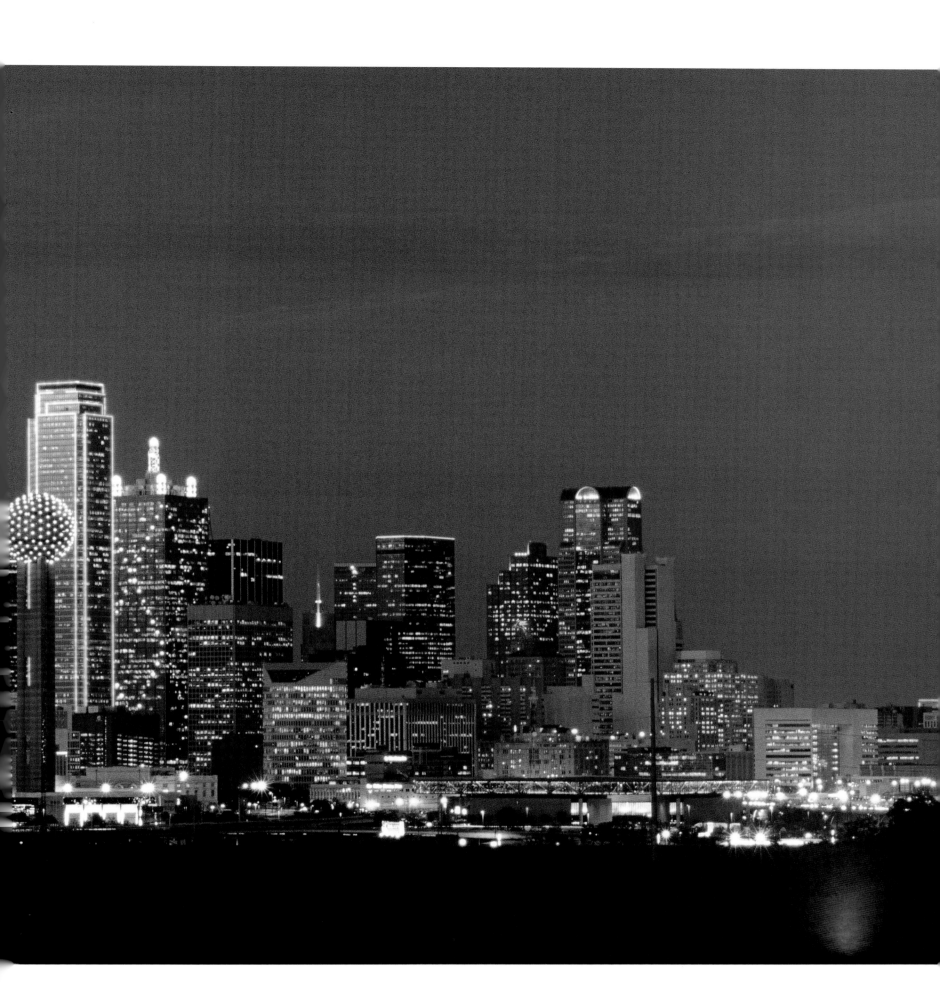

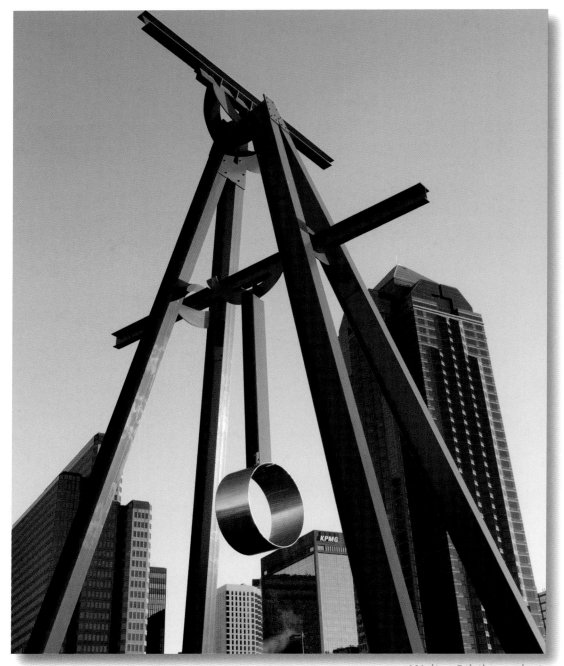

This extraordinary sculpture, Proverb, by Mark di Suvero, was on display in downtown Dallas courtesy of the Nasher Sculpture Center. Built as an art oasis in the middle of the city, the center features rotating installations of the Nasher's extensive private art collection as well as visiting exhibitions.

The dramatic colors of a Texan sunset are reflected in the Reunion Tower and the Hyatt Regency Hotel. Atop the 560-foot-tall Reunion Tower is a geodesic dome with 260 lights, a prominent feature of the Dallas skyline. Completed in 1978, Dallas' 15th tallest building features three levels at its peak, housing an observation deck, a restaurant, and a cocktail lounge. (*right*)

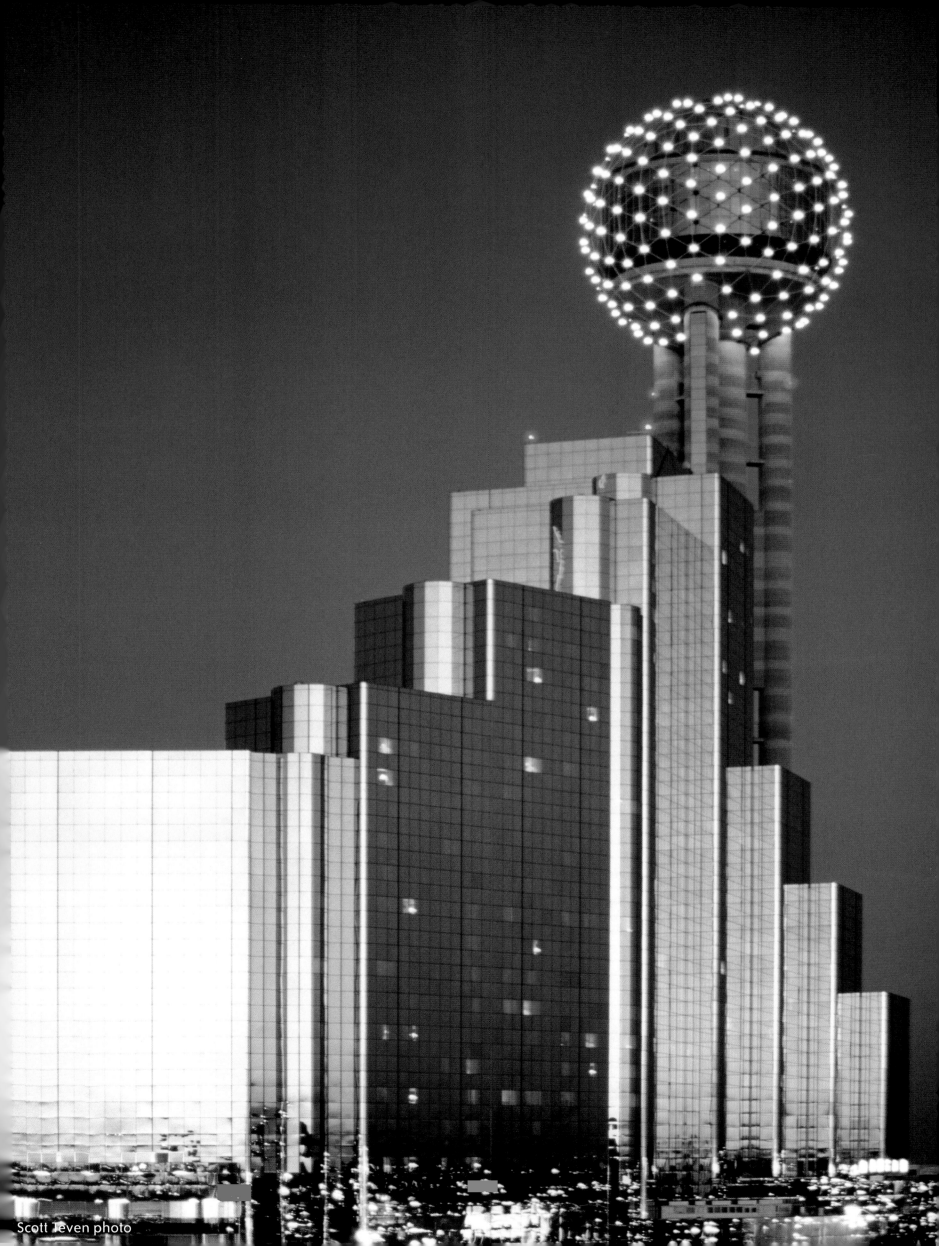

The Dallas Aquarium, housed in this art deco building, opened in 1936 as part of the Texas Centennial celebrations. It features thousands of species of aquatic animals. Among the marine and freshwater fish, reptiles, amphibians, and invertebrates are lionfish, alligators, electric eels, seahorses, and jellyfish.

Richard Cummins/Folio photo

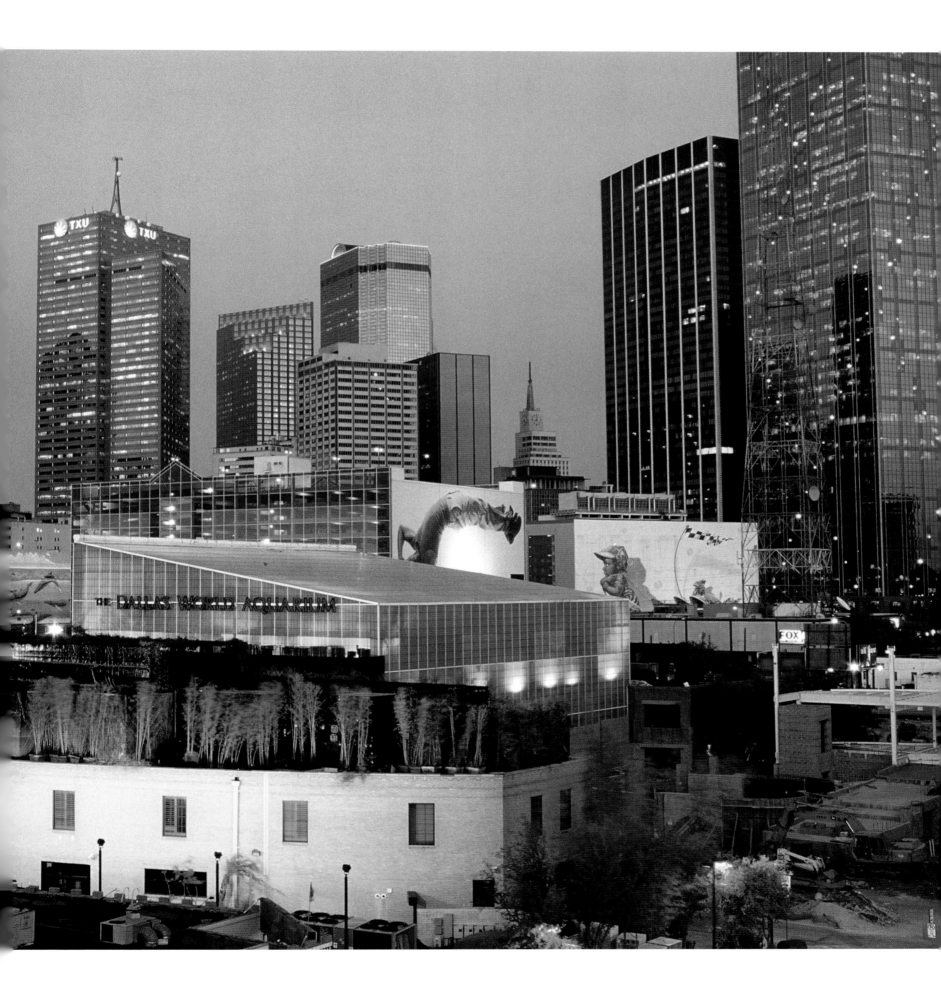

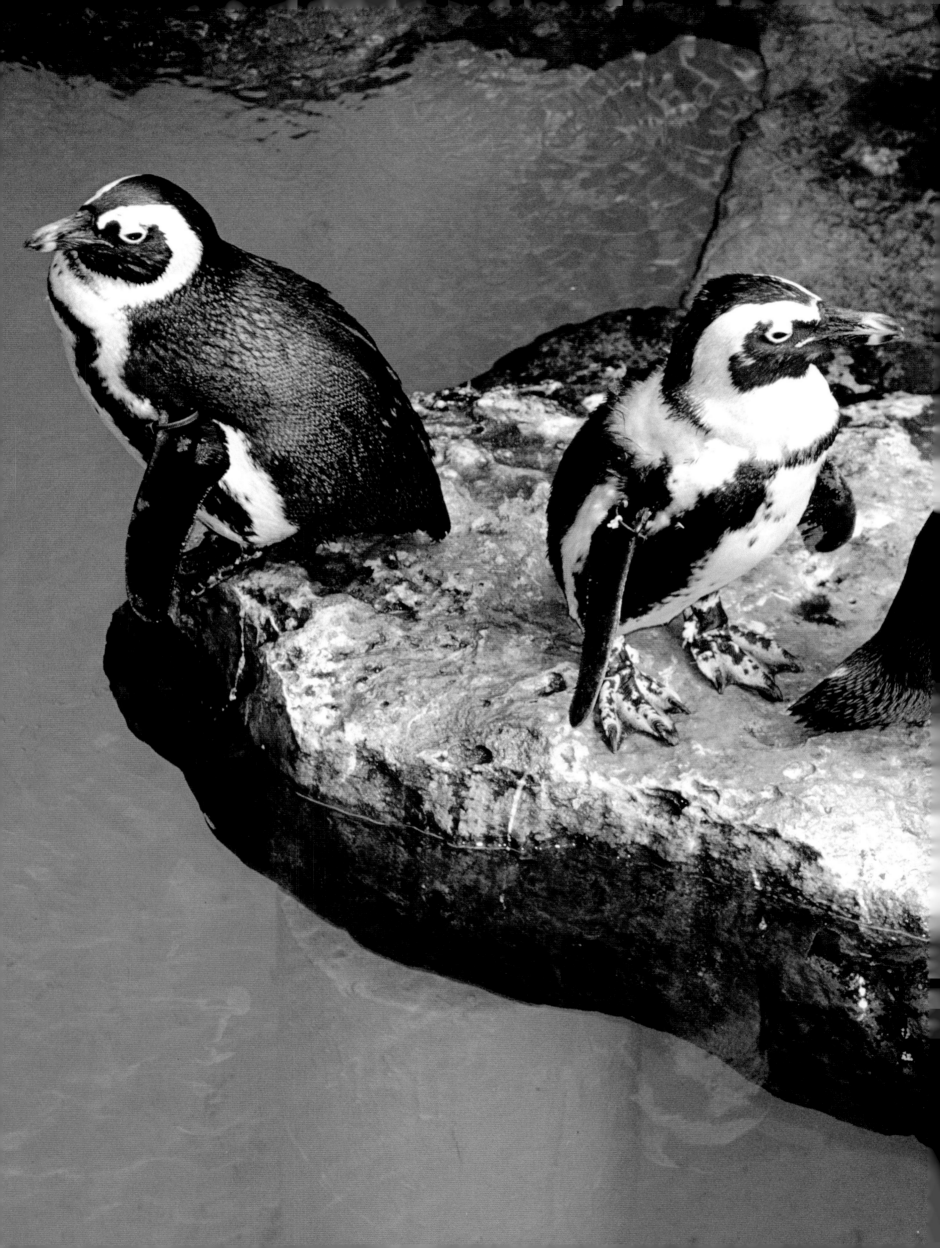

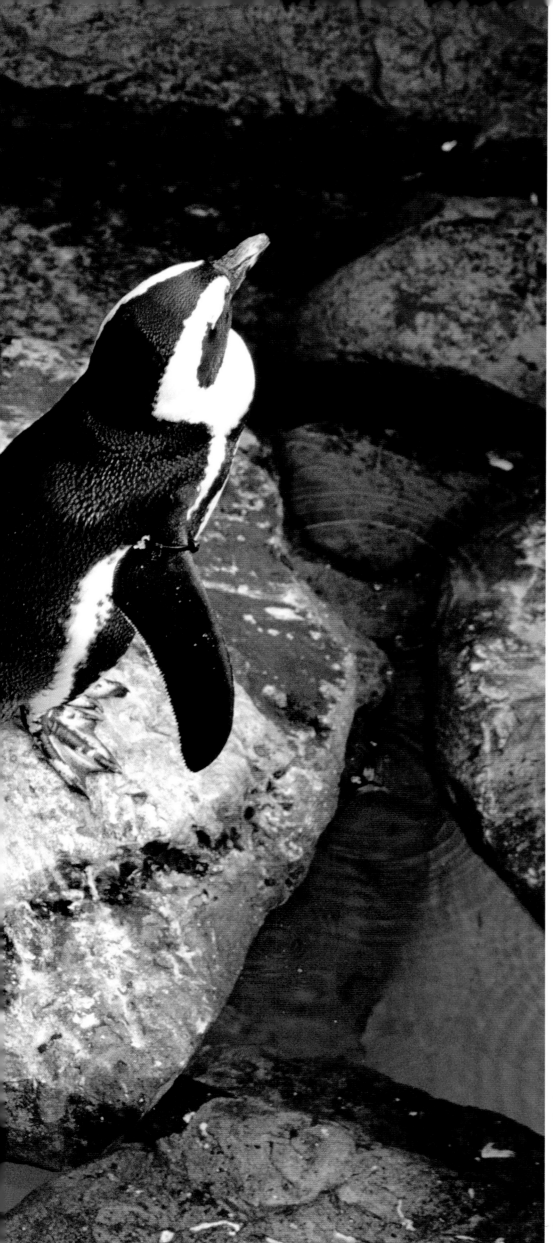

These black-footed penguins call the South African exhibit of the Dallas Aquarium home. Sub-tropical birds that can swim up to 20 miles per hour, they live in an outdoor 30,000-gallon aquarium.

Sitting in the middle of downtown Dallas, this landmark county courthouse is the sixth building and fifth county courthouse to occupy this site. Completed in 1893, Old Red was designed in the Romanesque style. This historic building is a testament to the people of Dallas who, in 1938, defeated a proposal to demolish Old Red and replace it with a modern structure.

Scott Teven photo

128

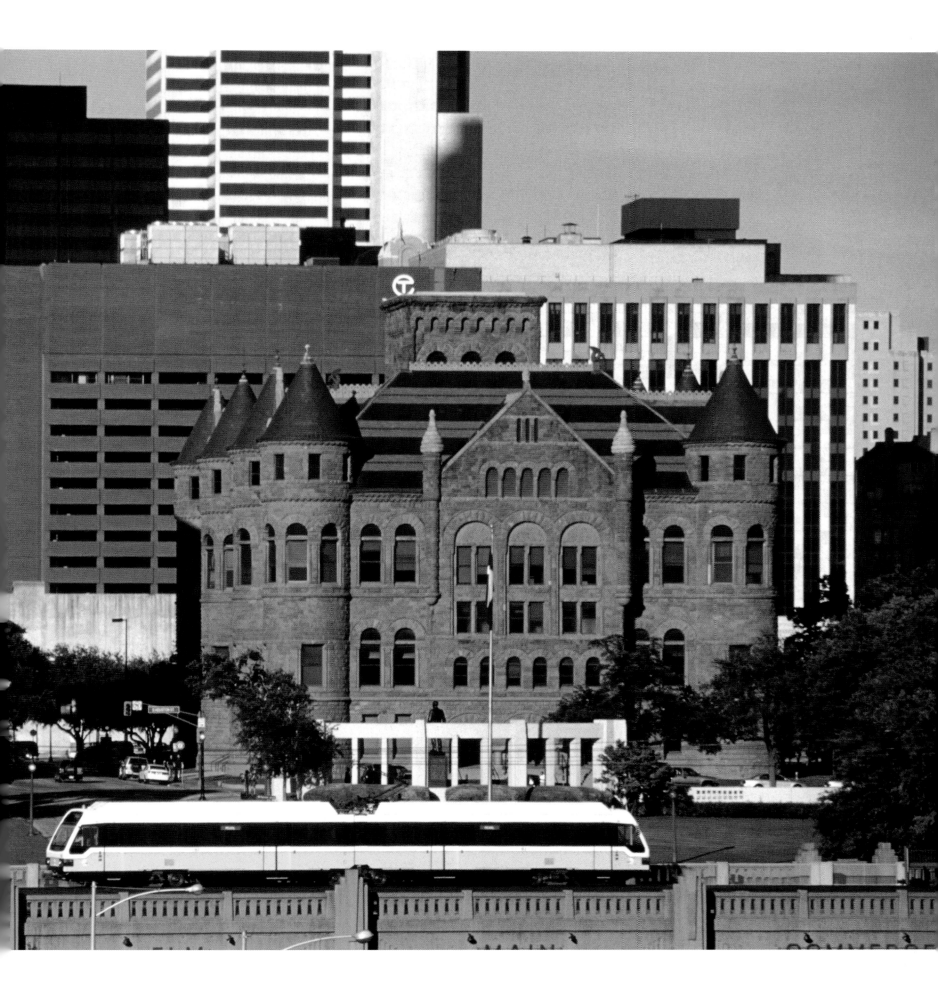

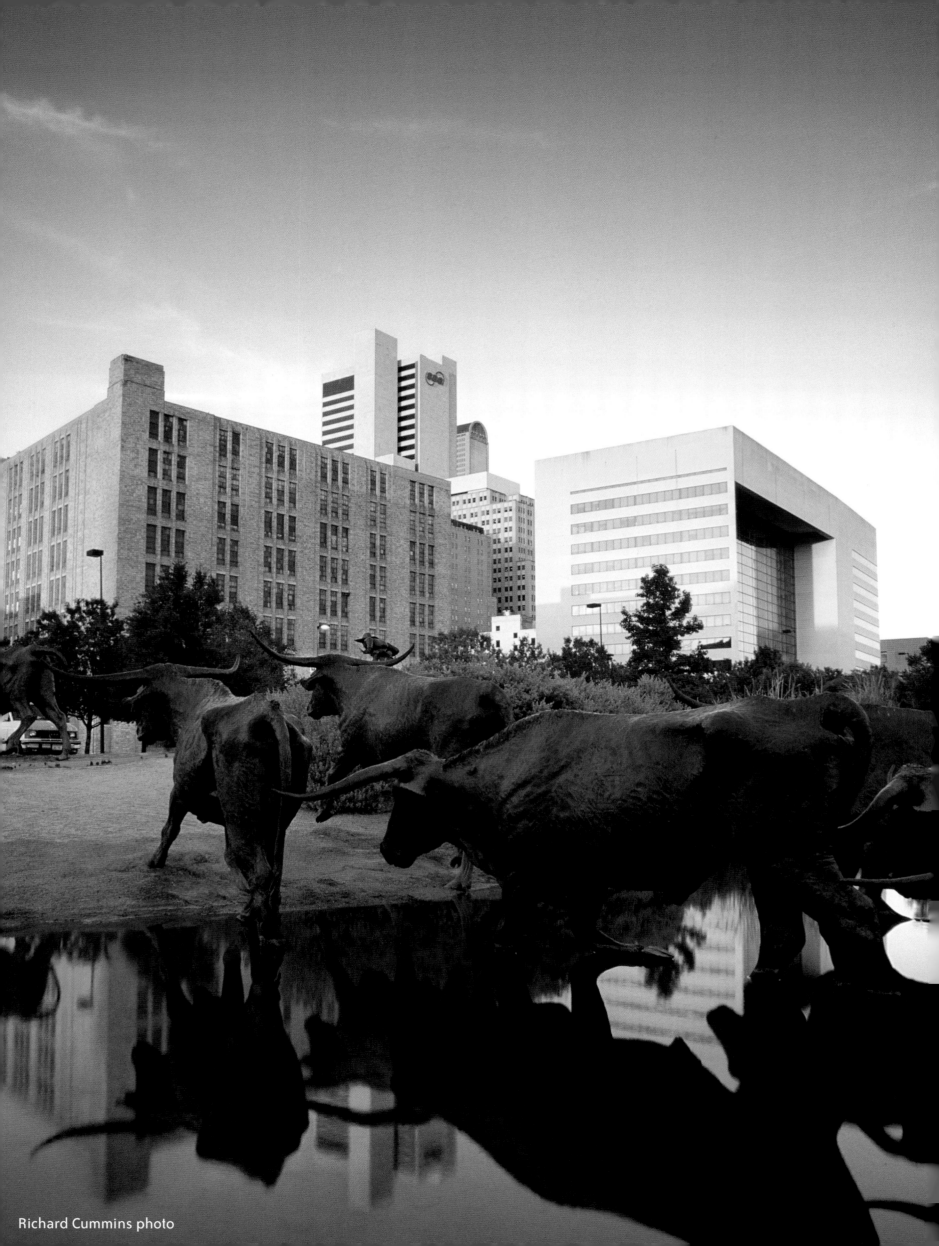

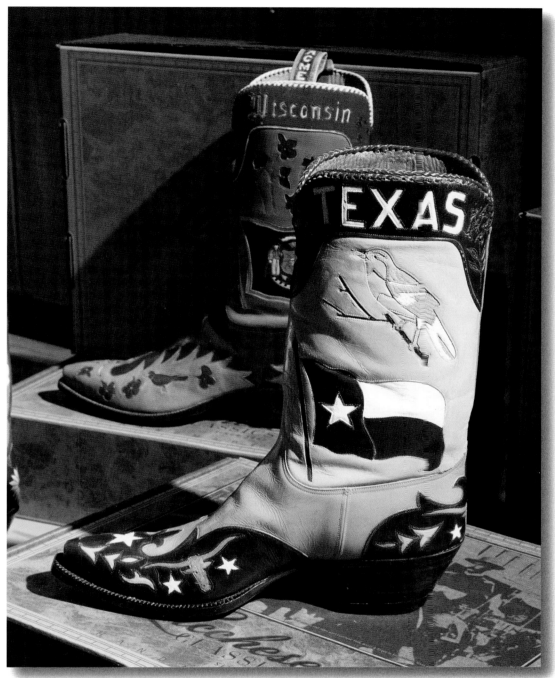

Quintessentially Texan, these cowboy boots adorned with the state flag are on display at the Texas State Fair. This yearly celebration in Dallas features musicians, a garden exhibit, an auto show, and a livestock competition.

This massive commemorative sculpture in Pioneer Plaza features 40 bronze longhorn cattle being herded by three cowboys on horses. Built by Robert Summers of Glen Rose, Texas, this artwork pays tribute to the spirit that brought settlers here to Dallas. Pioneer Plaza, located in front of the Dallas Convention Center, is the city's largest public green space. *(left)*

Here at the Fort Worth Exhibition Center, the famous Fort Worth Stock Show and Rodeo, the nation's oldest event of its kind, is well underway. Since 1896, the best of the Wild West have gathered here to showcase their skills in the championship rodeo competition. Also featured are chuck wagon races and a livestock exhibition.

This elegant locomotive — which earned its nickname of the Tarantula Train because an early map of its tracks resembled a giant spider — was built in 1896 for Southern Pacific. Today, visitors can experience 19th-century train travel by riding the Tarantula between Grapevine Vintage Railroad Station and the Stockyards National Historic District in Fort Worth.

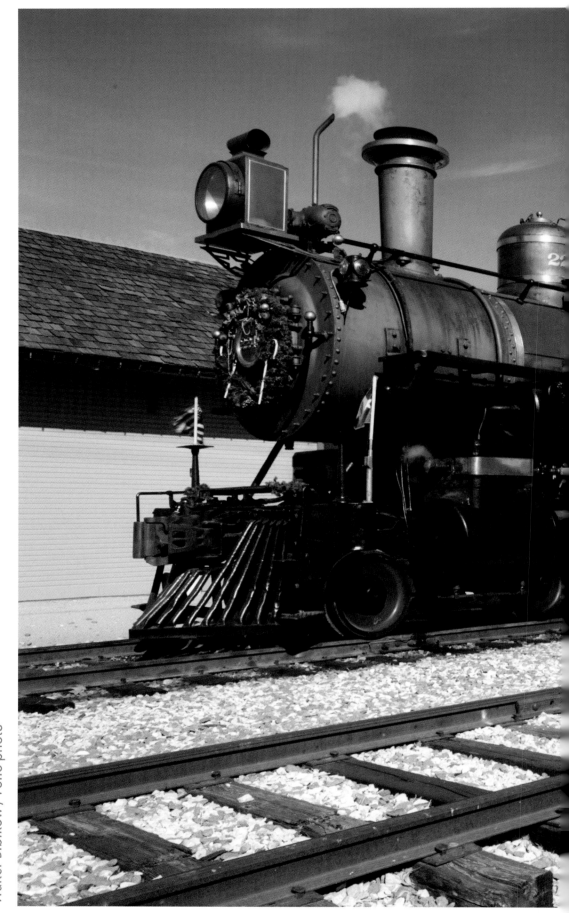

Walter Bibikow / Folio photo

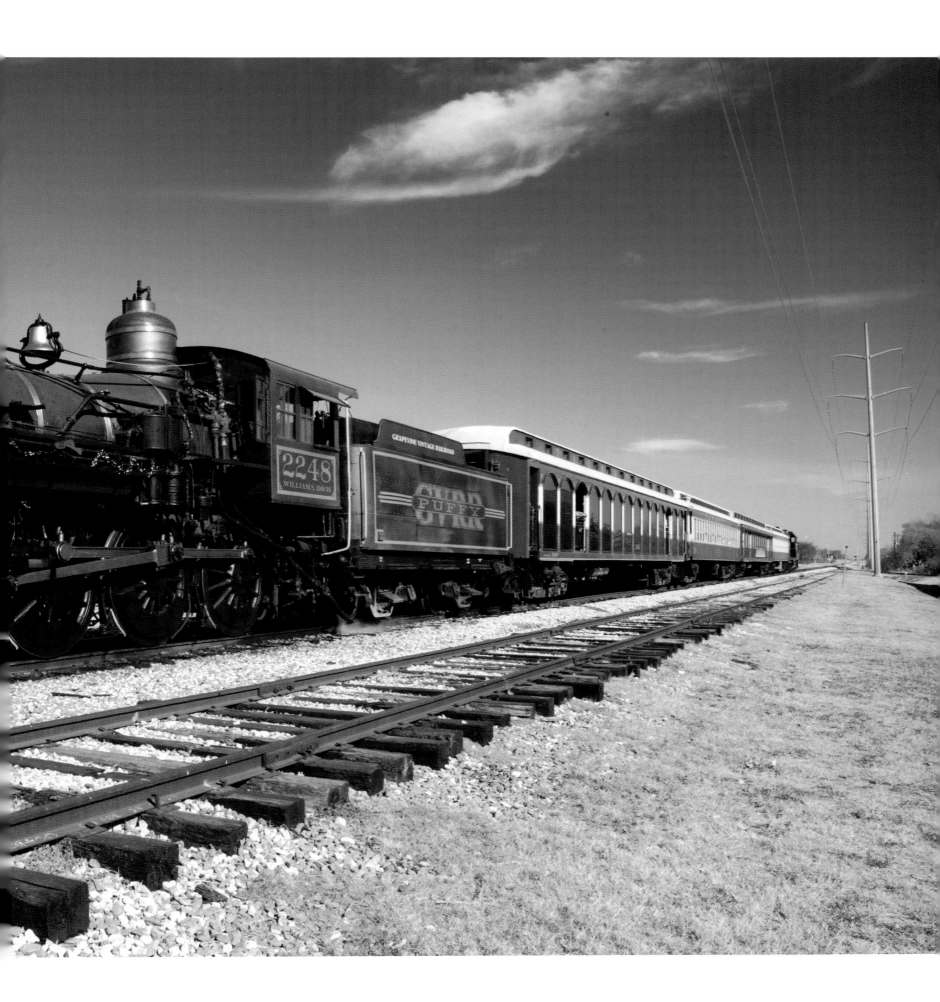

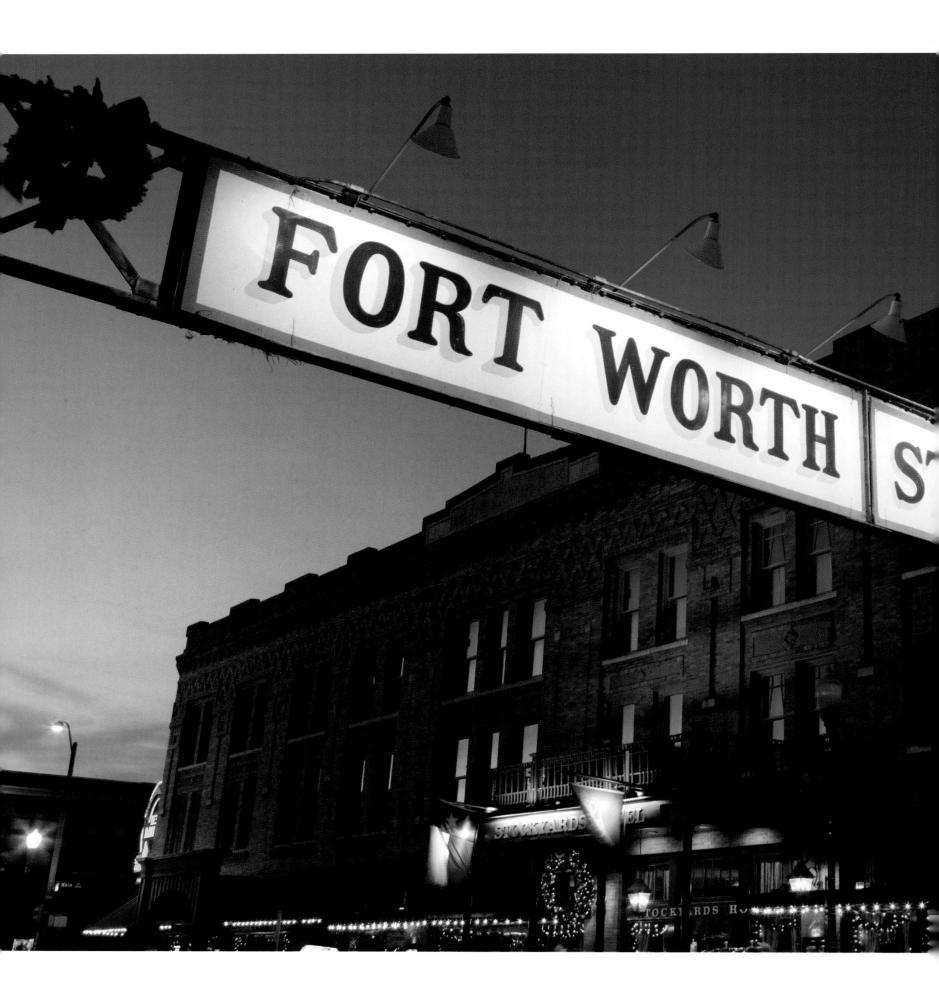

Designated a historic district in 1976, the Fort Worth Stockyards were once the hub of the Texan cattle industry. When the railroad was built through Fort Worth in 1876, this stockyard shipped livestock, and the area became an important breeding center until the 1960s. Today, the many restaurants, bars, and shops in the stockyards, notably the western-themed Billy Bob's Texas, maintain the area's wild west character.

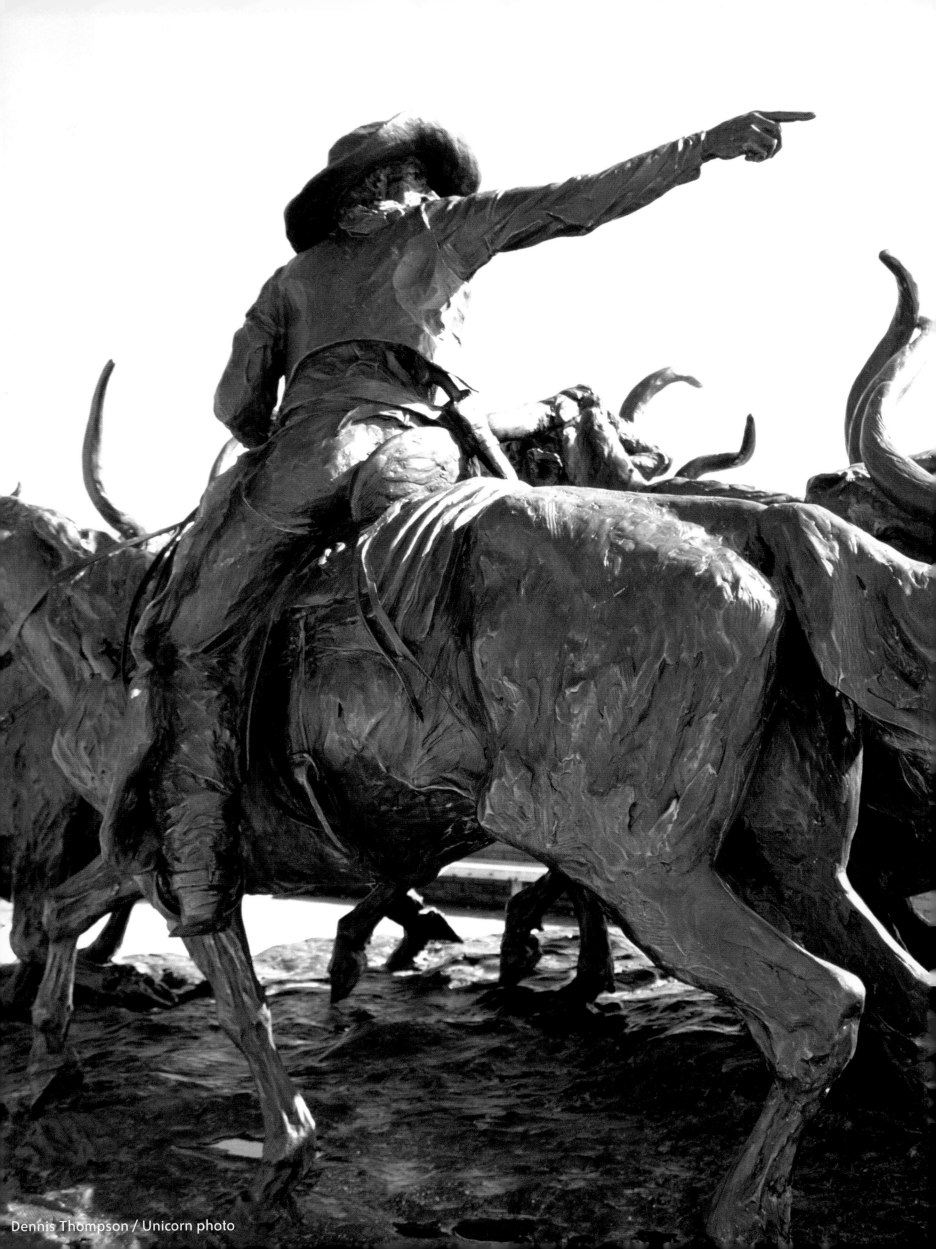

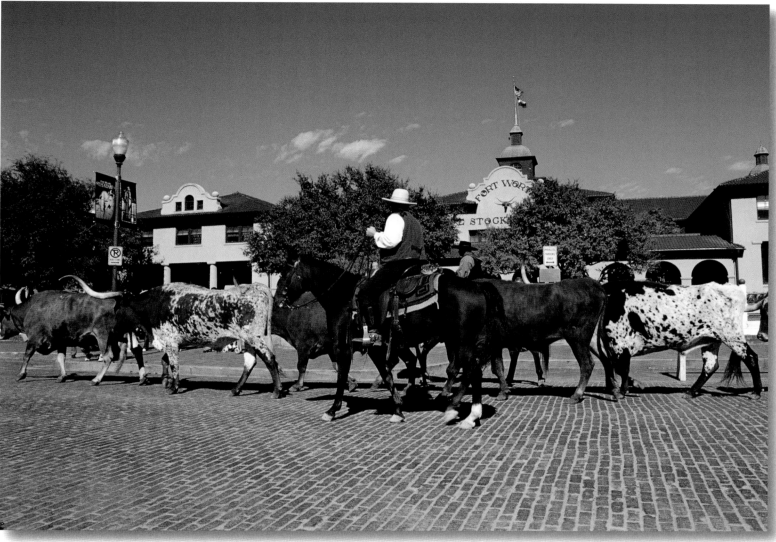

The only daily longhorn cattle drive in the U.S., the Fort Worth Herd recalls the Wild West. Originating in the U.S. in the 19th century, cattle drives usually had one cook, one cowboy, and one wrangler for every 250 to 300 cows.

This sculpture of a cowboy wrestling a steer commemorates Fort Worth's history as a hub for livestock breeding, riding, and exhibiting. Nicknamed Cowtown because of its history as the terminus of the Chisholm Cattle Drive Trail, Fort Worth lived up to its motto: Where the West Begins. *(left)*

The bright red of the Texas Indian paintbrush colors the fields of this ranch near Llamo, Texas. This glorious wildflower, which grows all over Texas, is an important source of nectar for hummingbirds.

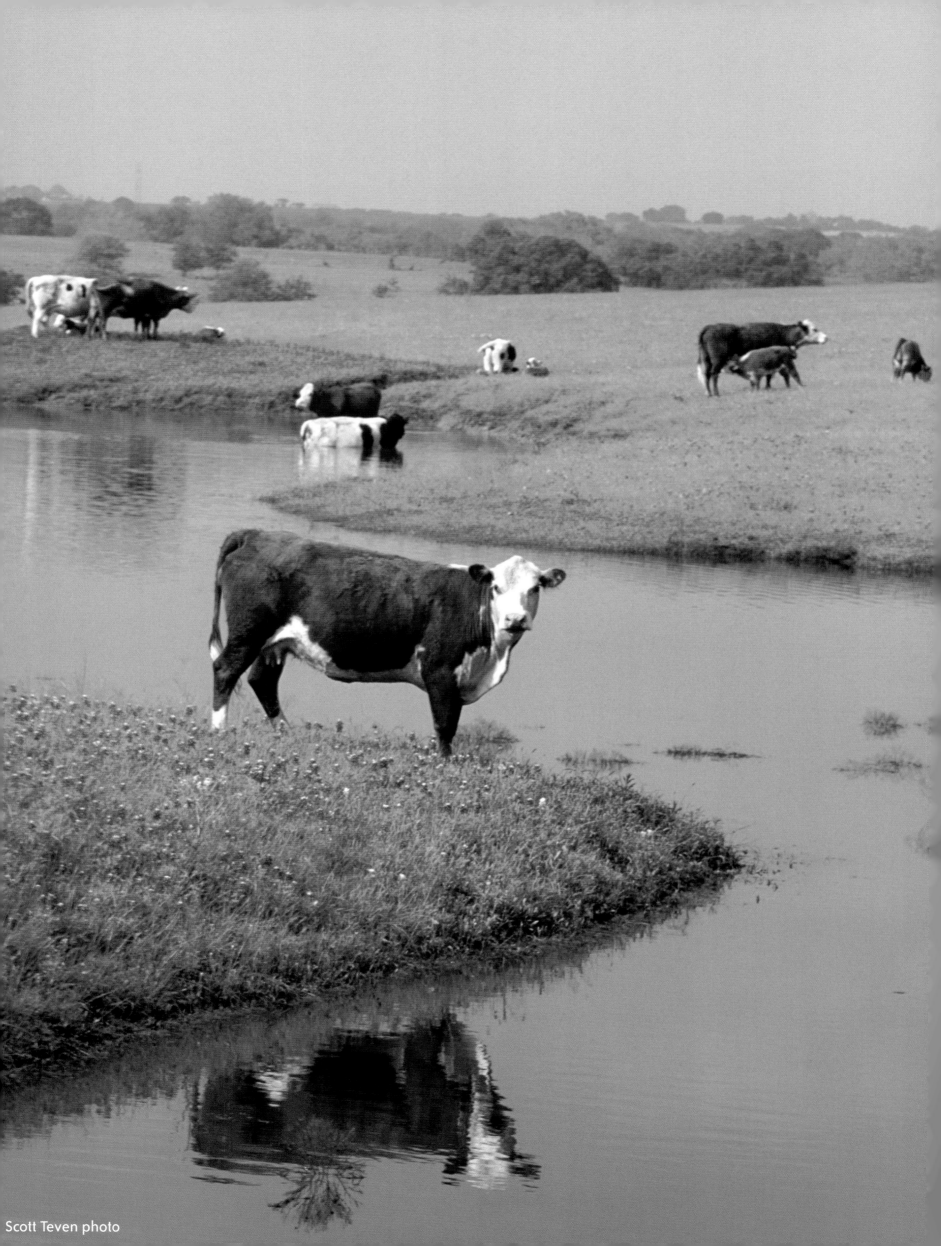

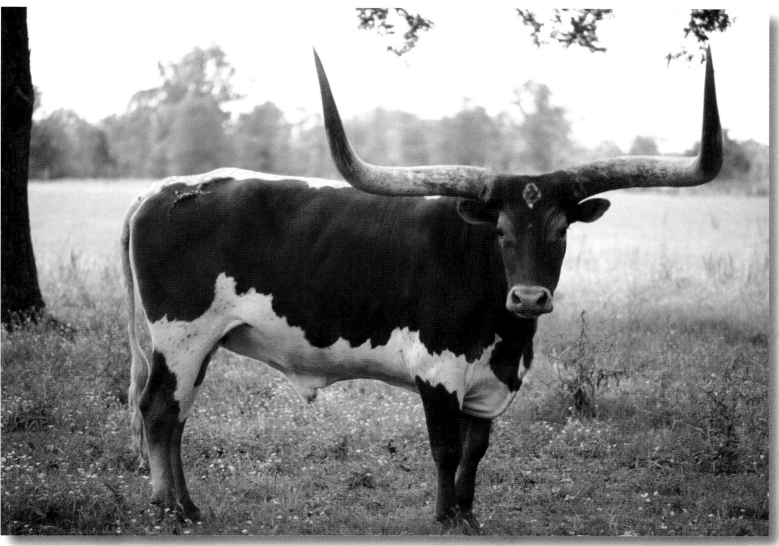

This rugged longhorn steer exhibits the huge horns that give it its name. Its distinctive horns, which turn up at the tips and bear an orange tinge, can grow up to six feet long. Longhorn cattle are believed to be a mix of Spanish retinto cattle brought over by explorers and English breeds.

These Hereford cattle graze in a pasture in Fayette County, Texas. Although Texas has focused on oil production since the Second World War, cattle are still important to the state's economy. Texas cattle and calves account for 15 percent of all the cattle in the U.S. *(left)*

Tim Fitzharris photo

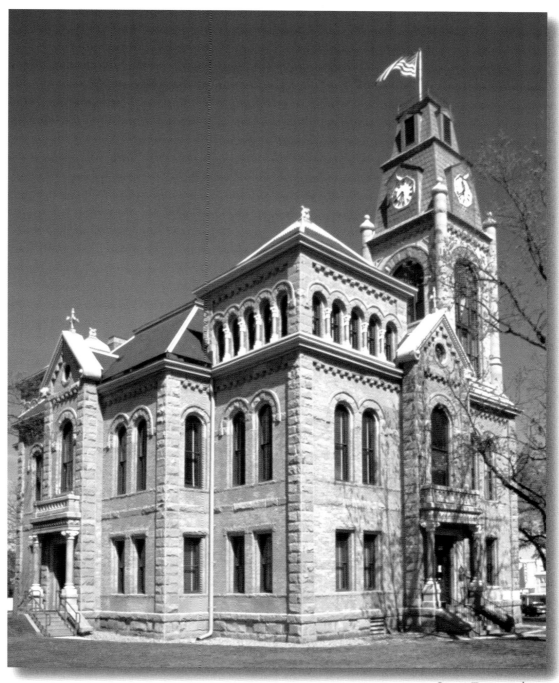

This historic county courthouse, added to the National Register of Historic Places in 1989, is Llano County's Fourth. Completed in 1893 after a fire destroyed its predecessor, this Romanesque Revival building differs from other Texan county courthouses in that its tower rises from its northeast corner instead of its center.

This meadow of brilliant purple prairie verbena is part of the 500 acres of South Llano State Park, which sits adjacent to the South Llano River. The leaves of this delicate plant are often used to make tea and to remedy insomnia. *(left)*

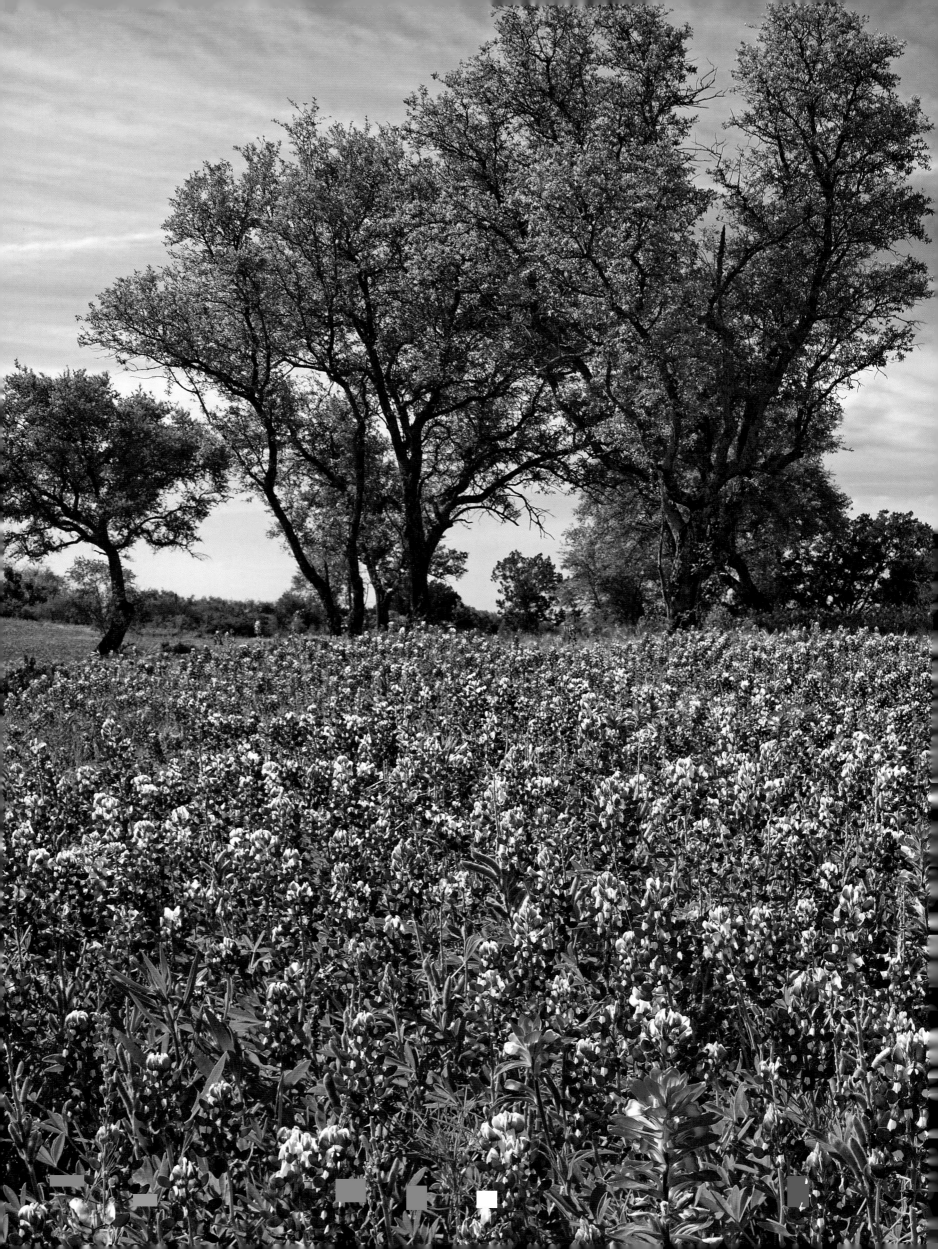

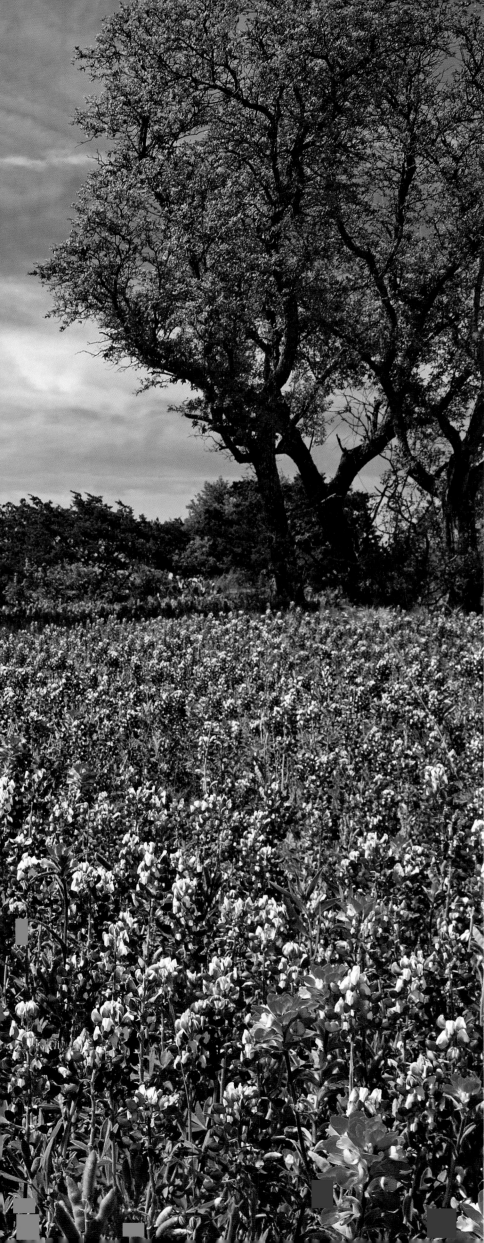

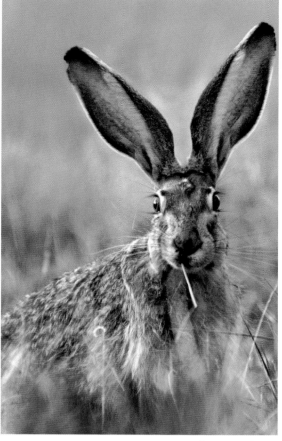

A common sight throughout Texas, the black-tailed jackrabbit has distinctive long ears with black patches on the tips. Herbivores that prefer areas with sparse vegetation, they often gather in pastures grazed by livestock. It takes almost 130 jackrabbits to consume as much vegetation as one cow.

Texas bluebonnets and Indian paintbrush add vibrant splashes of color to Edwards Plateau. Marine deposits of limestone formed this highland millions of years ago when it was submerged under the ocean. Today, elevations in Edwards Plateau range from 100 to over 3,000 feet above sea level. *(left)*

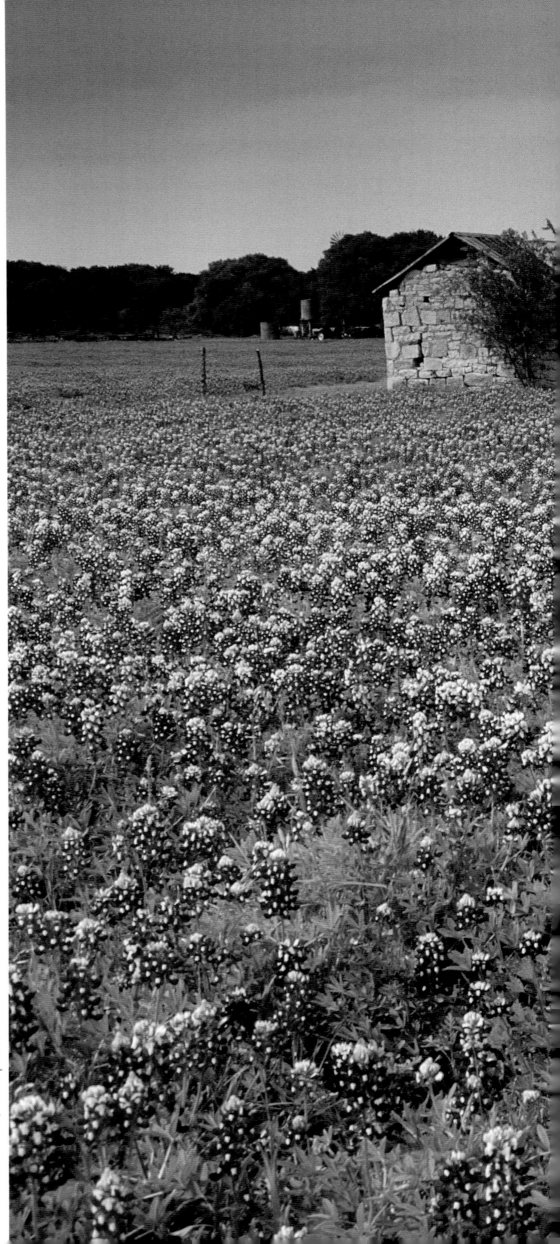

This old farmhouse nestles in a field of bluebonnets in Hill County. Hill County is named after early settler and surgeon George Washington Hill, who served as both secretary of war and secretary of the navy for the Republic of Texas.

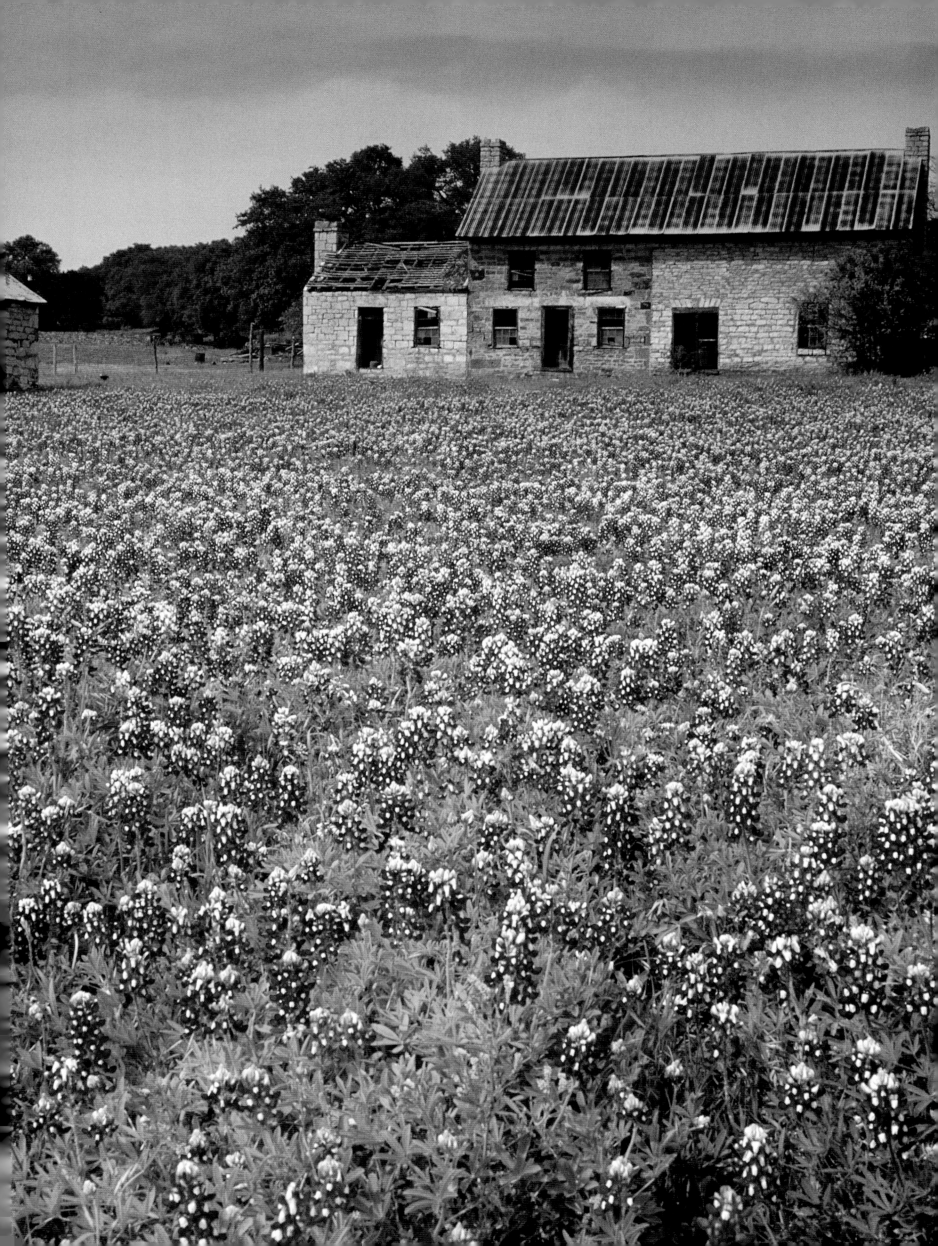

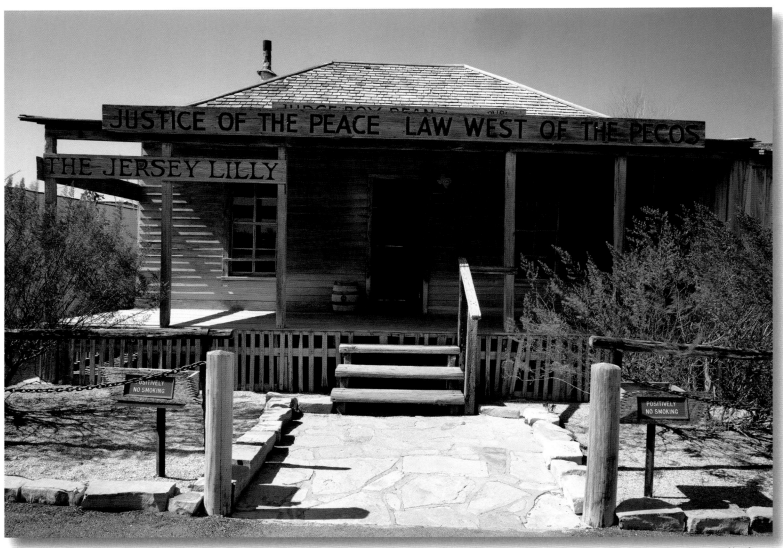

An emblem of the Wild West, this saloon was once office, home, and courthouse for legendary Texan Judge Roy Bean. Bean built this saloon, called the Jersey Lilly, after he was appointed as the Justice of the Peace for Pecos County. He reputedly held court in this saloon, where legend finds him adopting the motto Hang Em' First, Try Em' Later. The Hangin' Judge, as Bean is known, called himself The Law West of Pecos.

It was here that eccentric Texan legend Judge Roy Bean doled out his own brand of justice — with only one law book and a shotgun. The "Hangin' Judge" has been immortalized in pop culture through movies and television. The 1940 film *The Westerner*, the 1955–56 television series "Judge Roy Bean," and the 1972 film *The Life and Times of Judge Roy Bean* are all loosely based on him. He's buried at the Whitehead Museum in Del Rio, Texas. *(right)*

Sotol, which is often used to weave baskets, grows on this hillside in the stark landscape of the Chihuahua Desert in Big Bend National Park. Almost all of the plant can be put to use. The seeds, stalks, and heart are eaten, and the sap is fermented into an alcohol, also called sotol. *(overleaf)*

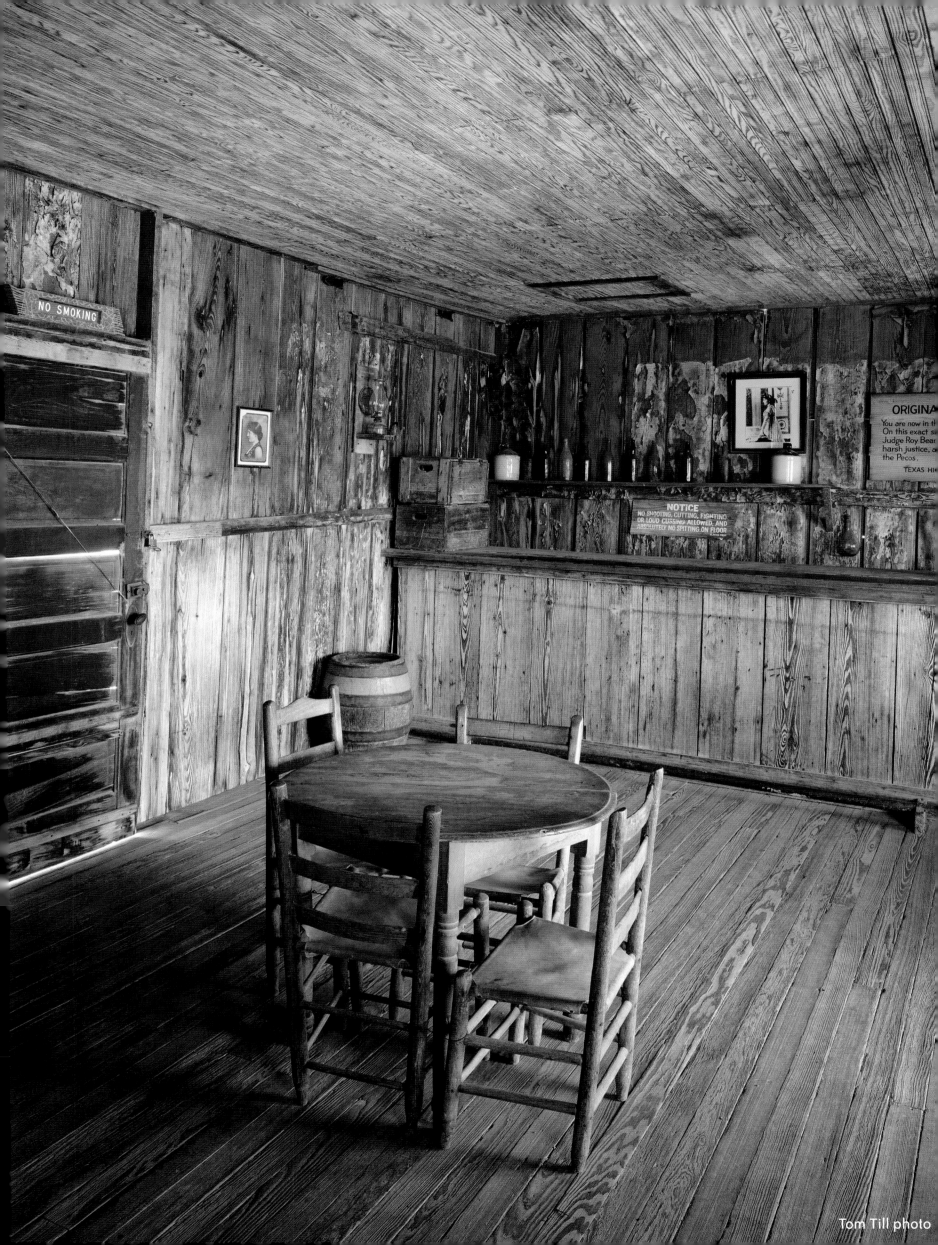

NO SMOKING

ORIGINA

You are now in th
On this exact si
Judge Roy Bear
harsh justice, a
the Pecos.

TEXAS HI

NOTICE
NO SHOOTING, CUTTING, FIGHTING
OR LOUD CUSSING ALLOWED, AND
ABSOLUTELY NO SPITTING ON FLOOR

Tom Till photo

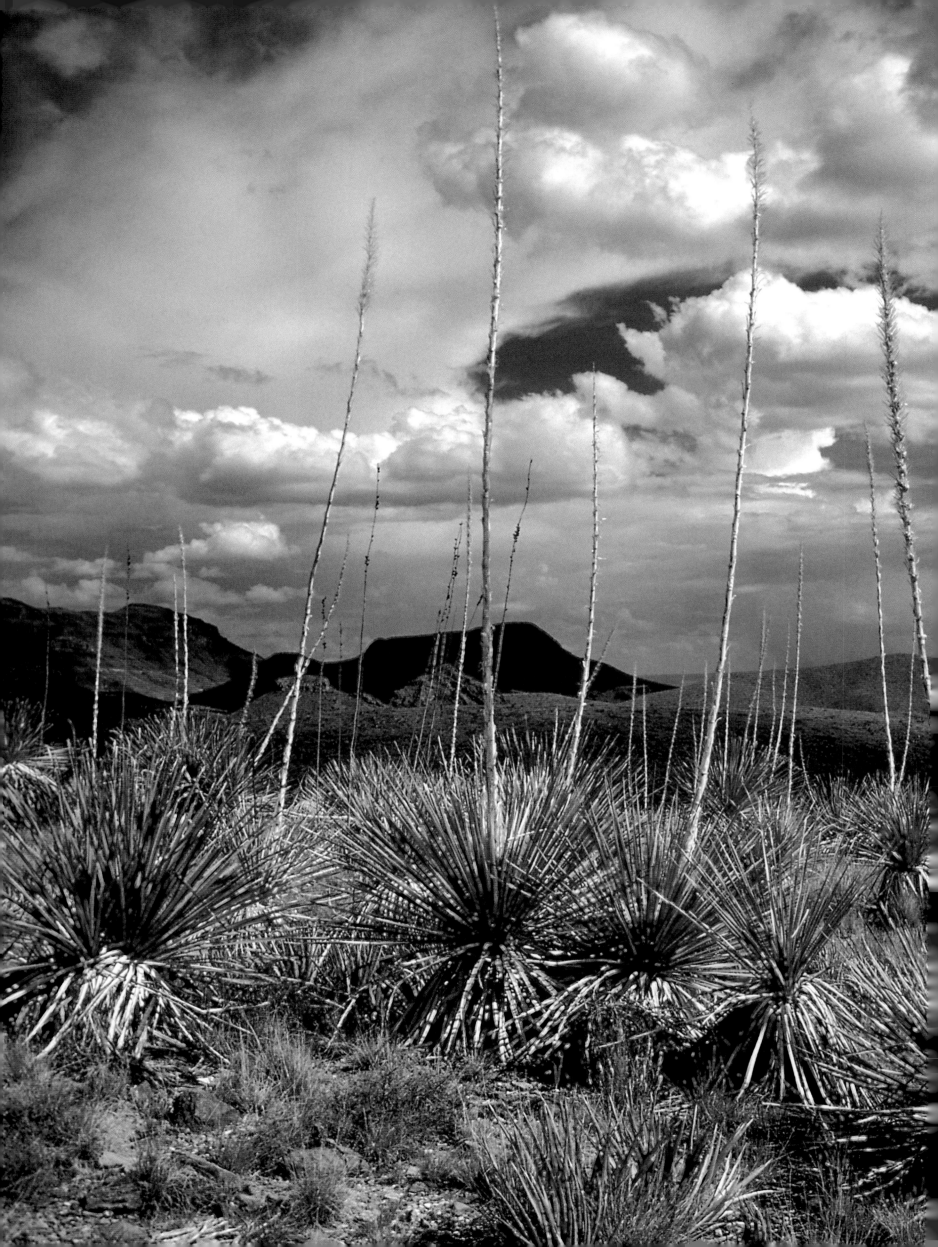

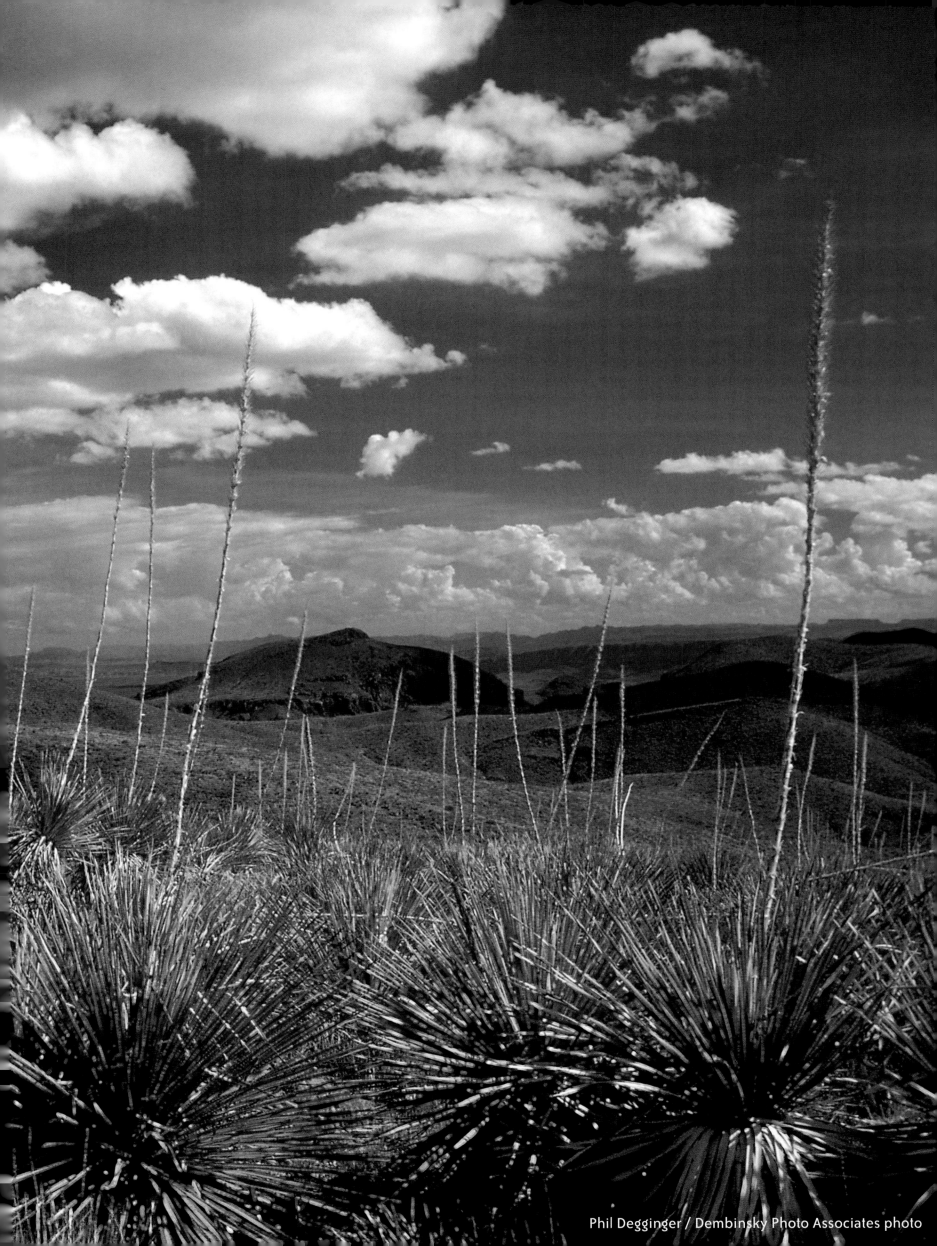

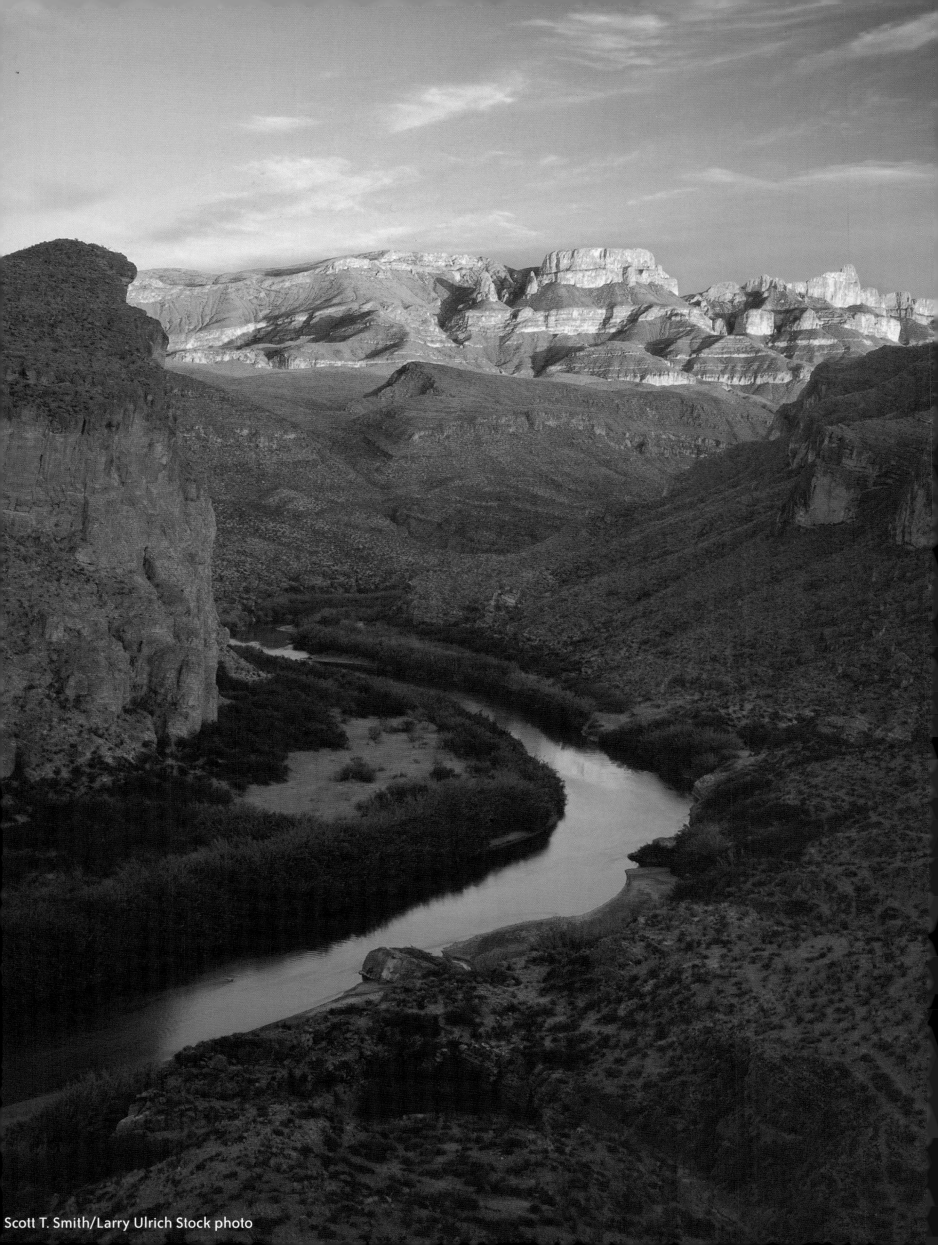

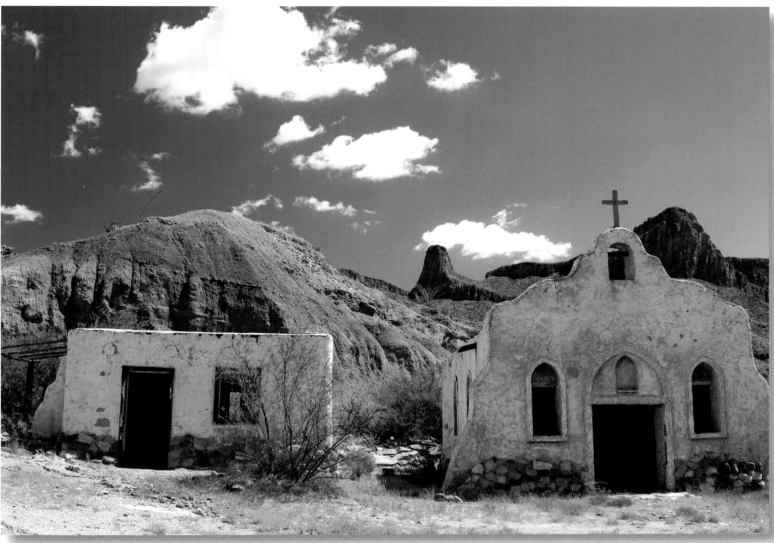

Scattered in the desert along the Rio Grande, these dusty adobe buildings belong to an abandoned movie town, now part of Big Bend National State Park.

A setting sun brings out the many colors of the majestic Sierra Del Carmen mountain range, as the Rio Grande meanders through its contours. Straddling Texas and Mexico, this vast mountain range, because it rises out of the Chihuahuan Desert to such staggering heights, is often called Sky Island. *(left)*

Stark landmarks, the Mule Ears Peaks are twin rock columns overlooking the vast, rugged terrain of Big Bend National Park. This massive area features rivers, mountains, and desert, and includes the largest protected stretch of the Chihuahuan Desert in the U.S. In spite of its harsh climate, Big Bend supports about 1,200 plant species, 3,600 types of insect, and 600 different animals, including black bears and mountain lions. *(overleaf)*

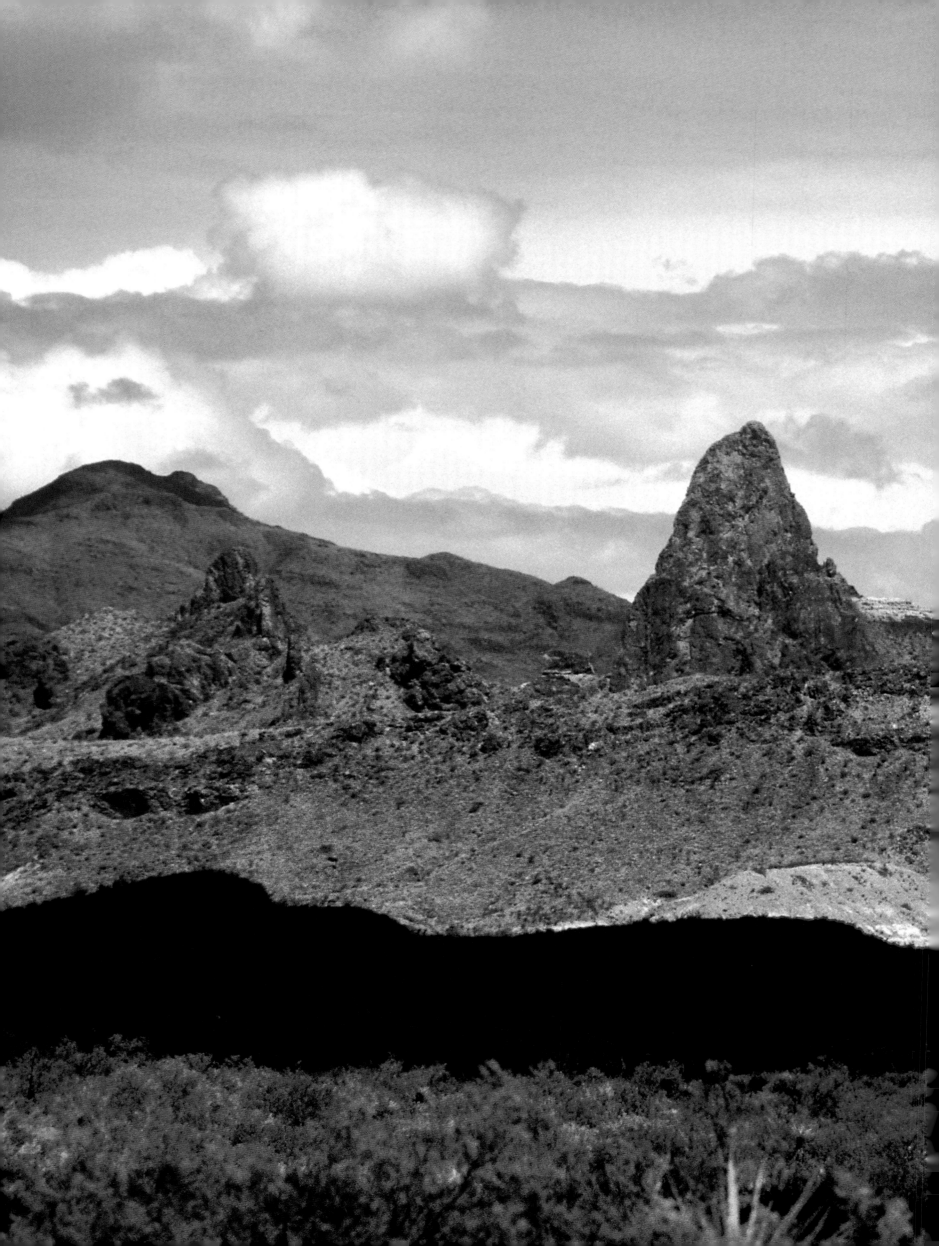

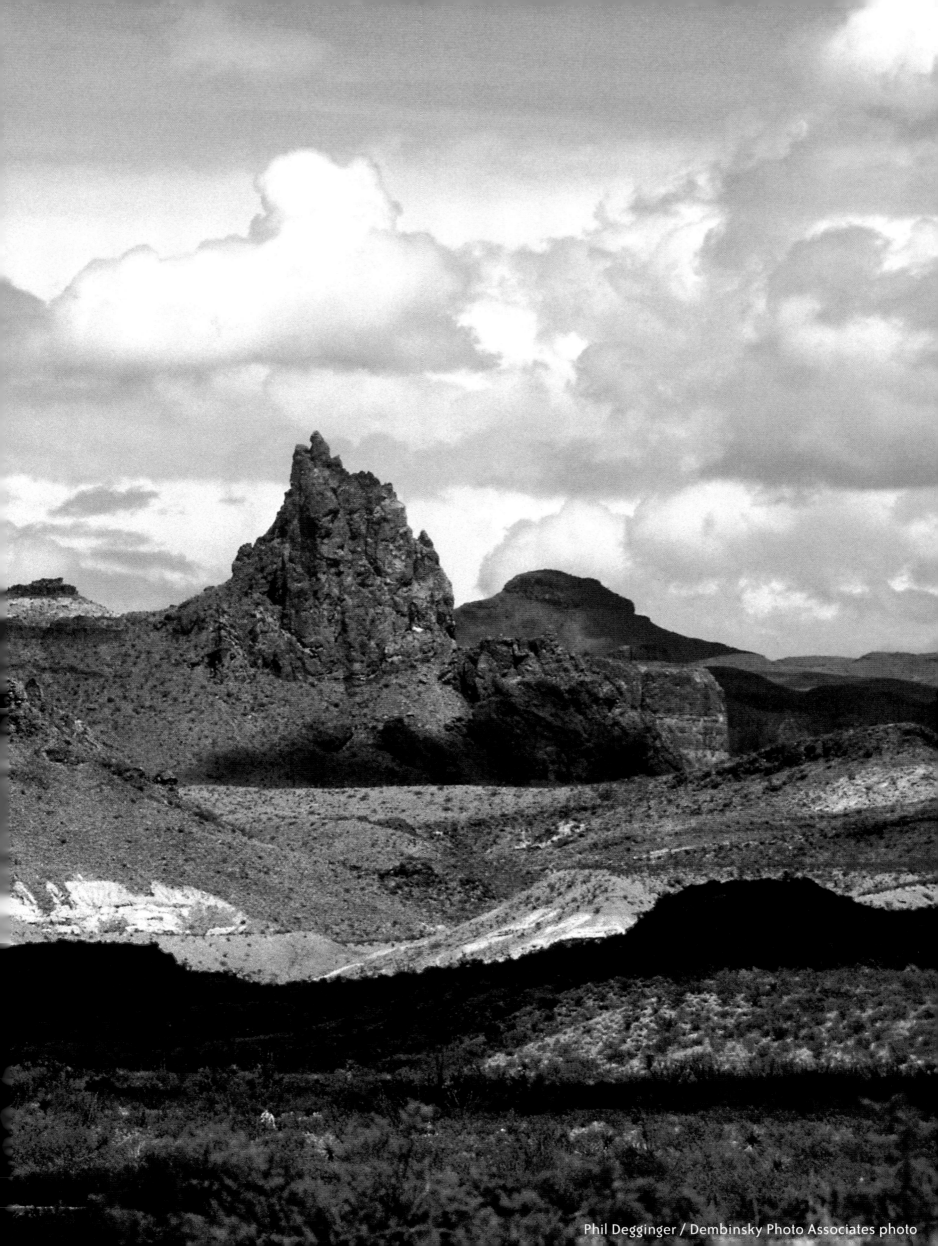

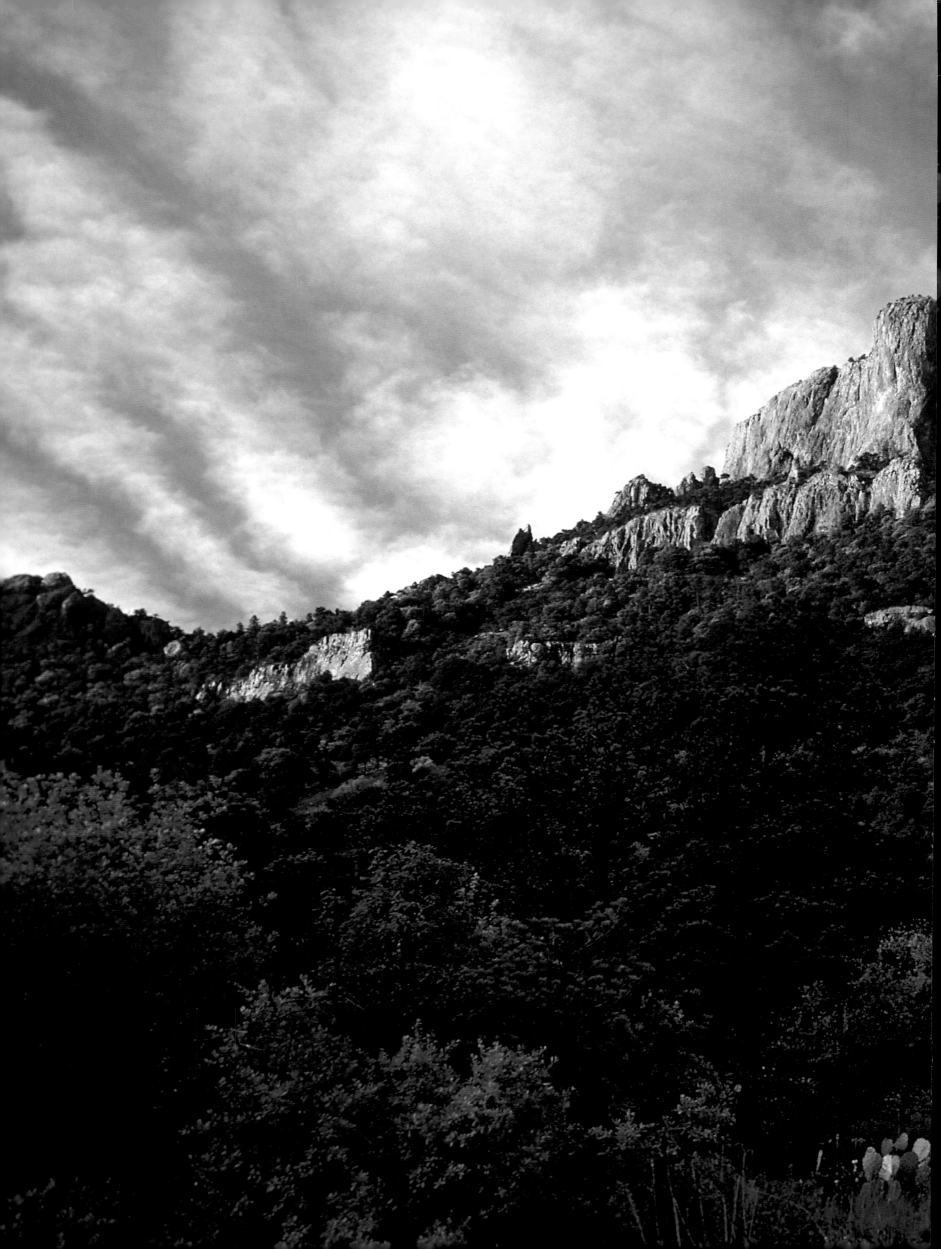

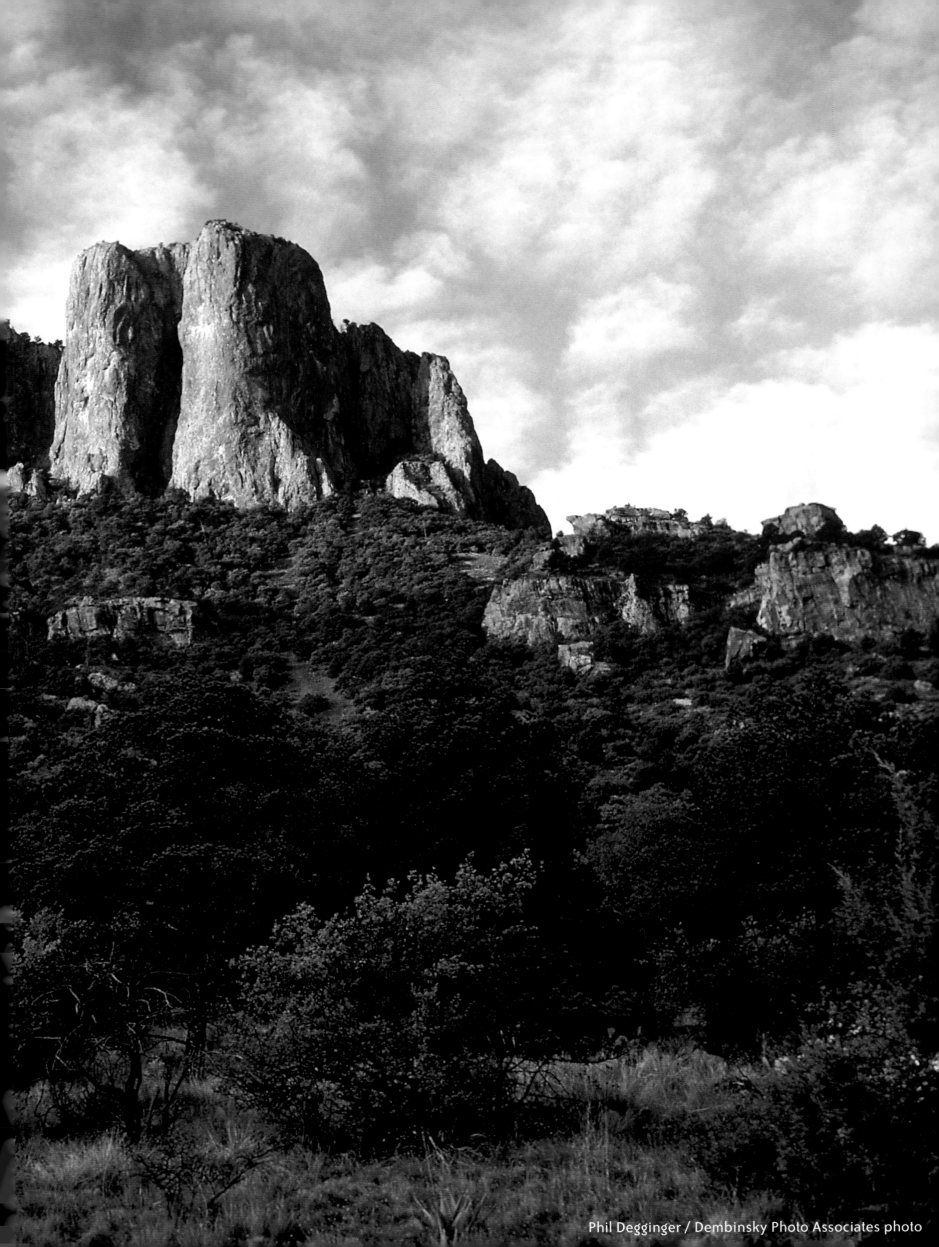

Here at the base of the volcanic Davis Mountains stands the Fort Davis Historic Site. Called Officer's Row, these barracks were built by the military to protect the pioneers who first journeyed across the state from potential attacks. The first of its kind in Texas, the restored Fort Davis features 18 residences, two barracks, a warehouse, and a hospital.

Aptly called Casa Grande, meaning big house in Spanish, this prominent peak in the Chisos Mountains is one of the most dramatic sights at Big Bend National Park, the only U.S. national park that contains an entire mountain range. *(previous pages)*

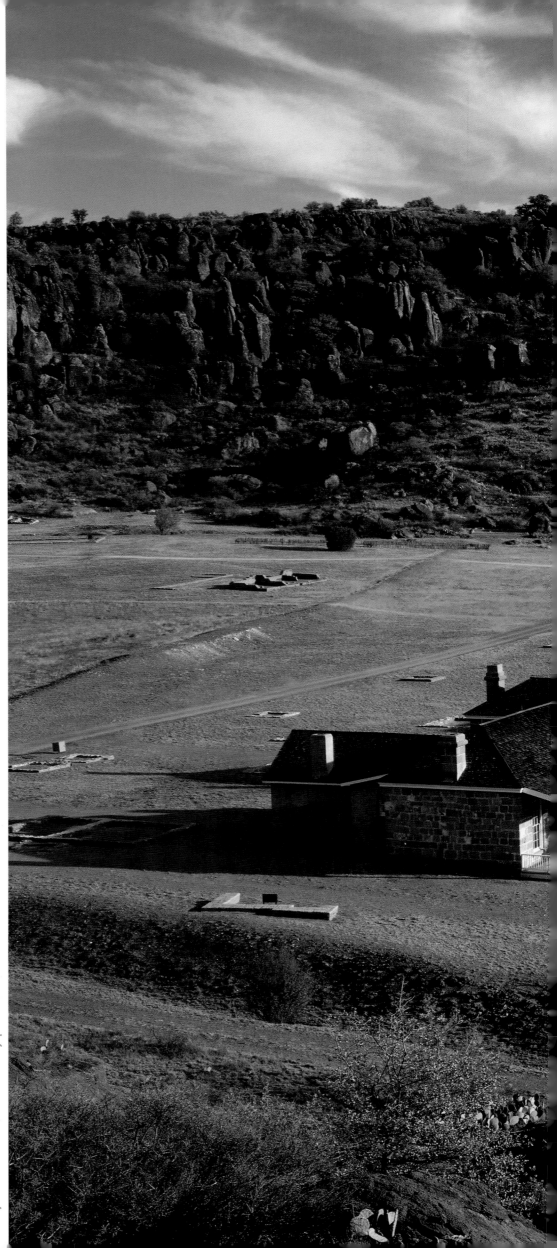

Gary Alan Nelson / Dembinsky photo

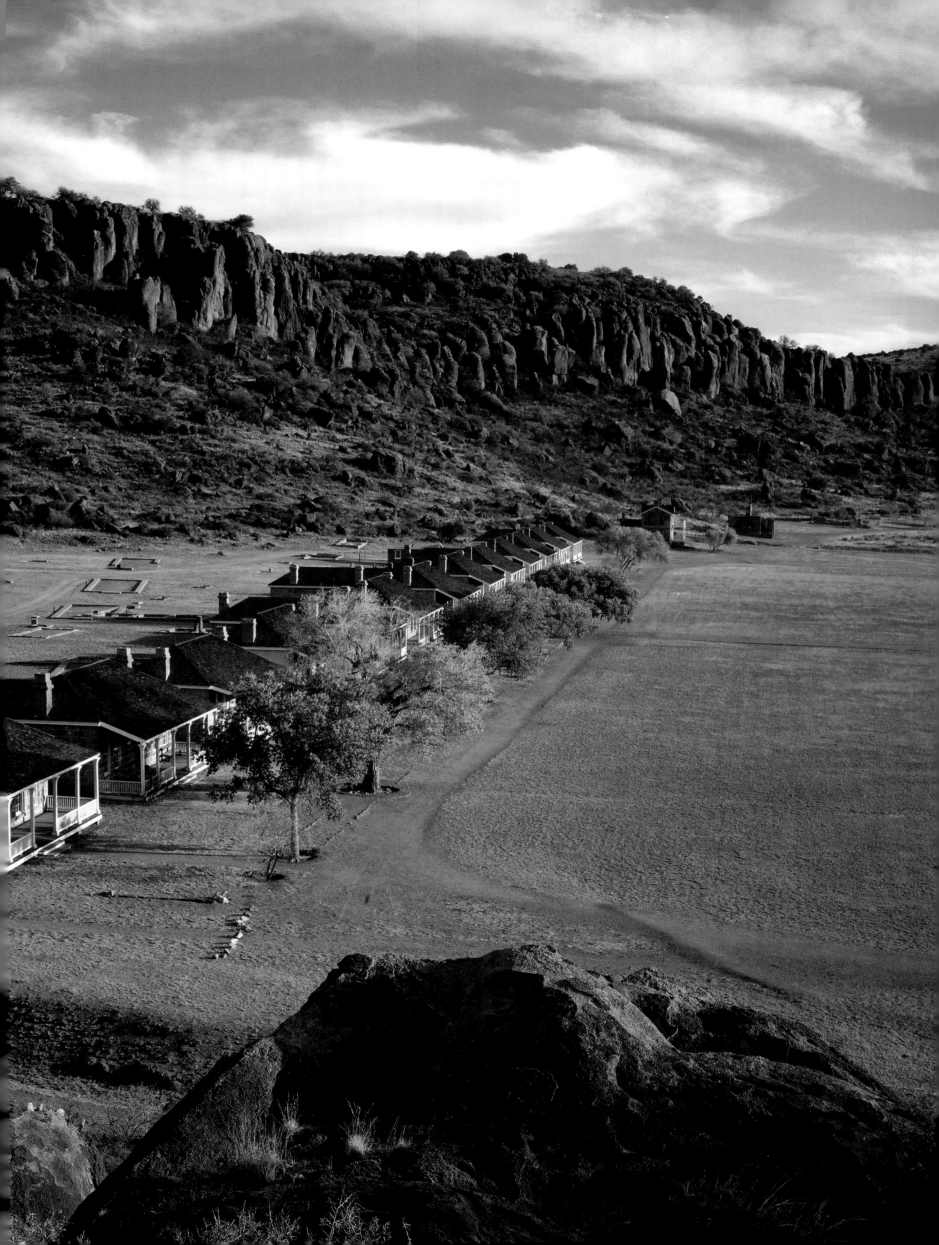

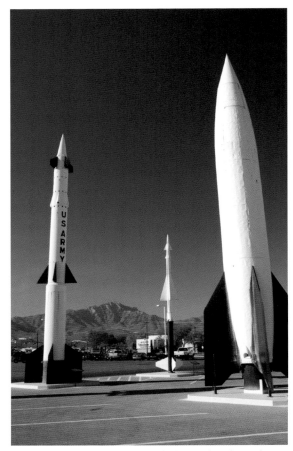

The largest 19th-century cavalry post in the U.S., Fort Bliss is now home to the U.S. Army Air Defense Center and the U.S. Army Air Defense Artillery Museum. On display here at Fort Bliss, where troops from all over the world train in air defense, are exhibits of 19th-century weapons.

This replica museum at Fort Bliss recreates the base as it was in 1849, when it was established to protect settlers in the El Paso region from Mexican and Native attacks. The museum and U.S. Army Air Defense Center at Fort Bliss occupy a million acres of Texas and New Mexico land, roughly equal in size to the state of Rhode Island. *(right)*

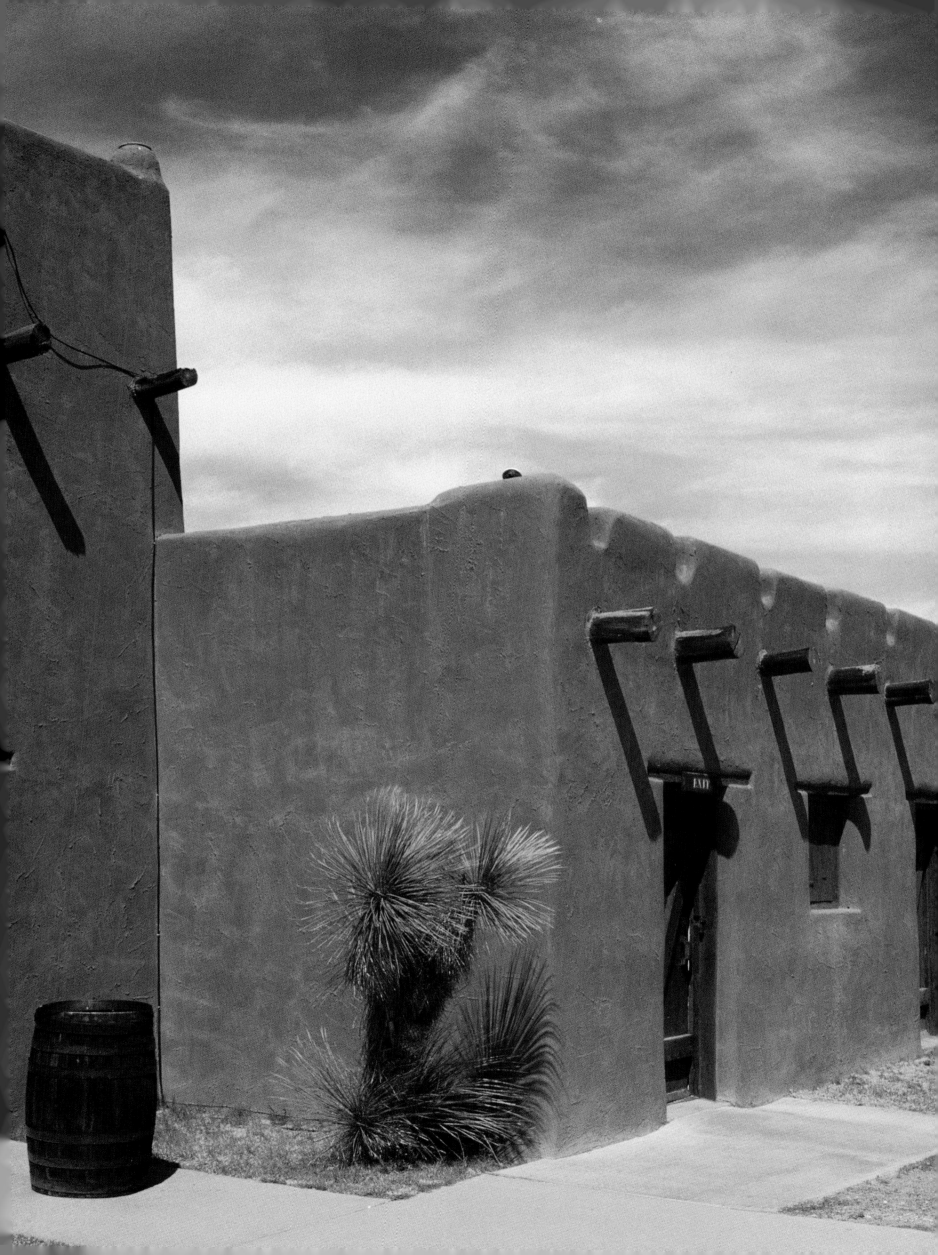

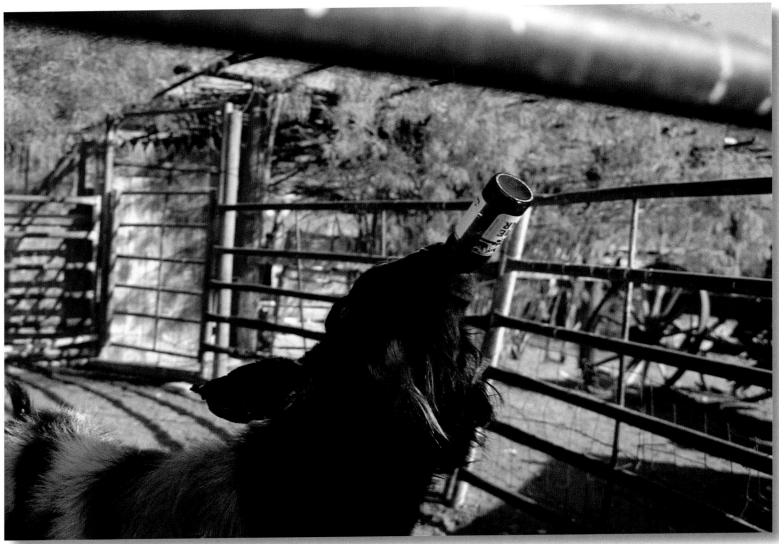

Marshall Prescott / Unicorn photo

The tiny resort of Lajitas on the Rio Grande is famous for its unlikely mascot: a beer-drinking goat. Nestled between Big Bend National Park and Big Bend State Park, Lajitas is home to a dynasty of the beer-swilling goats, who take the bottles with their teeth, chug the beer, and then spit the bottle out.

Now a church serving the community of Ysleta, this former mission is the second oldest continuously used church in the U.S. Originally a refugee camp built out of mud, logs, and reeds for Pueblo Indians in the 17th century, this church was Texas' first mission and is now one of three historic sites along El Paso's Mission Trail. *(right)*

The signature peak of West Texas, El Capitan is the eighth highest mountain in the Lone Star State. As the sun sets here in Guadalupe Mountain National Park, this jagged peak rising out of the barren Chihuahuan Desert creates a spectacular silhouette. *(overleaf)*

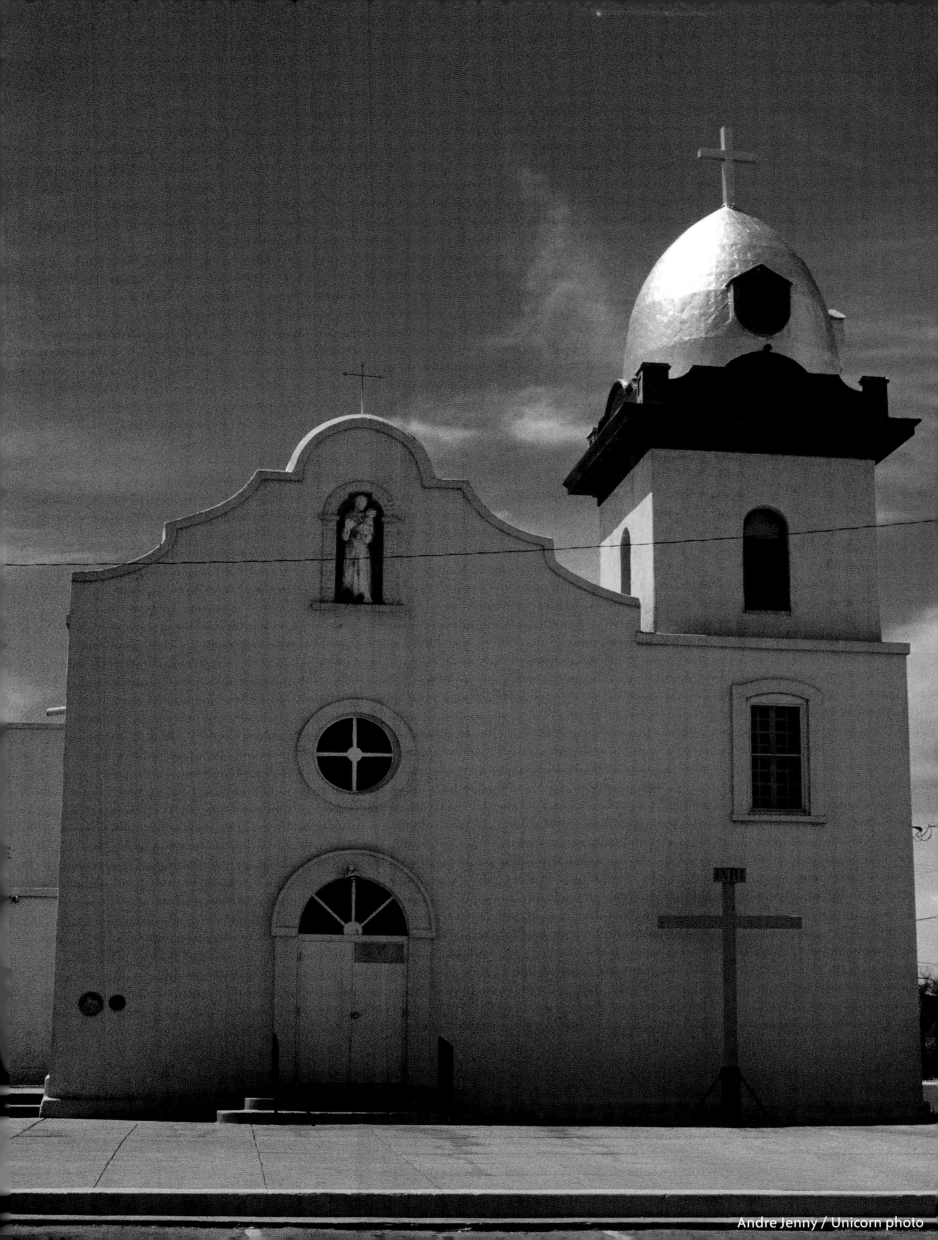

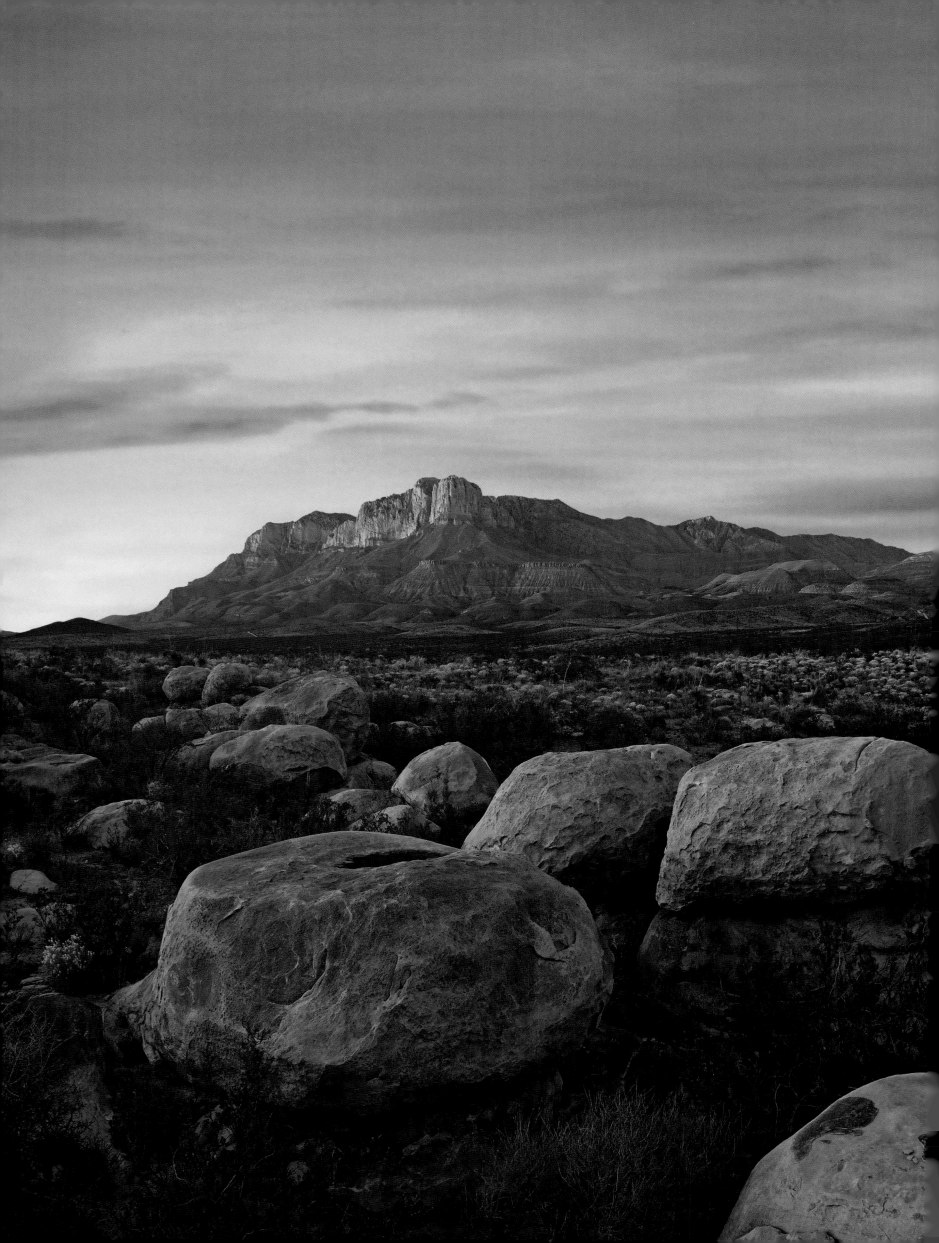

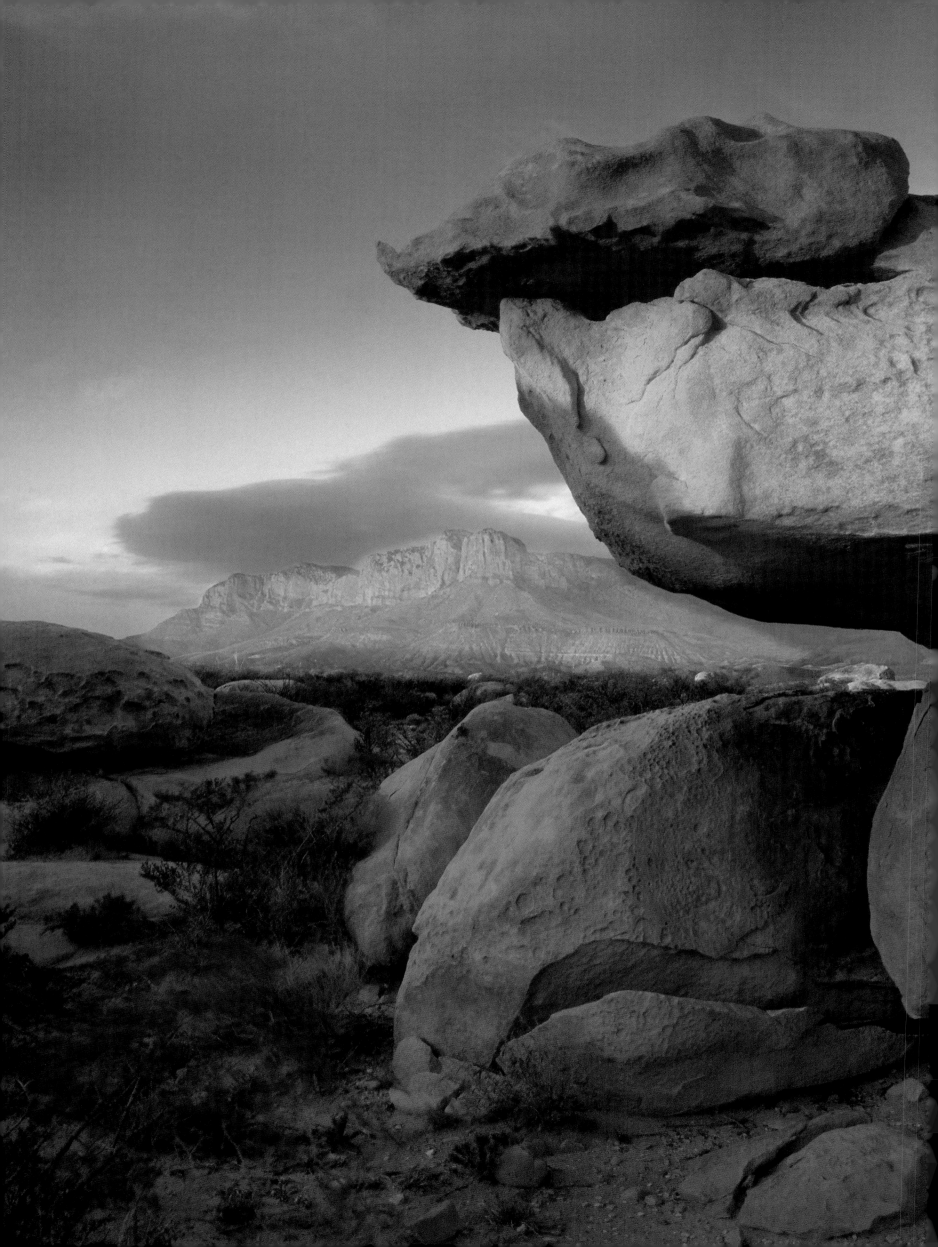

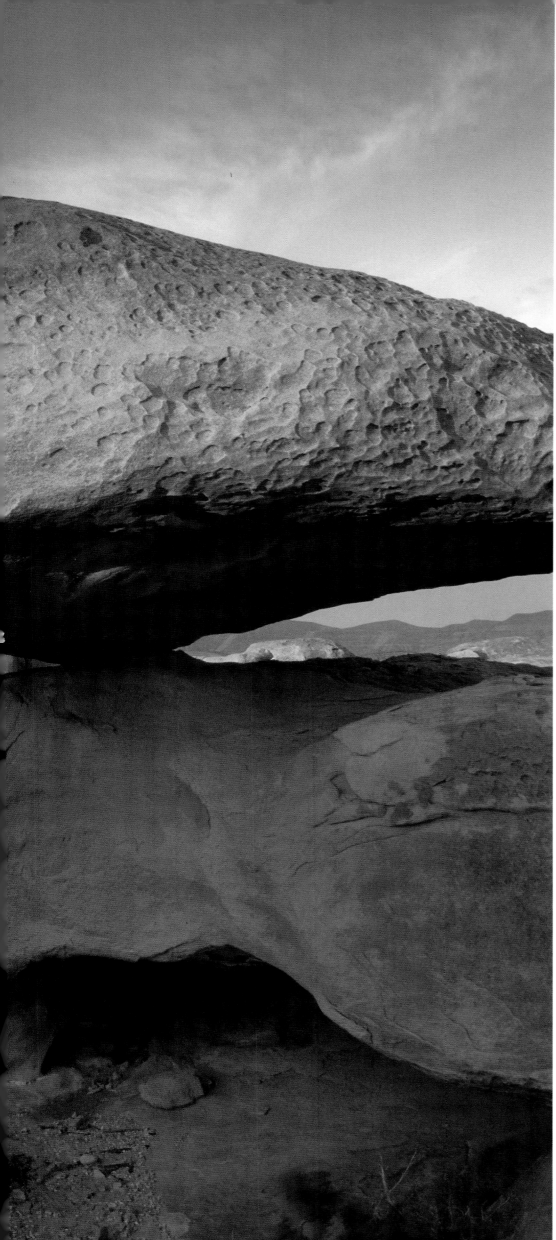

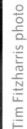

This 128-foot-tall sandstone structure, Balanced Rock, enhances the rugged beauty of Guadalupe Mountain National Park, the only designated wilderness in West Texas, where millions of years of erosion have created stark outlines and jagged peaks.

The Gypsum Dunes in Guadalupe Mountain National Park create the surreal vision of snow on the desert floor at the foot of Guadalupe Peak. These silvery dunes are formed by winds carrying gypsum from the surrounding salt flats. When gusts of wind hit the mountain walls of the Guadalupe range, crystal grains fall onto the desert landscape. *(overleaf)*

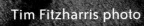

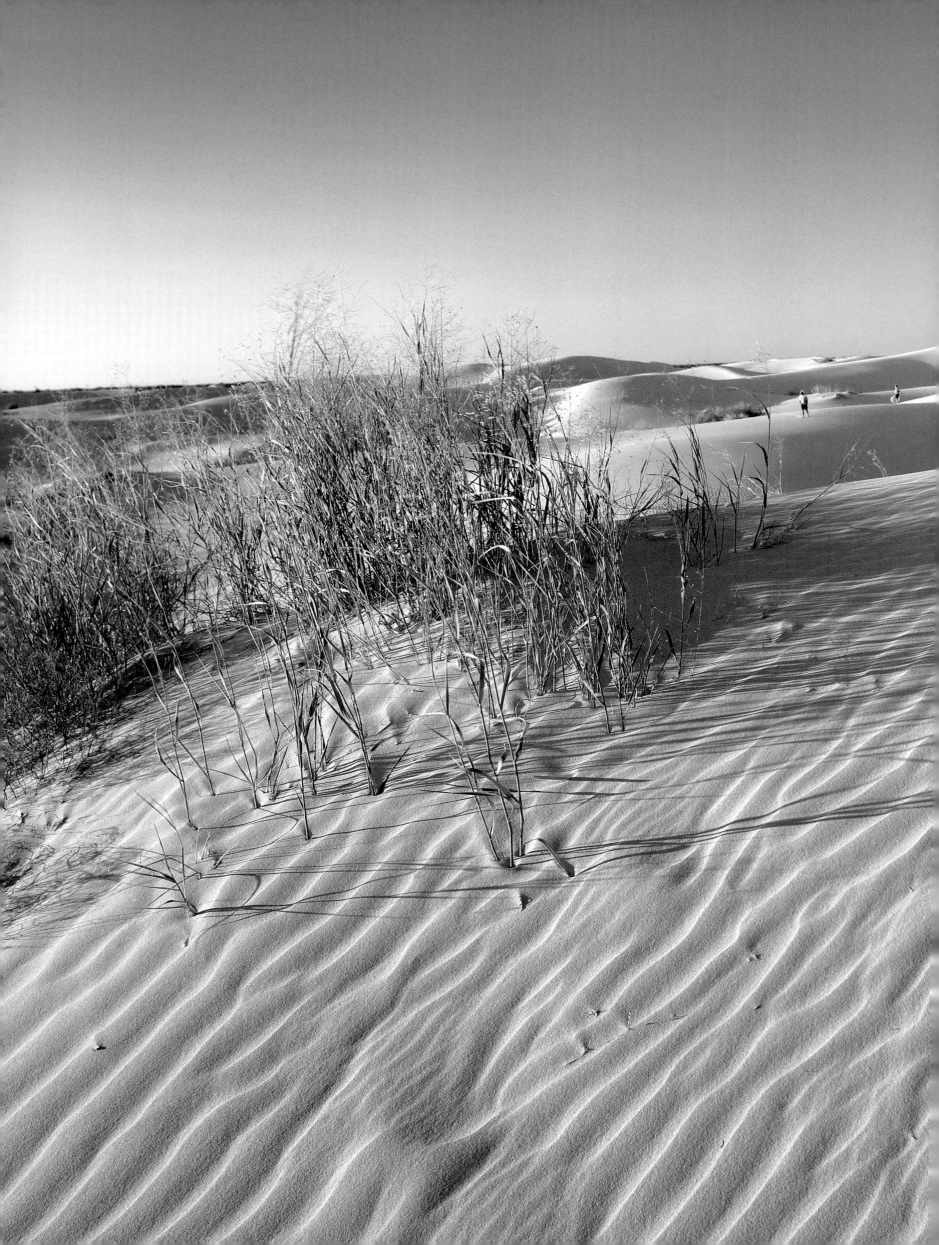

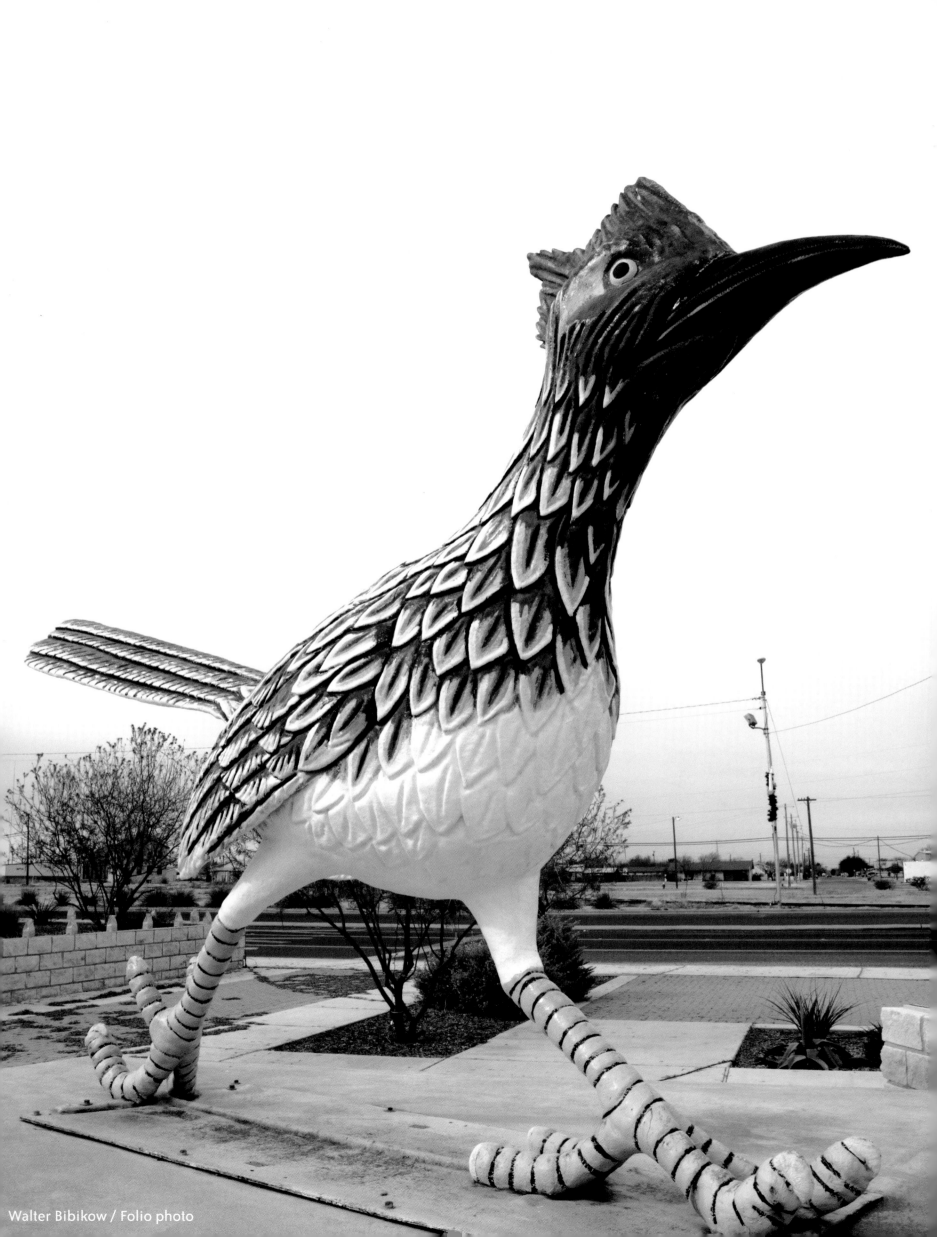

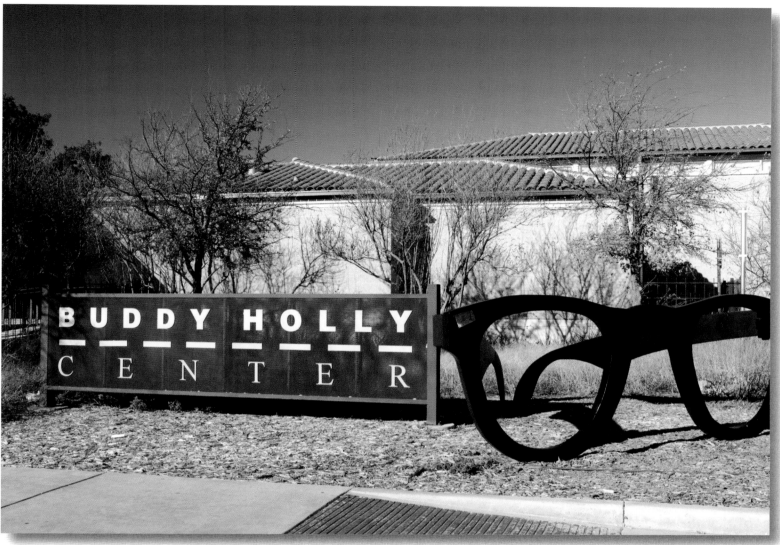

The Buddy Holly Center in Lubbock, Texas, pays homage to rock and roll legend and hometown boy Buddy Holly. The Center, which also features interactive exhibits about Texan music and visual art, displays artifacts related to the pioneering musician who wrote the classic song "Peggy Sue."

An unlikely host greets visitors to Fort Stockton. The nation's largest roadrunner, Paisano Pete, is a 10-foot-tall, 22-foot-long bird that has put Fort Stockton on the to-do list for those eager for quirky sights. *(left)*

The vast Monahans Sandhills are another beautiful example of the immensity of Texan scenery. Comprised of 3,840 acres of sandhills that reach as high as 70 feet, this state park was once a water stop along the Texas and Pacific Railroad. *(previous pages)*

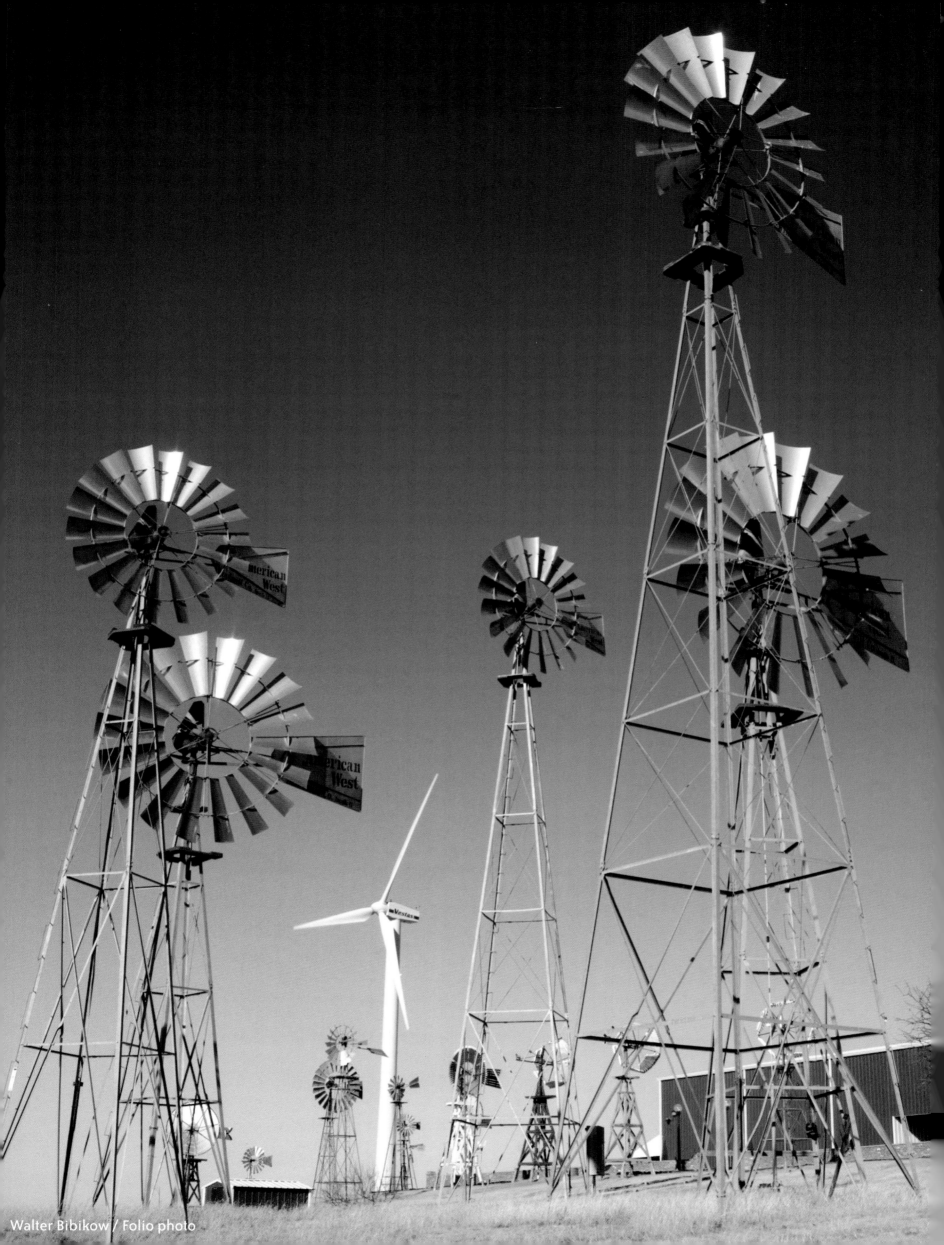

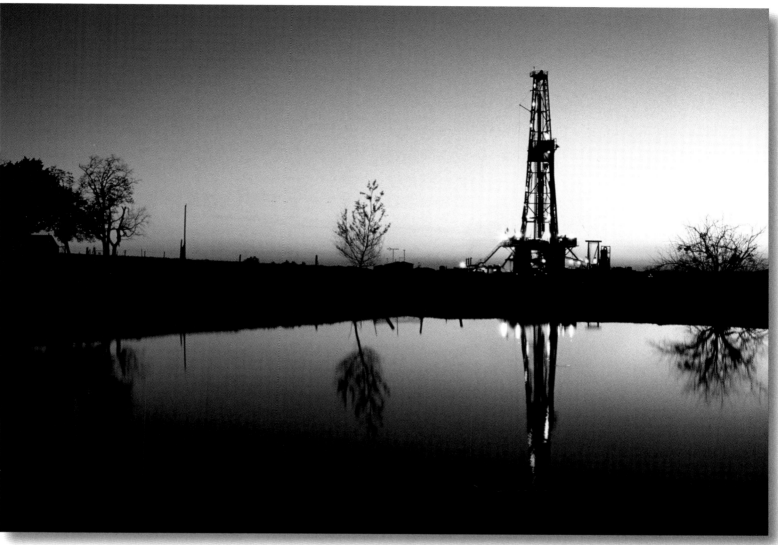

A colorful sunset creates a silhouette out of an oil derrick, a symbol of the Lone Star State. Oil, natural gas, and fuel processing are strongholds of the Texan economy, which also relies on information technology, the aerospace industry, and agriculture.

The assortment of windmills at the American Wind Power Center in Lubbock, Texas — which houses over 100 of the historic machines — is the most comprehensive in the world. The center, on 28 acres of the city's parkland, features restored windmills dating back to the 1860s. *(left)*

Overlooking the massive canyon at the Grand Canyon of Texas, this rock called the Lighthouse is perhaps the most striking feature of Palo Duro State Park. Located in the Texas panhandle, Palo Duro canyon, which reaches 3,500 feet above sea level, is the second largest canyon in the U.S. after the Grand Canyon. *(overleaf)*

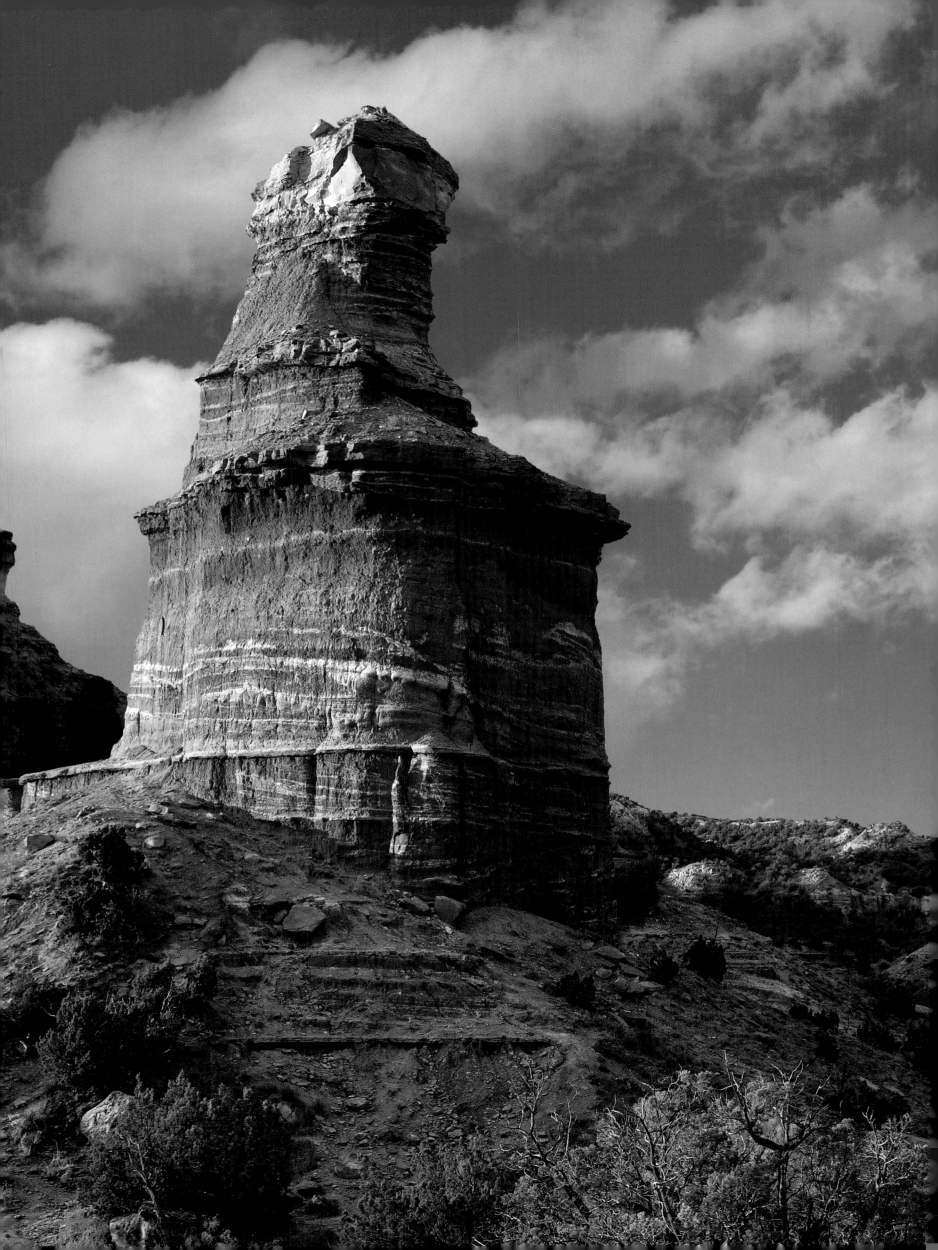

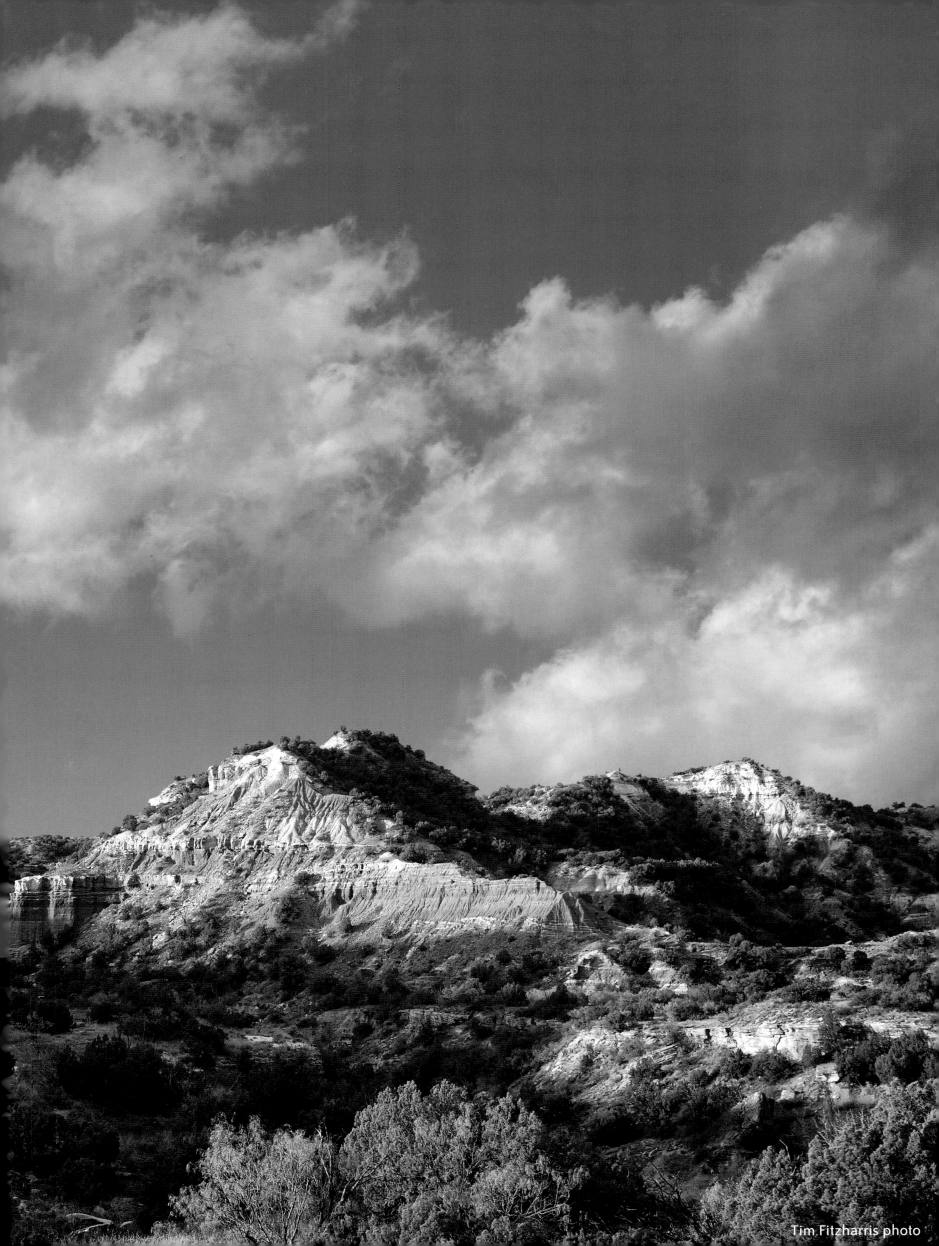

Encompassing over 15,000 acres, Caprock Canyon State Park consists of sparse badlands and fertile bottomlands. Among the many animals in the canyon — including foxes, African aoudad sheep, opossums, bobcats, and coyotes — is the official Texas State Bison Herd, the largest bison herd in a state park. Over 175 species of bird visit Caprock Canyon State Park, including the elusive golden eagle.

The feathery leaves and delicate pink and yellow flowers of the feather dalea blanket the dry ground here at Caprock Canyon State Park. A member of the Formosa family, this shrub flourishes in dry, rocky landscapes between 3,000 and 7,000 feet above sea level. *(right)*

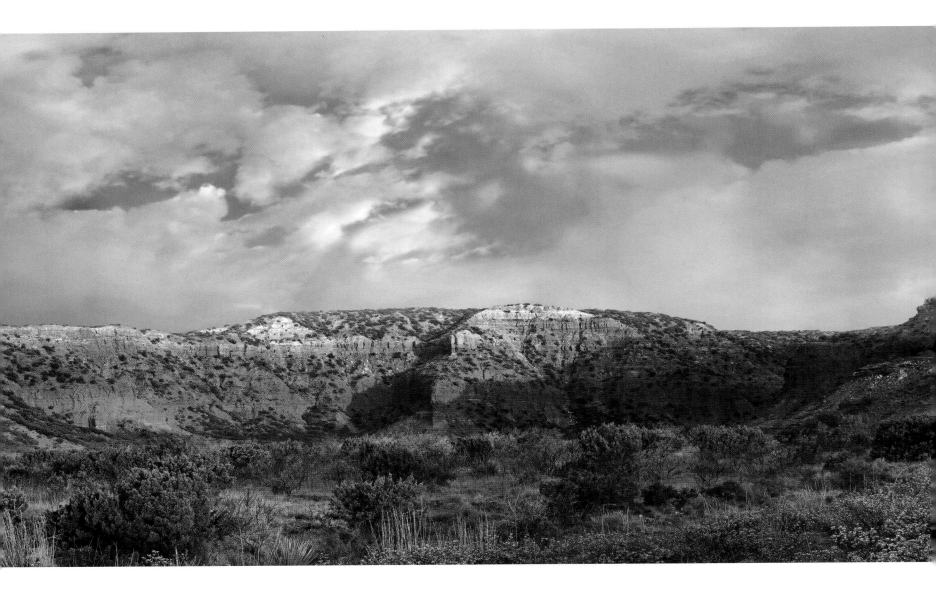

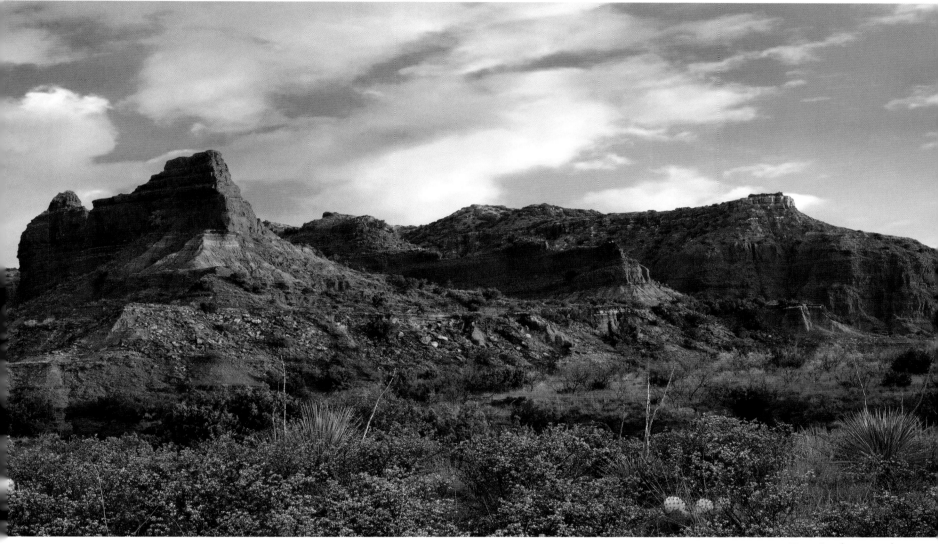

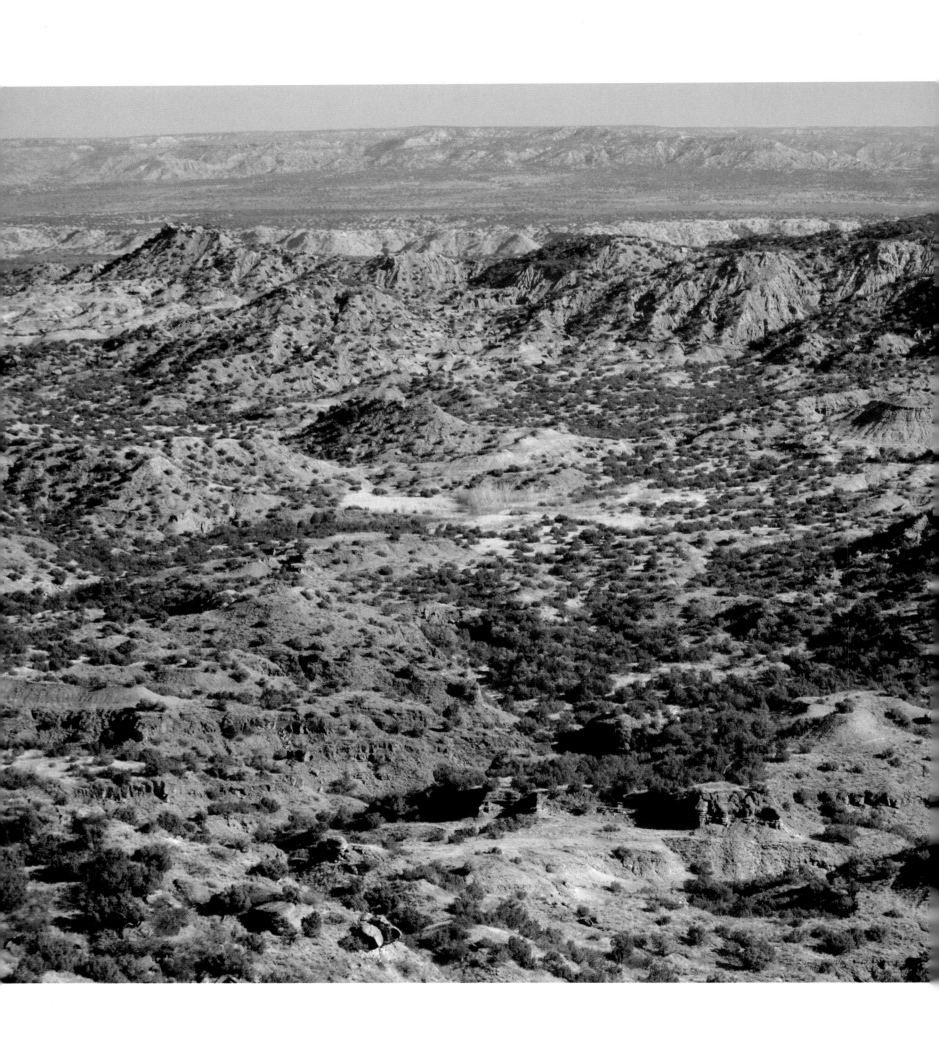

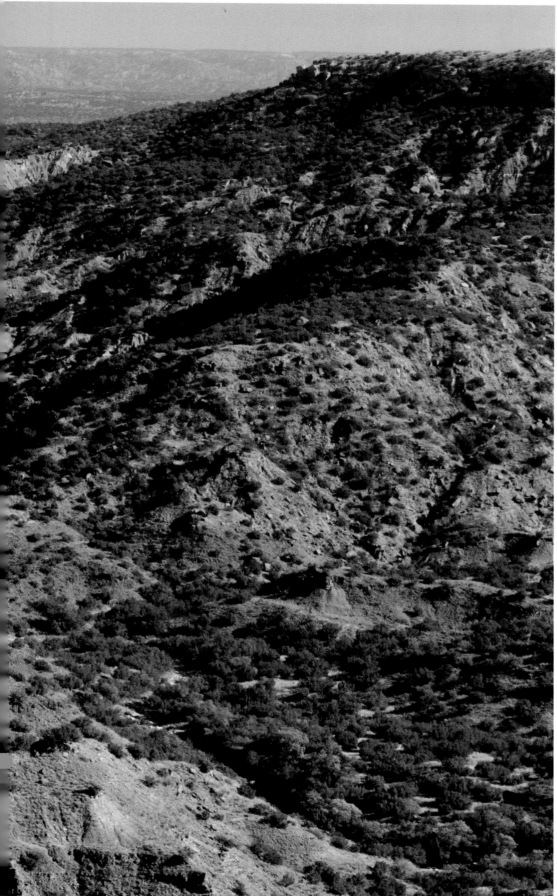

The vast, arid landscape of the Texas panhandle region includes the state's 26 northernmost counties. Once used for cattle drives and buffalo hunts, this region is now home to some of the state's most magnificent parks and the burgeoning city of Amarillo.

Feather dalea prosper in arid Caprock Canyon State Park. The park's ecosystems support many different kinds of vegetation, from juniper, mesquite, and cacti in the badlands to grasses, cottonwoods, and plum thickets in the lush bottomlands. *(previous pages)*

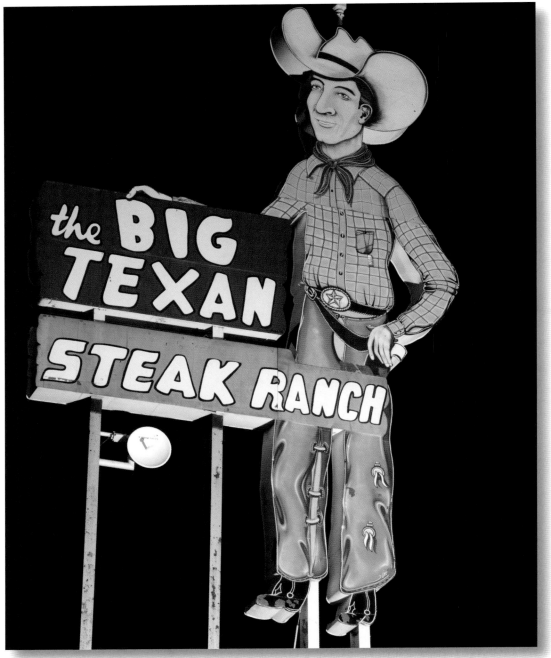

A popular destination for steak lovers with big appetites, the Big Texan Steak Ranch is renowned for its free 72-ounce steak dinners. If you can eat up every morsel of the huge piece of meat within an hour, your meal is free. Thousands of people have put their stomachs to the test since this restaurant along historic Route 66 opened in 1960.

Decorative cattle skulls recall the wild west spirit of cowboys of the American Southwest. *(right)*

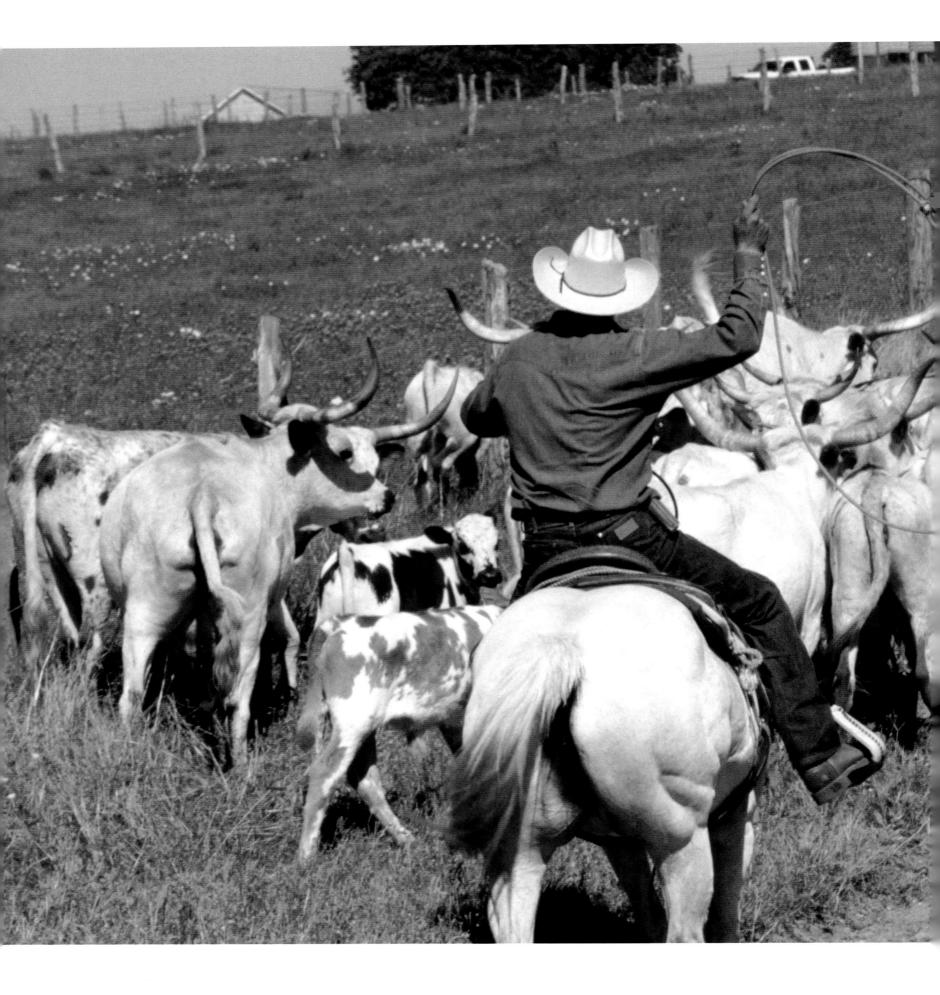

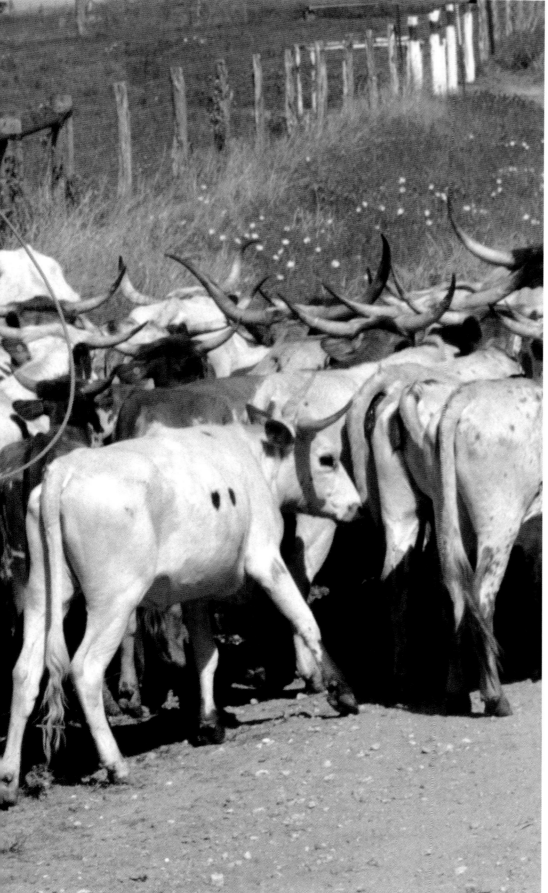

A cowboy gets his cattle moving with a swing of his lariat on a Texan ranch. Although industry in the Lone Star State has shifted from agriculture to oil, aerospace, and technology, Texas still has many working cattle ranches.

Scott Teven photo

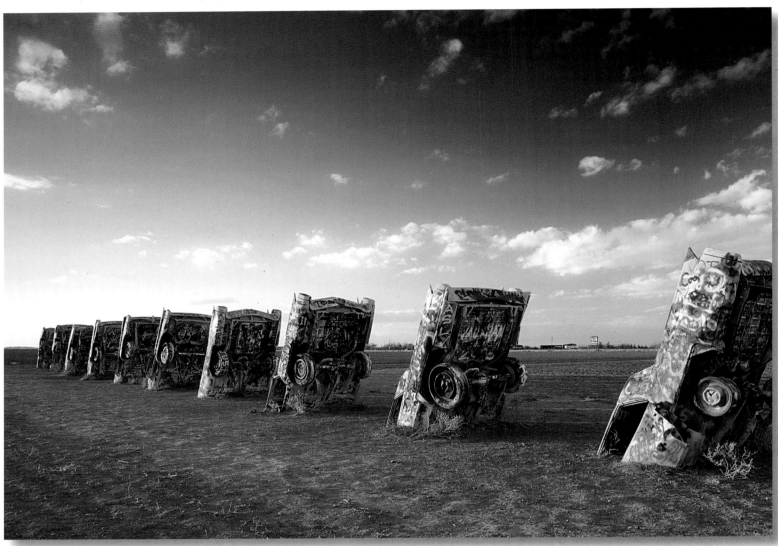

Rising out of the plains of the Texas panhandle like a large, unwieldy forest are the 10 cars of Cadillac Ranch. Assembled by a collective of artists called the Ant Farm, Cadillac Ranch features a 1949 Club Coupe as well as a 1963 sedan.

The cars at Cadillac Ranch, driven nose-first into large holes dug in the ground, have become an interactive installation. Visitors are encouraged to bring paint and add to the wildly decorated Cadillacs, which are regularly painted over to provide a fresh canvas for the public. *(right)*

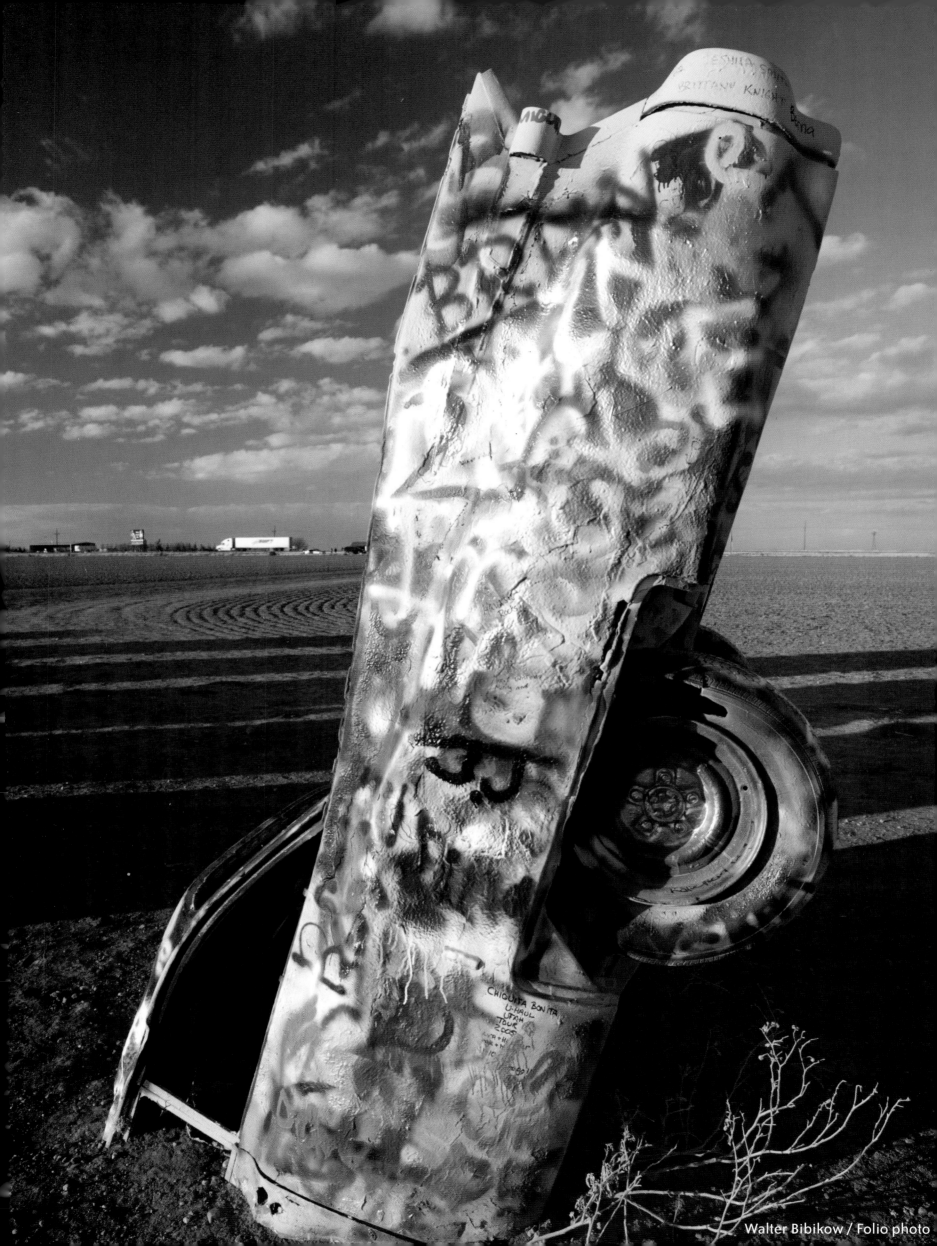

P H O T O C R E D I T S